ONE
SHOW
DESIGN

◆

VOLUME
6

CREDITS

Mary Warlick
Chief Executive Officer
Kevin Swanepoel
President
Yash Egami
Editor-in-Chief
Design Army
Concept and Design
Seth Callaway
One Show Design Manager/
Assistant Editor
Jennah Synnestvedt
Layout
Alison Bourdon
Photo Editor
Alison Jordan
Assistant Editor

Cover Photo: Cade Martin

First published in the
United States of America
by One Club Publishing
260 Fifth Avenue
2nd floor
New York, NY 10001
Telephone: (212) 979-1900
Fax: (212) 979-5006
www.oneclub.org

Distributed in the US
and Internationally by
Rockport Publishers, a member
of Quayside Publishing Group
100 Cummings Center
Suite 406-L
Beverly, Massachusetts 01915-6101
Telephone: (978) 282-9590
Fax: (978) 283-2742
www.quaysidepublishinggroup.com

ISBN-13: 978-0-929837-54-3

10 9 8 7 6 5 4 3 2 1

TABLE
OF
CONTENTS

To view the winners, visit
www.oneclub.org/theoneshow/osd

ONE SHOW DESIGN JUDGES

Pum Lefebure
Jury Chair
Design Army/Washington, DC

Malcolm Buick
Violette Design/New York

Juan Frontini
MTV/Buenos Aires

Hélène Godin
Sid Lee/Montreal

Paul Groves
W&cie/Paris

Michael Jager
JDK/Vermont

Diti Katona
Concrete Design/Toronto

Bradford Lawton
BradfordLawton/San Antonio

Chris Lee
Asylum Creative/Singapore

Edwin van Gelder
Mainstudio/Amsterdam

Kenjiro Sano
Mr_Design/Tokyo

Pum Lefebure
Jury Chair
Design Army/Washington, DC

Malcolm Buick
Violette Design/New York

Hélène Godin

Paul Groves

Bradford Lawton

Chris Lee

Kenjiro Sano

MESSAGE FROM THE JURY CHAIR

Pum Lefebure
Co-Founder & Creative Director, Design Army

This year marked the 12th year of One Show Design – an event synonymous with global design excellence. As we all know, a One Show Design Pencil has quickly become one of the most prestigious awards in the industry.

The design recognized this year blew the jury away by nailing the most important design criteria: idea, execution and strategy. The One Show Design Pencil winners aren't necessarily the most beautiful, but they are the most memorable. When evaluating work, I always ask myself: does this design move me? Always design something worth saying; otherwise, you are just wasting paper, pixels, and people. At the end of the day, these award winners solved complex business problems with simple aesthetic elegance.

Another inspiring aspect of chairing this year's One Show Design was collaborating with 10 other talented jury members from all over the world. Each judge brought a different perspective to the table, but in the end we all came together with a singular view for the winners. This year featured expanded broadcast design and spatial design categories to reflect the ever-evolving media landscape; and yet while the media is changing, one thing never does: powerful design always stands out.

There were thousands of amazing pieces in the show but only a few Pencils reserved for the best. The winning design celebrated in the pages of this annual truly speaks different languages from all aspects of the creative landscape. This year's list of winners not only left a lasting impression on our eyes and in our minds, it has set the bar even higher for 2013.

It was such an honor to be asked to chair One Show Design this year. Congratulations to all the winners!

Austria Solar
"The Solar
Annual
Report 2011"

Best of Show

Art Director
Matthaeus Frost
Writer
Moritz Dorning
Designer
Mathias Noesel
Creative Director
Alexander Schill, Christoph
Everke, Alexander Nagel,
Cosimo Moeller
Client
Austria Solar
Agency
Serviceplan/Munich
—
ID No. 12001D

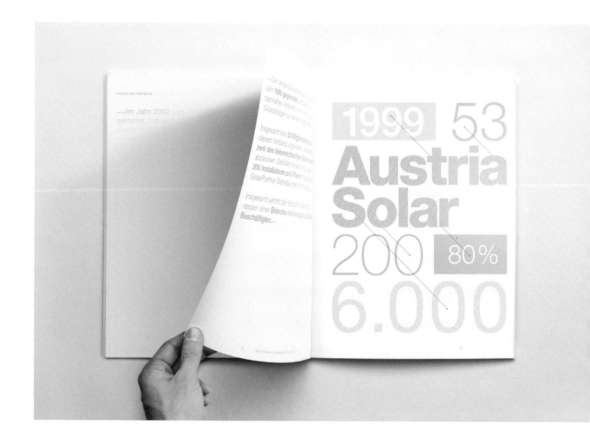

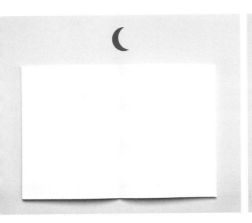
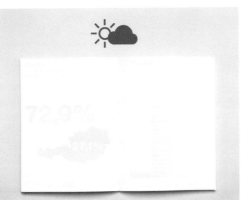
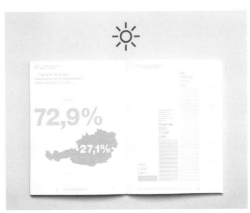

Austria Solar "The Solar Annual Report 2011"

Branding:
Annual Report

Art Director
Matthaeus Frost
Writer
Moritz Dornig
Designer
Mathias Noesel
Creative Directors
Alexander Schill, Christoph
Everke, Alexander Nagel,
Cosimo Moeller
Client
Austria Solar
Agency
Serviceplan/Munich
—
ID No. 12001D

Solar energy is the main
business of our client
Austria Solar. That's why
we thought about how
we could put this energy
on paper. The result:
the first annual report
powered by the sun. Its
content remains invisible
until sunlight falls on its
pages. "The Solar Annual
Report 2011 – powered by
the sun."

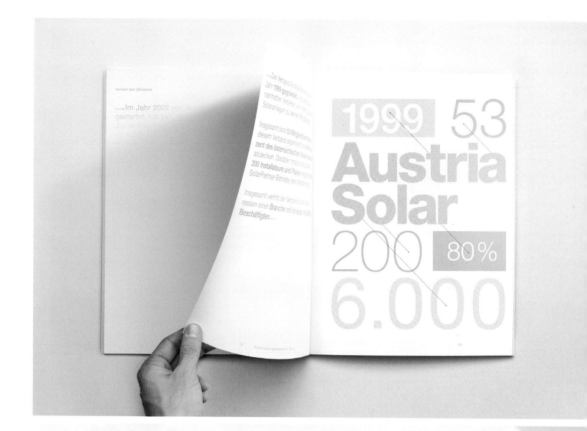

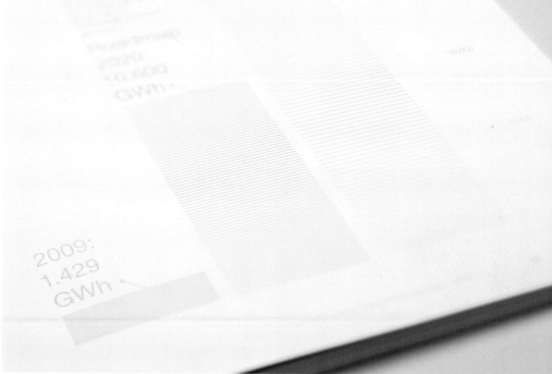

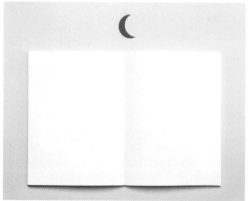

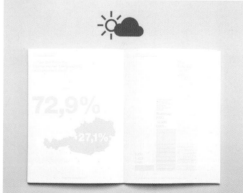

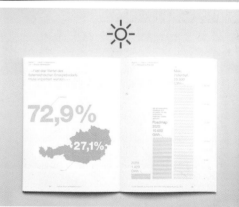

2010'S FAIREST ANNUAL REPORT
ALL YOU NEED TO KNOW ABOUT FAIRNESS, IN 33 PAGES.

LEMONAID BEVERAGES GMBH

LemonAid Beverages "The World's Fairest Annual Report"

Branding:
Annual Report

Art Directors
Annika Frey, Katja Kirchner
Writer
Christina Drescher
Photographers
Stefanie Buetow,
Johannes Cohrs
Creative Directors
Wolf Heumann,
Peter Kirchhoff
Client
LemonAid Beverages
Agency
Jung von Matt/Hamburg
–
ID No. 12002D

Also Awarded:
Silver: Typography in Design:
Single

Purpose: To communicate that LemonAid is the first soft drink manufacturer that doesn't just follow fair trade and sustainable sourcing principles, but also pursues a policy of active social engagement. We wanted to build momentum behind this philosophy by making readers aware of its power and importance.

The idea: An annual report that takes the concept of fairness to new extremes – on each and every page.

Placement: The initial print run of 1,500 copies made an overwhelming case for a sustainable approach to business at the Internorga trade show.

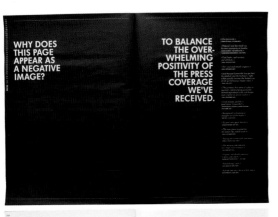

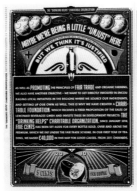

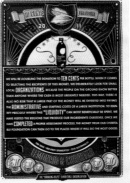

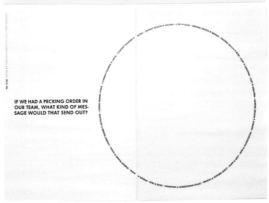

General Insurance Association of Singapore (GIA) "The Progressive Years"

Branding:
Annual Report

Writer
Ai Wei Lua
Designer
Weicong Lee
Creative Director
Larry Peh
Client
General Insurance Association
of Singapore (GIA)
Agency
&Larry/Singapore
—
ID No. 12003D

Often viewed as the less "sexy" cousin to banking, GIA constantly strives to correct opinions about general insurance from members of the public and fresh graduates. Following a rebranding exercise, as well as the implementation of successful outreach activities and internship programs, the past three years have been instrumental in showing the organization's growth and progress. Having made tangible leaps and bounds, we decided to utilize this as the central design theme. Three distinct chapters were carved out in different sizes and colored paper stock to visually depict GIA's significant progression over the years. Bound together with exposed thread–sewn binding, the result is a visually interesting and intriguing expression of an otherwise standard corporate document.

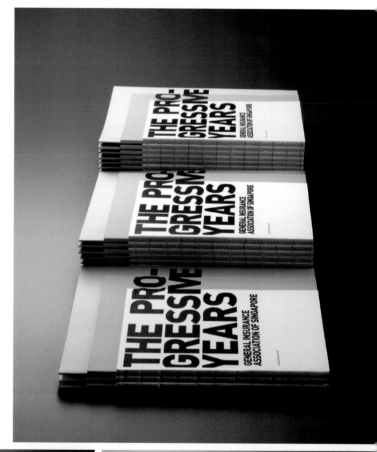

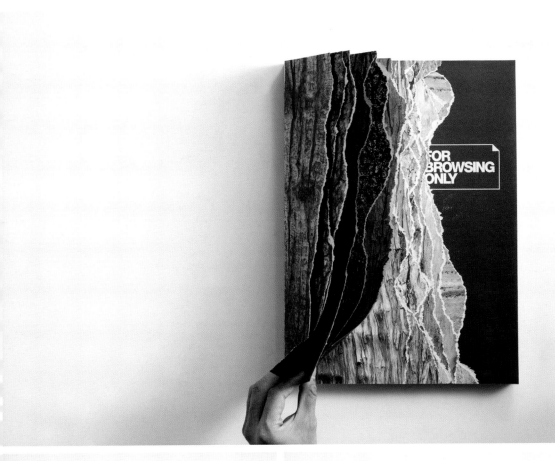

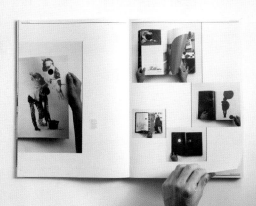

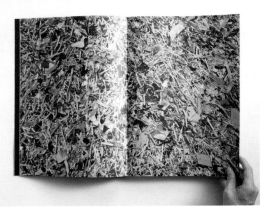

The Browsing Copy Project "For Browsing Only"

Branding:
Booklet/Brochure

Writer
John Nursalim
Designer
Roy Poh
Photographer
John Nursalim
Illustrator
Roy Poh
Typographer
Roy Poh
Creative Director
Roy Poh
Client
The Browsing Copy Project
Agency
Beautiful/Singapore
—

ID No. 12004D

The Browsing Copy Project focuses on unloved books, those that remained on the shelves unsold. These books are collected from local bookstores, and designers from around the world are invited to use them as canvases to express their creativity and give the books a second life. The "before & after" results are documented. This is an ongoing project and 20 to 25 designers are invited for each series. This catalogue features both series 1 & 2 of the project and the 45 designers' contributions. Only 300 copies were printed and circulated around the world's best bookstores, shops and design studios just for people to browse. It's not for sale. The catalogues will be collected back after a period of time and passed on to the next line of shops. The condition of the catalogues and the places they've been will be documented on its website: www.browsing-copy.com

Mission Design "World Summit and Congress of Architecture, Design and Planning Montreal 2017 – Brochure"

Branding:
Booklet/Brochure

Art Director
Daniel Robitaille
Creative Director
Louis Gagnon
Client
Mission Design
Agency
Paprika/Montreal

—

ID No. 12005D

For the 2017 Montreal World Summit and Congress installation, branding and brochure, we took our inspiration from one of the host city's best known icons: the traffic cone. The orange cones and the Interstate font used for road signs simply imposed themselves. We also gave a nod to our Asian friends with the folded pages as it was handed out during the 2011 Taipei World Design Expo.

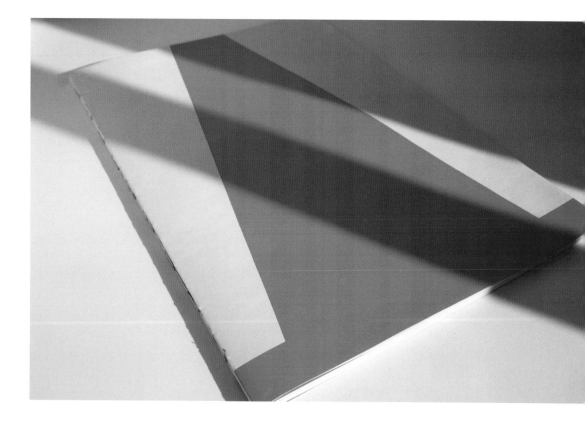

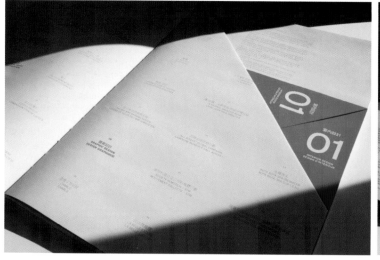

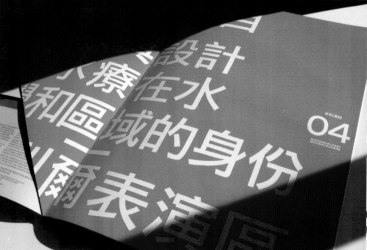

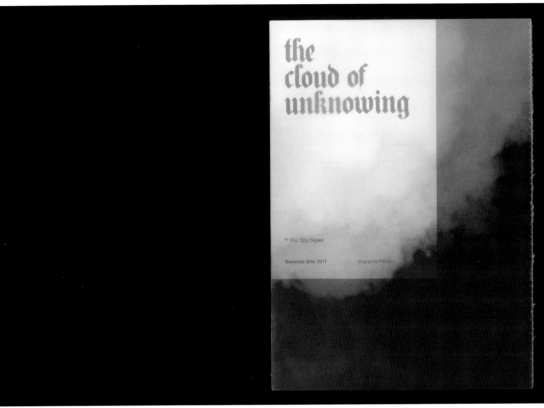

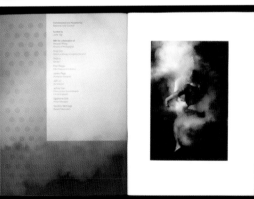 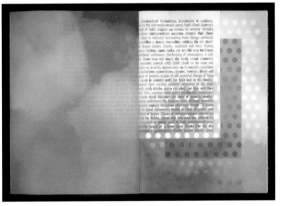

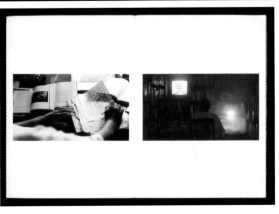

National Arts Council "Cloud of Unknowing – Venice Biennale 2011"

Branding:
Booklet/Brochure

Designers
Cara Ang, May Chiang
Creative Director
Chris Lee
Client
National Arts Council
Agency
Asylum/Singapore
—
ID No. 12006D

Commissioned by the National Arts Council Singapore, artist and filmmaker Ho Tzu Nyen was selected to represent Singapore at the 54th Venice Biennale in 2011. His artwork, "The Cloud of Unknowing," is an audio and visual installation piece set in an old church, exploring the multiple roles of the cloud within art, as a "historical object, a representation of emptiness, as exercises for the imagination, as screens for projection." Ho's exploration of the cloud is carried through with the accompanying catalogue. The catalogue, meant to recreate the qualities of a cloud, features film stills of Ho's current and past work and essays on a variety of translucent and lightweight paper stock finished with roughed edges.

Committee of Organ Dona– tion in Lebanon "Gift a Life"

Branding:
Logo Design

Art Director
Makarand Patil
Writer
Kartik Aiyar
Creative Directors
Kartik Aiyar, Makarand Patil,
Shehzad Yunus
Client
Committee of Organ Donation
in Lebanon
Agency
DDB/Dubai
–
ID No. 12007D

Our objective was to
design the logo and
corporate identity of an
organ donation initiative
in Lebanon.

When you donate an
organ, you gift someone
a new life. We simply
brought this insight to life
through our design.

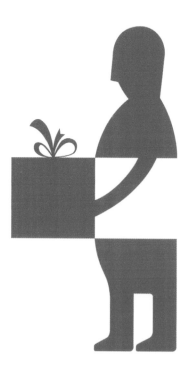

organ donation

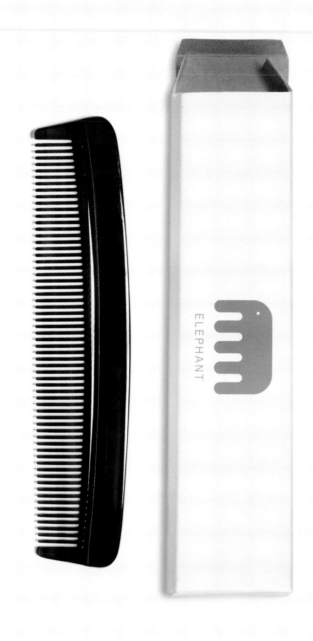

MKV Household Products "Elephant Combs"

Branding:
Logo Design

Art Director
Rishi Chanana
Writers
Rishi Chanana, Shagun Seda
Designer
Rishi Chanana
Photographer
Rishi Chanana
Illustrator
Rishi Chanana
Creative Directors
Rahul Sengupta,
Rishi Chanana
Client
MKV Household Products
Agency
TBWA\Mumbai
—
ID No. 12008D

MKV is one of the emerging manufactur–ers of plastic molded personal care products in Northern India. The brief was to redesign their branding. A logo was designed for Elephant Combs that brings alive the brand name with a unique visual play. With the new brand logo Elephant Combs achieved a remarkable increase in visibility on retail shelves and a boost in sales.

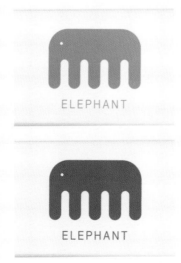

UPDN Broking
Logo

Branding:
Logo Design

Art Director
Viral Pandya
Writers
Vaibhav Pandey, Viral Pandya
Designers
Viral Pandya, Prachi Grover
Creative Directors
Viral Pandya, Guneet Pandya,
Sabu Paul
Client
UPDN Broking
Agency
Out of the Box/New Delhi
—
ID No. 12009D

Brief: To create a name
and logo for a brokerage
firm.

Background: When
partners Upen Patel and
Dhruv Narang, veterans
in trading stocks, wanted
to start a brokerage com-
pany of their own, they
had just one motive—to
generate profits for
investors regardless of the
vagaries of the market.

Solution: While creat-
ing various options, we
stumbled upon some-
thing interesting. We
realized that the first
letters of their names,
when put together forms
UPDN. The name per-
fectly captures how the
market behaves: it goes
UP and DOWN. Turn the
logo upside down and it
remains the same. And it
describes the philosophy
of the company—whether
the market moves up or
down, the investors will
always make a profit.
We extended the idea to
create collateral materials
as well.

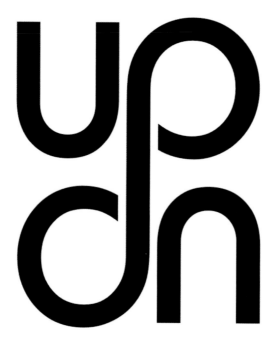

BARDOT™

Advanced Ice Cream Technol‐ogies "Bardot"

Branding:
Logo Design

Writer
Jen Jordan
Designers
Tosh Hall, Lia Gordon
Illustrator
Michael Goodman
Typographer
Jessica Minn
Creative Director
Tosh Hall
Client
Advanced Ice Cream
Technologies
Agency
Landor Associates/
San Francisco
–
ID No. 12010D

Advanced Ice Cream
Technologies, a bou‐
tique ice cream purveyor
from Mexico, came to us
with dreams of sharing
their artfully crafted ice
cream bars with America.
Unfortunately, their
name sounded more
like an innovator in cold
storage than an arti‐
san iced confectionery.
Our goal was to create a
name, identity and design
system that conveyed the
unparalleled decadence of
their product, creating a
sense of luxury, sensu‐
ality and desire. Their
product was delicious;
our job was to make it
beautiful.

Elections Ontario "We Make Voting Easy"

Corporate Identity: Campaign

Art Directors
David Federico, Mike Morelli, Matthew Kenney, Scott Leder, Ron Cueto, Brendan Good
Writers
Josh Rachlis, Len Preskow, Morgan Kurchak, Joy Panday
Designers
Tracy Ma, Scott Leder, Kimberley Pereira, Jeff Watkins, Chris Duchaine
Photographer
Jesse Senko
Illustrators
Chris Duchaine, Kimberley Pereira, James Joyce
Creative Directors
Lisa Greenberg, Shirley Ward-Taggart, Judy John
Client
Elections Ontario
Agency
Leo Burnett/Toronto
–
ID No. 12011D

Elections Ontario's sole responsibility is to help the people of Ontario vote in Ontario's provincial election.

We discovered a large number of people don't vote because they think it's hard, or inconvenient. So our mission for Elections Ontario was to make voting easy.

To make voting easy, they had to make all their materials friendly and easy to understand so we gave them a whole new friendly look in both print materials and online. We redesigned everything from their voting handbooks and voter information guides, to the voter registration cards so they were easy to read. We extended this ethos to TV, OOH and a piece called 'The Householder' that is distributed to every household in Ontario.

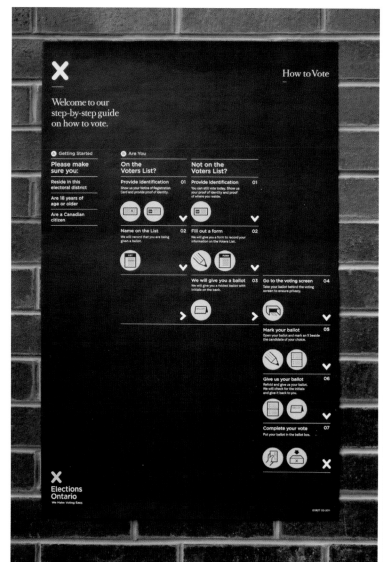

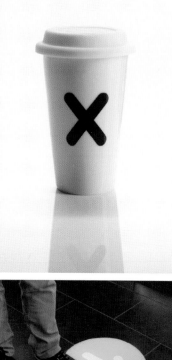

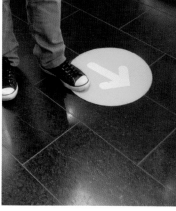

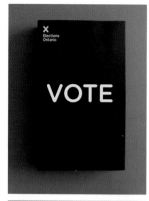

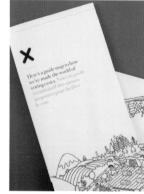

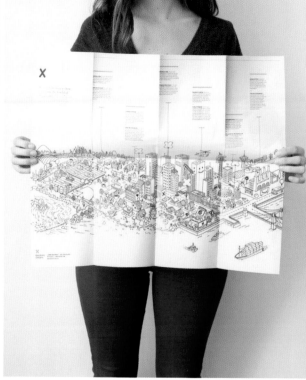

blink

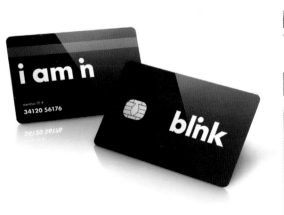

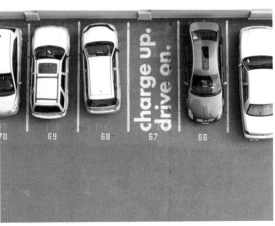

ECOtality "Blink"

Corporate Identity:
Campaign

Designer
Andy Baron
Creative Directors
Nicolas Aparicio, Paul Chock
Client
ECOtality
Agency
Landor Associates/
San Francisco
—
ID No. 12012D

Also Awarded:
Merit: Logo Design

ECOtality, a leader in clean electric transportation and storage technologies, needed to develop a consumer brand for its electric vehicle (EV) charging stations and network infrastructure. ECOtality manages the EV Project and will oversee the installation of approximately 14,000 commercial and residential charging stations in 18 major cities and metropolitan areas. Landor and ECOtality developed the brand idea, "Simply Smarter" and later the name "Blink," for the charging stations and infrastructure. The approach speaks to the intuitive and intelligent nature of the product and personifies the brand as friendly and easy to use. The ligature in the Blink logotype expresses the efficiency and ease of use that this electric vehicle power product provides. The visual system, nicknamed "energy in black and white," distinguishes Blink as the confident and emphatic choice for EV users and as the new standard for the industry.

524
Architecture
"524A–
ArchiTypo"

Corporate Identity:
Campaign

Art Director
Zhou Wenjun
Designer
Zhou Wenjun
Creative Director
Zhou Wenjun
Client
524 ARCHITECTURE
Agency
524 Studio/Beijing
—
ID No. 12013D

Typography is Archi–
tecture. We designed a
Modularized Typography
System as the official
typography of 524A.
The system holds three
scripts: Traditional Chi–
nese Character, Arabic
numerals and Latin
letters. Here we clearly
showed the characteris–
tics of the firm through
our logo design, and
people that speak dif–
ferent languages could
easily understand the
meaning. Several styles
of envelopes and business
cards were designed for
multiple uses.

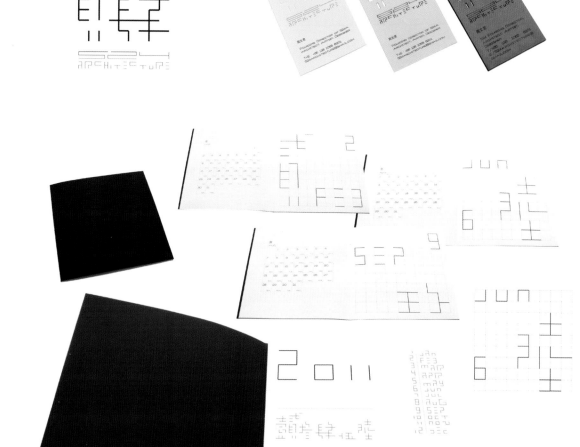

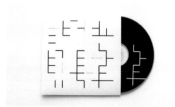

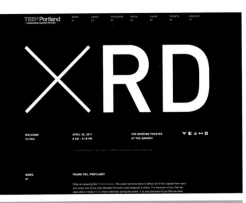

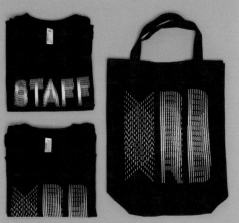

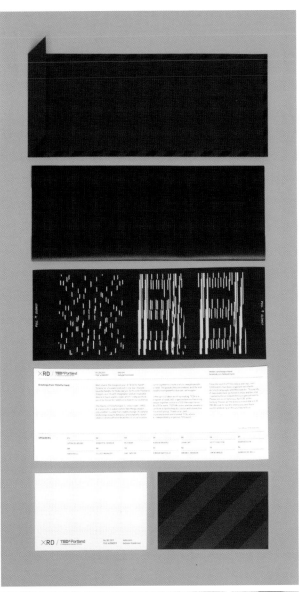

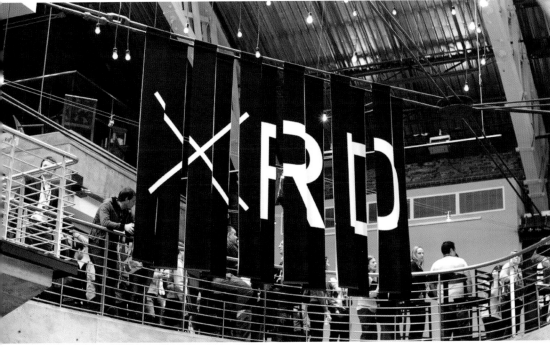

TedX "TedX Portland"

Corporate Identity: Campaign

Art Directors
Ken Berg, Derek Kim, Dom Murphy
Designers
Sarah Hollowood, Steve Denekas, Michael Frediani, Lisa Reinhardt, Lis Moran, Peiter Hergert
Photographer
Kyle Pero
Creative Directors
Susan Hoffman, Renny Gleeson
Client
TedX
Agency
Wieden+Kennedy/Portland
—
ID No. 12014D

TedX Portland approached us to create a unique and memorable identity for their event, the first of its kind in Portland. We were tasked to art direct and design the entire identity from scratch. The brief was simple: Crossroads. We decided to use a lenticular effect as the unifying aesthetic for the identity. It was a simple and effective solution – it used the motion of the lenticular to create a visual cross-road. The adaptability and versatility of the aesthetic we developed allowed us to easily translate it into different media ranging from print to interactive and motion design. The daylong event not only attracted hundreds of people in person, it was watched in 10 countries around the world via Livestream. In addition to sparking buzz within Portland, TedX Portland became the talk of the Twitterverse, trending organically both in Portland and nation-wide.

Committee of Organ Dona-tion in Lebanon "Gift a Life"

Corporate Identity:
Individual Item

Art Director
Makarand Patil
Writer
Kartik Aiyar
Creative Directors
Makarand Patil, Kartik Aiyar,
Shehzad Yunus
Client
Committee of Organ Donation
in Lebanon
Agency
DDB/Dubai
—

ID No. 12015D

Our objective was to
design the logo and
corporate identity of an
organ donation initiative
in Lebanon.

When you donate an
organ, you gift someone
a new life. We simply
brought this insight to life
through our design.

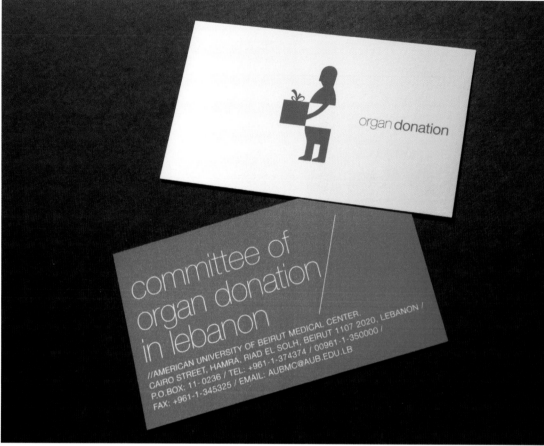

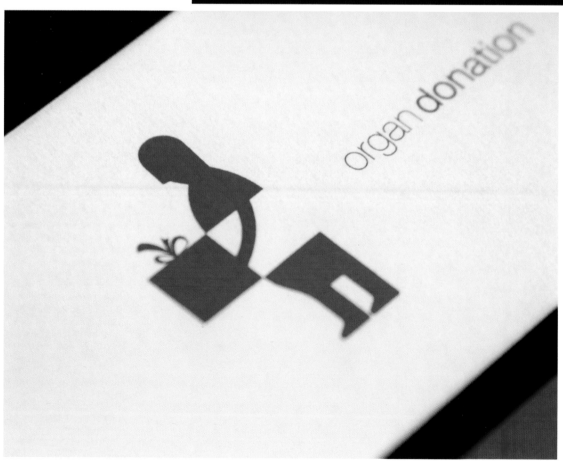

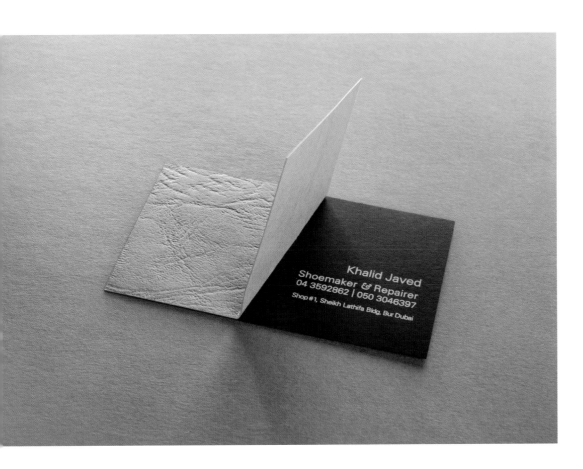

Khalid Javed
"Shoe Repair"

Corporate Identity:
Individual Item

Writer
John Mani
Designer
Alok Gadkar
Creative Directors
John Mani, Vitthal Deshmukh,
Alok Gadkar
Client
Khalid Javed
Agency
The Classic Partnership
Advertising/Dubai
—
ID No. 12016D

Brief: Khalid Javed is a cobbler whose shop is located in a large residential and shopping area in Dubai mainly populated with Asian expatriates. These residents, by tradition, have a habit of repairing their shoes, sandals and slippers rather than disposing of them. He asked us to create a business card for himself to promote his expertise.

Idea: We created a very distinctive split-open business card, mimicking a leather upper and bottom sole that hinted at his expertise of both making and repairing shoes.

Result: Not only did he freely distribute this card, but he also placed them at the cashiers of the local restaurants and grocery stores to be distributed to the public (a very common practice here to promote services.) He also used this unique business card as a flyer, placing them on the windshields of cars parked in the vicinity, and in door-drops in the residential buildings around.

Menicon "Magic"

Package Design: Campaign

Art Director
Yoshihiro Yagi
Writer
Haruko Tsutsui
Designers
Toshimitsu Tanaka,
Ayano Higa
Director
Steve Newman
Producers
Dai Sakashita, Tetsuji Nose,
Koji Wada, Takeshi Arimoto
Creative Director
Morihiro Harano
Client
Menicon
Agencies
Dentsu, Drill, Party/Tokyo
—
ID No. 12021D

Magic is an all-new,
1-mm thin contact lens
flat pack. The catch-
phrase "New Dawn" was
created from the unique
package design where
each lens pops up. The
campaign helped convey
the company's develop-
ment ingenuity.

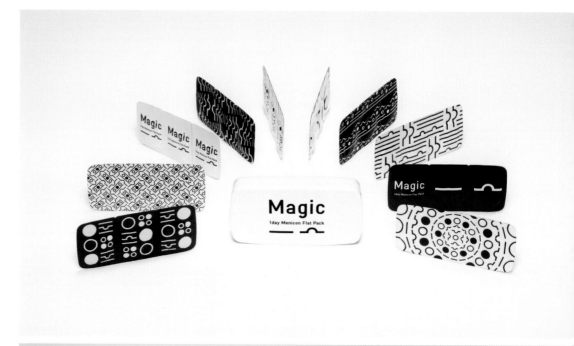

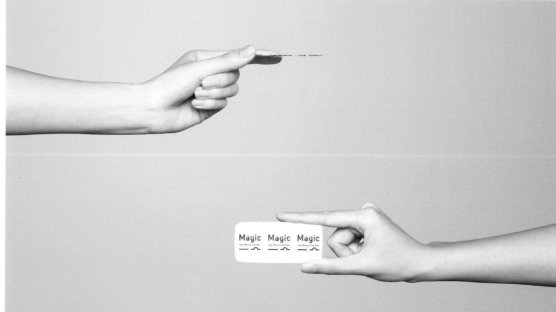

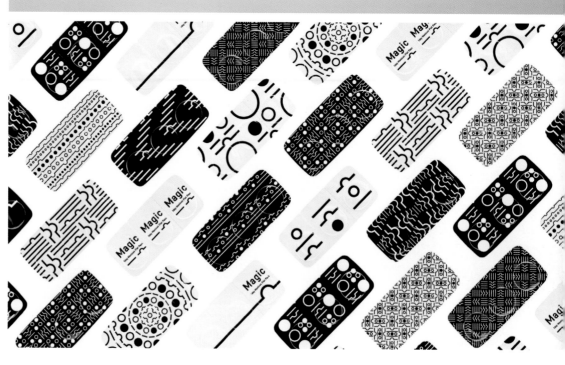

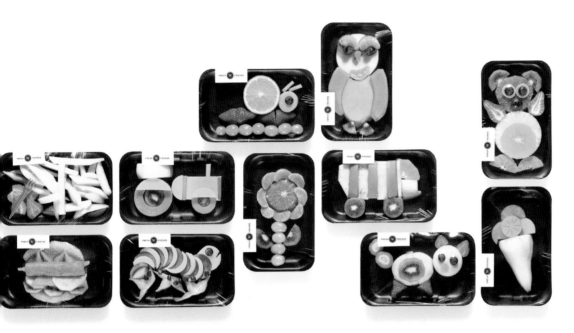

Fresh N Friends "Obstfiguren" (Fruit Figures)

**Package Design:
Campaign**

Art Directors
Jinhi Kim, Bjoern Kernspeckt,
Rene Gebhardt, Loic Sattler
Writers
Alexander Doepel,
Sandra Krebs
Designers
Simon Rossow,
Peter Schoenherr
Photographers
Attila Hartwig,
Cosima Walther
Illustrators
Volker Hobl, Maren Boerner
Directors
Matthias Rebmann,
Florian Schwalme
Creative Directors
Martin Pross, Matthias
Spaetgens, Wolf Schneider
Client
Fresh N Friends
Agency
Scholz & Friends/Berlin
—

ID No. 12018D

Children love sweet
things – unfortunately,
sweets are seldom the
healthy option. So how
does one make healthy
fruit look sweet enough
for children to voluntarily
choose?

Fresh`N`Friends` custom-
ers are young, urban,
very busy and concerned
with providing a healthy
diet for themselves and
their children. That`s
why healthy, convenient
food takes first place on
their shopping lists.

Sweet does not necessar-
ily equal unhealthy: we
created child-friendly
motifs from fresh fruit in
order to grab the young
customers` attention.
That way they were
encouraged to go for the
fruit voluntarily instead
of chocolate.

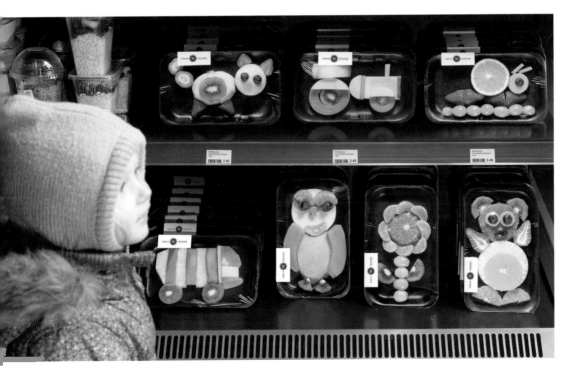

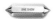

Ricola
"Unwrap"

**Package Design:
Campaign**

Art Director
Johannes Riffelmacher
Writer
Hannah Haeffner
Designers
Lars Jakschik, Karina Riehle
Illustrator
Julien Canavezes
Creative Directors
Fabian Frese, Goetz Ulmer,
Thimoteus Wagner,
Martin Strutz
Client
Ricola
Agency
Jung von Matt/Hamburg
▬
ID No. 12019D

Ricola is the favorite loz‑
enge of the great voices of
the world. Its traditional
blend of 13 natural herbs
provides instant relief
even to the most strained
throats – an effect that
we visualize with the help
of the wrapping paper.
An illustrated special
edition turns the drops
into the heads of suffering
singers. Each and every
throat appears to be con‑
stricted. However, when
you unwrap a Ricola, the
throat is relieved and all
hoarseness disappears.

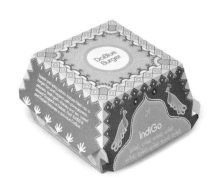

IndiGo Airlines "Onboard Food Packaging"

Package Design: Campaign

Art Directors
Rocky, Hanif Kureshi,
Sarah Fotheringham,
Latheesh Lakshman
Writers
Sarah Coles, Keshav Naidu,
Hemant Anant Jain,
Molona Wati Longchar
Illustrator
Reshidev R.K.
Creative Director
V. Sunil
Client
IndiGo Airlines
Agency
Wieden+Kennedy/New Delhi
—
ID No. 12022D

This set of packaging was designed for the updated 2011 in–flight menu for IndiGo, India's coolest low–cost airline. IndiGo features a unique onboard dining experi–ence through its Indian street food–centric menu and culturally reflec–tive packaging, which is designed to add a bit of fun and interest to the passenger's journey. The packages are created to be saved as mementos from the customer's trip. Some, like the Atta Biskoot tin, are intended to be reusable. As a result these packages have developed a cult following.

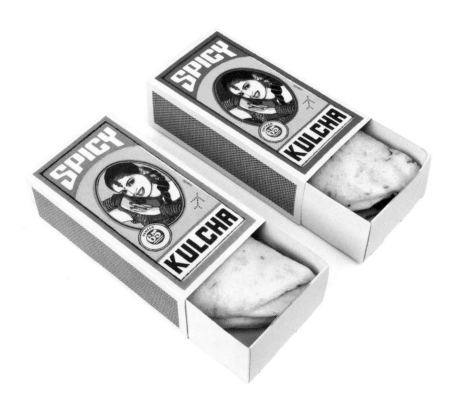

Umino Seaweed Store "Design Nori"

**Industrial Design/
Product Design:
Single or Campaign**

Art Director
Kenichiro Shigetomi
Writers
Ririko Murata, Kiyoyuki
Enomoto
Designer
Kenichiro Shigetomi
Photographer
Yasunari Kurosawa
Creative Director
Kenichiro Shigetomi
Client
Umino Seaweed Store
Agency
I&S BBDO/Tokyo

ID No. 12023D

Having struggled with a long declining sales trend, and with damage from the massive tsunami that swept away their factories, the client asked us to design new packaging that could boost their product's appeal to a modern urban audience. Rather than focus exclusively on packaging, we applied design to the product itself. We wanted to make nori the focus – to have it talked about by an urban, design–conscious target audience. We used laser cutters to carve designs into our nori – classic patterns from Japanese history called MonYo that signify growth, beauty, long–life, etc. We felt these themes could uplift people following the tsunami. The nori remains functional, but by combining tradition with modern technology, we created an entirely new type of nori never seen before – one that conveys our hopes for the future, as well as our respect for the past.

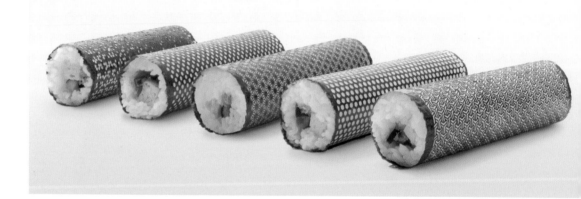

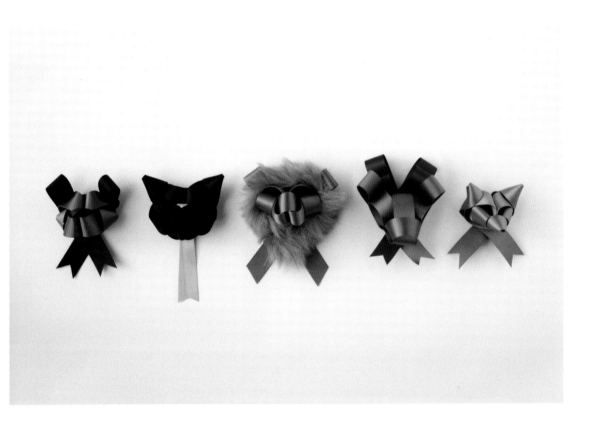

Ribbonesia "Adornments"

Industrial Design/ Product Design: Single or Campaign

Art Director
Ryo Ueda
Designer
Naohiro Iwamoto
Photographer
Kei Furuse
Director
Baku Maeda
Creative Director
Toru Yoshikawa
Client
Ribbonesia
Agency
Ribbonesia/Sapporo
–
ID No. 12024D

Ribbonesia is the new way of sculpture using ribbon. It is a mixture of a western style of gift-ing and a sense of the Japanese craft tradition of Origami to express spe-cial feelings of care. We chose to weave animals as a universal language and transform the gift-ing material into the gift itself. It is all carefully hand crafted so each has its own expression and character, just like living animals.

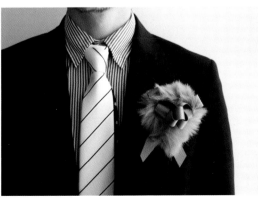

Leo Burnett
"Edit"

**Industrial Design/
Product Design:
Single or Campaign**

Art Director
Scott Leder
Designer
Scott Leder
Photographer
Arash Moallemi
Creative Directors
Judy John, Lisa Greenberg
Client
Leo Burnett/Toronto
Agency
Leo Burnett/Toronto
—
ID No. 12025D

Edit. Form hides Func-
tion. Equipped with
under mount drawers, an
invisible wire manage-
ment system and finished
with a high gloss lacquer
– Edit was designed to
beautifully hide the mess
of wires and clutter usu-
ally associated with the
personal workspace.

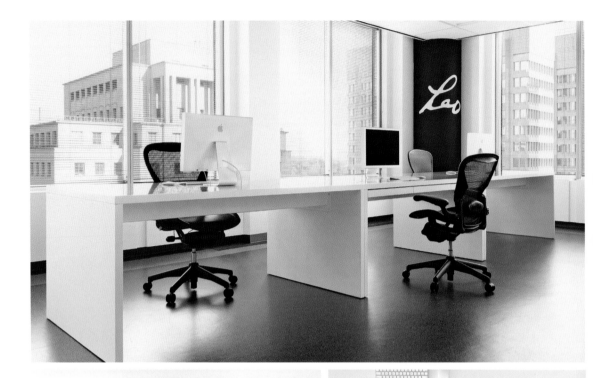

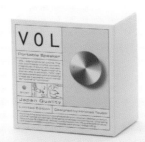
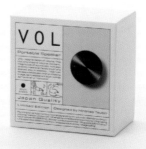

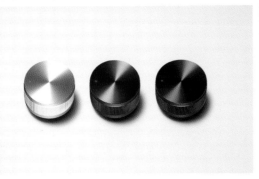
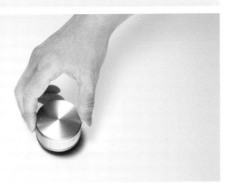

British American Tobacco Japan "Kent VOL Project"

Industrial Design/ Product Design: Single or Campaign

Art Directors
Takahisa Hashimoto,
Hironao Tsuboi
Writer
Takahisa Hashimoto
Designers
Hironao Tsuboi, Takanori
Kimura, Kiyoshi Imafuji,
Eriko Wakabayashi
Creative Director
Shoji Tamura
Client
British American Tobacco
Japan
Agency
Ogilvy & Mather Japan/Tokyo
—
ID No. 12026D

Since Kent is sold in cartons at airport dutyfree shops, many of the consumers are value conscious, and the presence or absence of a "gift item" often affects the brand selection. With competitors constantly conducting promotional activities using gift items, encouraging brand switching was difficult. Thus, developing an innovative gift item was necessary for the purpose of sales promotion. In collaboration with an upandcoming product designer, we developed an original portable speaker. By rotating, the power goes on, and the audio volume can be adjusted, or turned off. With no switch, "Kent VOL" is a portable speaker with excellent design operated by one simple act of rotating.

Volkswagen "Iconic"

**Collateral Design:
Posters – Single**

Art Director
Manish Darji
Writer
Akhilesh Bagri
Designer
Manish Darji
Illustrator
Manish Darji
Creative Directors
Bobby Pawar, KB Vinod
Client
Volkswagen
Agency
DDB Mudra/Mumbai
–
ID No. 12027D

The Volkswagen
Beetle has grown into an
instantly recognizable
icon over the last several
decades. However, it was
launched in India only
recently. Our task was to
capture its legacy, while
keeping the communica-
tion young and fresh. We
recreated pop–culture
icons with a series of
simplistic illustrations.
The designs were clean,
minimalistic and engag-
ing, much like the Beetle
itself. The icons made
their way into the walls
of showrooms, posters,
t–shirts, calendars, and
a book.

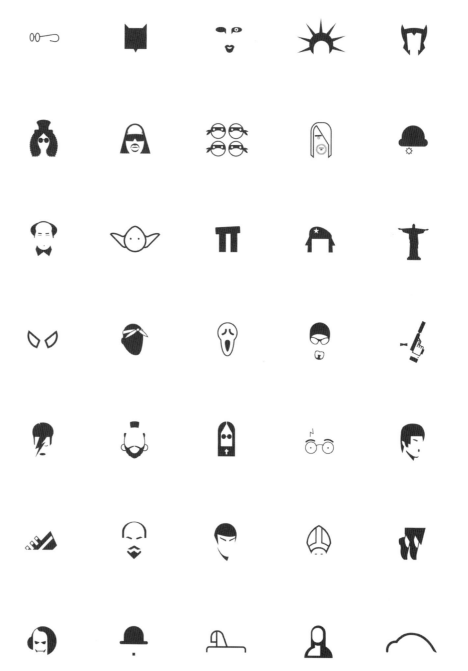

www.volkswagen.co.in

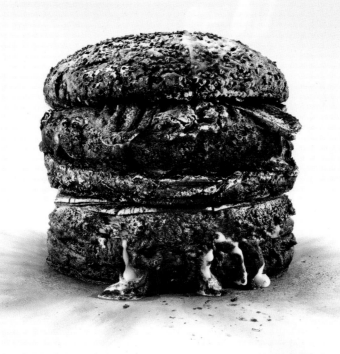

Gold's Gym "Burger"

**Collateral Design:
Posters – Single**

Art Director
Sebastien Deland
Photographer
Alain Desjean
Creative Director
Gaetan Namouric
Client
Gold's Gym
Agency
Bleublancrouge/Montreal
—
ID No. I2028D

**Burning calories can seem
like kind of an abstract
concept at times. But
this print campaign
shows how Gold's Gym
can make torching those
extra pounds a charred,
smoking reality.**

Ninseikan Karate School "Karate Boy"

Collateral Design: Posters – Single

Art Director
Takeshi Iwamoto
Writer
Kei Oki
Creative Director
Masayoshi Soeda
Client
Ninseikan Karate School
Agency
Grey/Tokyo

ID No. 12235D

Also Awarded: Merit: P.O.P. and In-Store: Single, Merit: Transit: Single

Objective: To inspire parents of children between 3 to 12 and make them enroll their children in Karate school.

Challenge: Given that Karate is considered outdated and boring compared to soccer and baseball, our challenge was to spotlight Karate as a captivating activity.

Result: We were able to convey that if a child learns the skills of Karate, he or she will be able to be as strong as their favorite anime hero. We have succeeded in enticing children who have stopped to look at the poster.

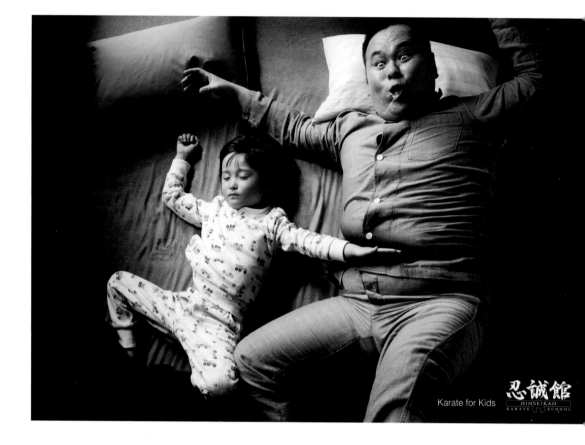

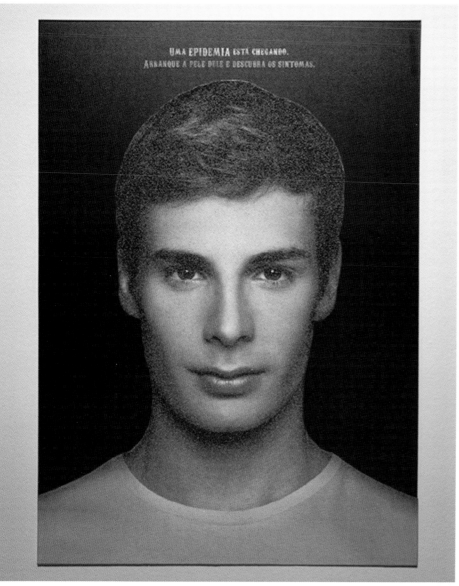

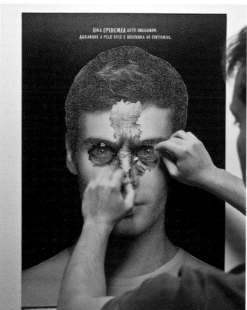

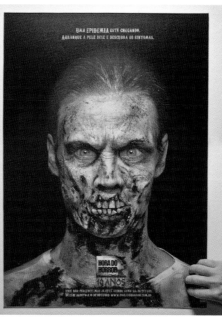

Hopi Hari "The Horror Time"

Collateral Design: Posters – Single

Art Directors
Bruno Salgueiro, Leo Macias
Writers
Luis Felipe Figueiredo,
Leo Macias
Photographer
Raul Raichtaler
Creative Directors
Hugo Rodrigues, Leo Macias
Client
Hopi Hari
Agency
Publicis/São Paulo
—
ID No. 12029D

The face of the young man on the poster was printed with a special coating that simulated human skin. The headline provoked people to tear at this skin and the more they pulled, the more the poster revealed the same young man as an infected zombie.

Hopi Hari is Latin America's biggest theme park. And every year it holds Hora do Horror, an event of suspense and horror.

The Yoshida Hideo Memorial Foundation/ Advertising Museum Tokyo "The Ultra Asian"

Collateral Design:
Posters – Campaign

Art Director
Yoshihiro Yagi
Writer
Haruko Tsutsui
Designers
Minami Otsuka, Kazuaki Takai
Creative Director
Yuya Furukawa
Client
Yoshida Hideo Memorial Foundation
Agency
Dentsu/Tokyo
•

ID No. 12030D

Also Awarded:
Silver: Craft: Printing and Paper Craft, Single

Brief: To announce and display the ADFEST 2011 exhibition, a collection of the best advertising work from Asia, by designing an exhibition based on the theme of "why Asian advertising is strong and mystical."

Concept: We developed the concept of "Life-Sized Asian," and aimed to describe how history, culture, technology, and trends of Asia comprise the flesh and blood of an Asian, which is why ideas from Asia are strong.

Result: A giant palm leads visitors into the exhibition hall, where they are welcomed by a giant Asian, who looks dynamic from a distance, but delicate at close range. Visitors could experience the Asian feel from the overall exhibition design while viewing the exhibited work. The number of visitors doubled, and the life-sized pamphlets received a lot of praise.

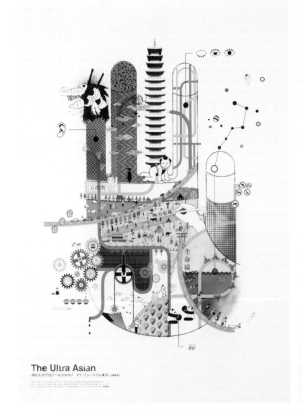

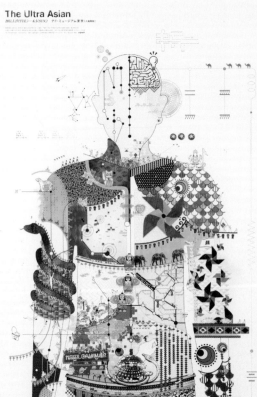

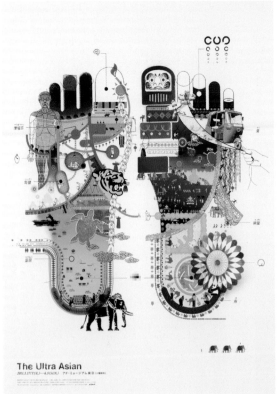

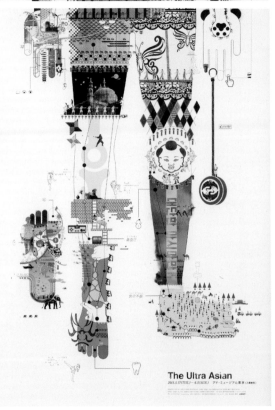

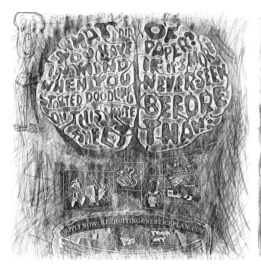
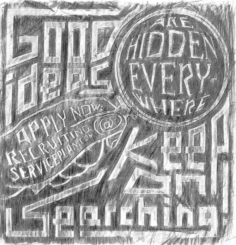
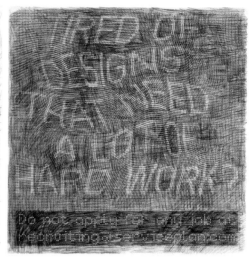

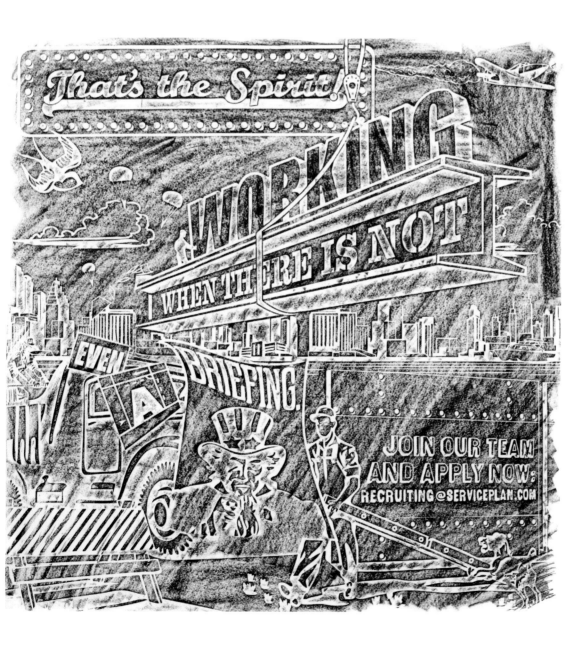

Serviceplan Hamburg "1m2 of curios- ity. The do- it-yourself recruitment posters."

Collateral Design: Posters – Campaign

Art Directors
Manuel Wolff,
Fernando Santos Silvestrin
Writer
Gesche Sander,
Michael Pilzweger
Designer
Aletta Grolman
Creative Directors
Alexander Schill, Maik
Kaehler, Christoph Nann
Client
Serviceplan
Agency
Serviceplan/Munich

—

ID No. 12031D

Serviceplan needs cre-
atives who are searching
for ideas everywhere
and who are challenged
by every blank sheet of
paper. In order to com-
municate this message,
we created posters that
don't reveal their mes-
sages until someone starts
doodling on them. Put
up on the blackboards
of design universities,
our seven differently
illustrated messages
address our target group:
creatives with a wild
imagination and a strong
power of endurance.

KT&G Sang– sangmadang "Hangeul. Dream.Path."

Collateral Design: Posters – Campaign

Art Director
Kum-jun Park
Writer
Kum-jun Park
Designer
Kum-jun Park
Photographers
Kum-jun Park, Sung-kwon Joe
Illustrator
Kum-jun Park
Typographer
Kum-jun Park
Creative Directors
Kum-jun Park, Jong-in Jung
Client
KT&G Sangsangmadang
Agency
601bisang/Seoul
—
ID No. 12032D

In this exhibition, celebrating the Hangeul Proclamation Day in October 2011, the ideas of dream and path are found in objects and nature around us. During the process of deconstructing and reconstructing the old typewriter, wall clock and instruments, diverse stories are found and the dreams with the passage of time are followed.

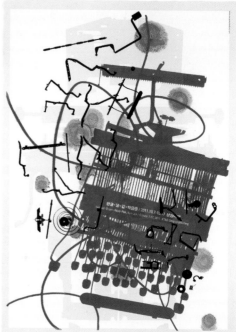
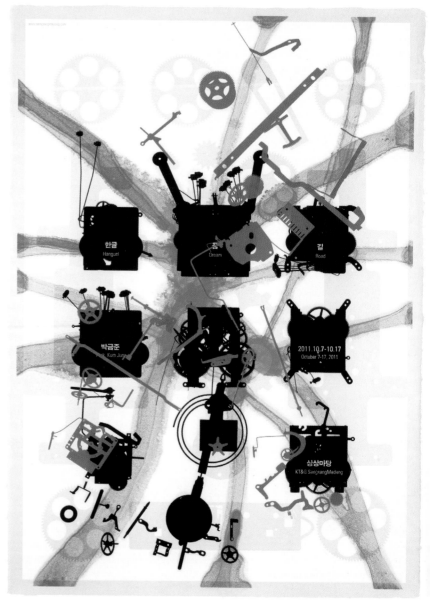

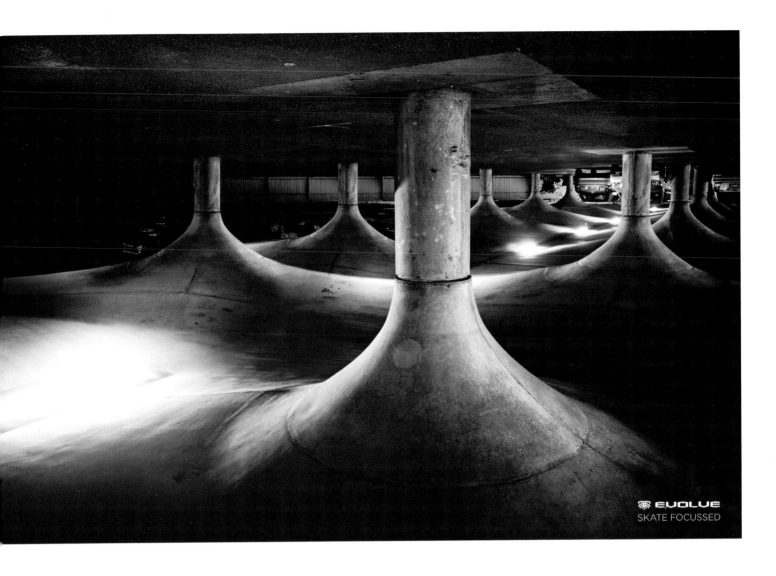

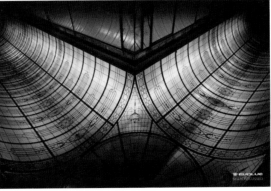

Scott Holding
"Evolve Skate"

Collateral Design:
Posters – Campaign

Art Director
Joe Hill
Photographer
Dave Tacon
Creative Director
Michael Knox
Client
Scott Holding
Agency
Ogilvy/Melbourne
–
ID No. 12033D

This campaign was devel-
oped to build the Evolve
brand via visual demon-
stration that Evolve sees
the world whole through
the eyes of a skater.

P&G "Ariel Big Stain"

**Collateral Design:
P.O.P. and In-Store –
Single**

Art Directors
Wendy Chan, Fan Ng,
Ocean Ye, Kobe Yu
Writers
Andy Greenaway, Lin Qi,
Wendy Chan
Photographer
Xiqiang Chen
Creative Directors
Fan Ng, Wendy Chan,
Jonathan Ip
Client
P&G
Agencies
Saatchi & Saatchi/Shanghai,
Pill and Pillow
–
ID No. 12034D

Objective: Raise aware-
ness of Ariel in China.
And increase sales in key
cities across the country.

Idea: We wanted to
demonstrate the clean-
ing power of Ariel on
a scale that nobody
had seen before. So we
created large outdoor
installations. And gave
people technology which
allowed them to have fun
with stains but also expe-
rience the satisfaction of
getting rid of them. We
made the world's biggest
t-shirt and erected it in
key outdoor sites across
China. We took the Wii
console and dressed it
up to look like bottles:
ketchup, mustard, soy
sauce, as well as Ariel.
People used the Wii con-
sole to stain the shirt, and
then used the Ariel Wii
console to clean the shirt.

Results: 113% increase in
sales in the first month.
300% increase in brand
awareness. 143 news
stories in major press and
magazines. Over 8 mil-
lion views of the stunt
online.

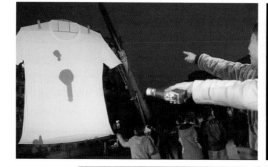

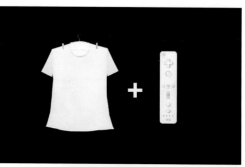

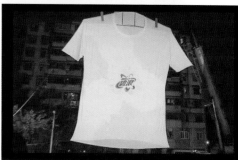

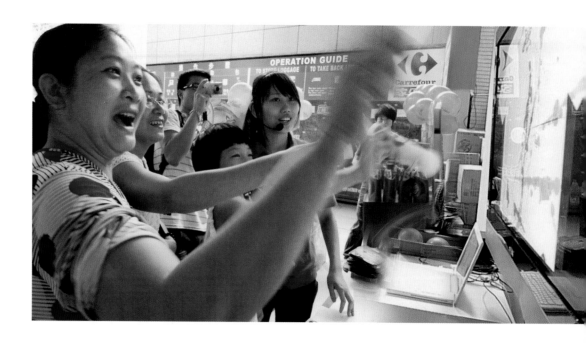

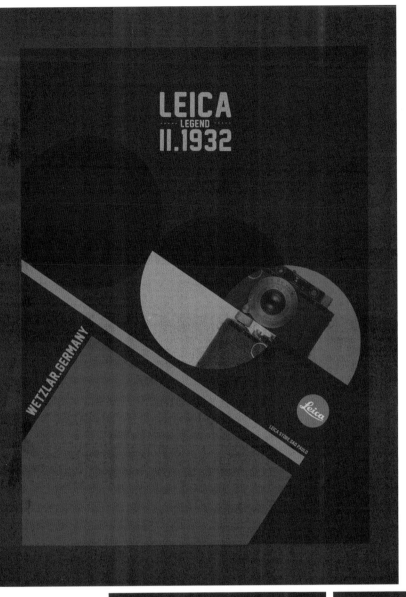

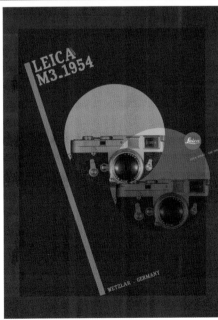

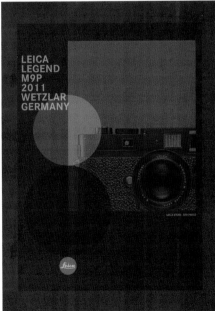

Leica "Legend"

**Collateral Design:
P.O.P. and In-Store –
Campaign**

Art Directors
Bruno Oppido
Writer
Romero Cavalcanti
Typographer
Jomar Farias
Illustrator
Bruno Oppido
Creative Directors
Fabio Fernandes,
Eduardo Lima
Client
Leica
Agency
F/Nazca Saatchi & Saatchi/
São Paulo
–
ID No. 12035D

With retro art direction,
the Legend series posters
pay tribute to the classic
models of Leica and the
years in which they were
released.

BEKO "The Recorded Contents"

Collateral Design:
P.O.P. and In-Store –
Campaign

Art Director
Burak Kunduracioglu
Writer
Ali Sener
Illustrators
Omur Kokes, Haluk Demirel
Creative Directors
Ilkay Gurpinar, Emre Kaplan
Client
Beko
Agency
TBWA\Istanbul
–
ID No. 12036D

Brief: Communicate the USB-recording ability of BEKO TV's in a distinct and attractive way.

Solution: Focusing on the content, we have shown instances where everything on the screen (motorbikes on a racetrack, animals in a desert, etc.) would be seen running into the connected USB disk; implying that one could fill the USB flash disk with the content he/she watches on the screen.

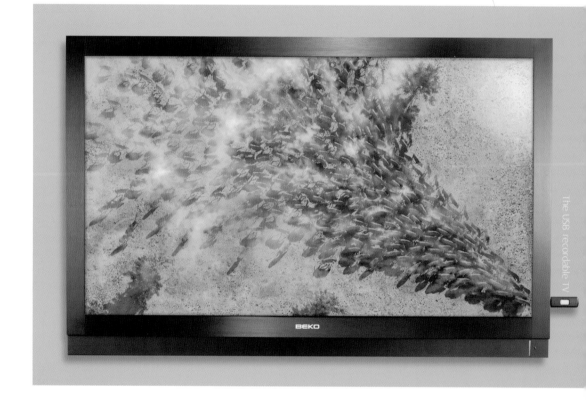

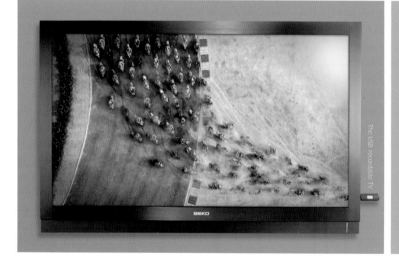

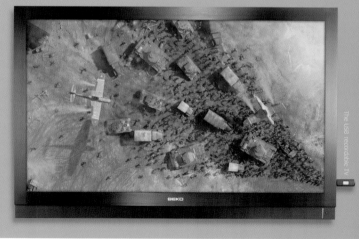

Lifestyle "Baddie Bags"

Collateral Design: P.O.P. and In-Store Campaign

Art Director
George Abraham
Writer
Vijay Joseph
Creative Director
Senthil Kumar
Client
Lifestyle
Agency
JWT India/Mumbai

ID No. 12037D

Plastic bags, like anywhere else in the world, pose a huge environmental hazard. So when the Bangalore Municipality Corporation decided to restrict their usage by charging for bags, we were happy to enforce it in our stores. The new regulation also opened up a space we had not paid much attention to: paper bags. So we went about creating a series of fun paper Baddie Mask Bags to dole out at our kids section. It came as no surprise that the kids were more excited about the bags than what was in it.

Siam Tamiya "Tamiya Calendar"

Collateral Design: Promotion

Art Directors
Thirasak Tanapatanakul,
Tienchutha Rukhavibul
Designers
Thirasak Tanapatanakul,
Tienchutha Rukhavibul,
Manasit Imjai, Chalermpun
Punjamapirom, Nitipong
Tancharoen, Kingkanok
Munkongcharoen, Kantaphat
Witwasin, Irada Sribyatta,
Chittiporn Chittapootti,
Manamai Rodpetch, Sermpan
Bunyalumlerk
Creative Director
Thirasak Tanapatanakul
Client
Siam Tamiya
Agency
Creative Juice
(TBWA Thailand)/Bangkok
—
ID No. 12038D

Also Awarded:
Bronze: Corporate Identity

Tamiya wanted to seize the New Year as an occasion to connect and build a lasting bond with its customers.

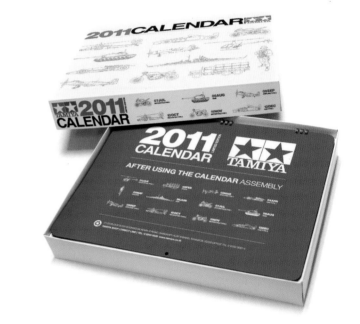

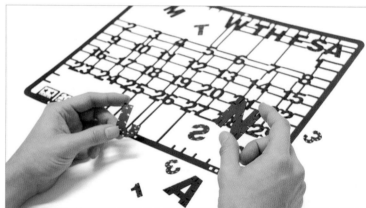

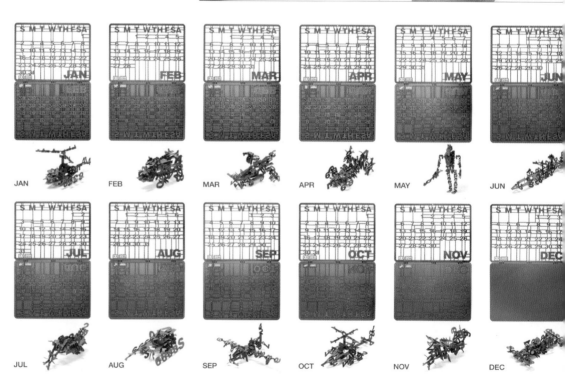

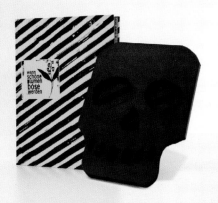
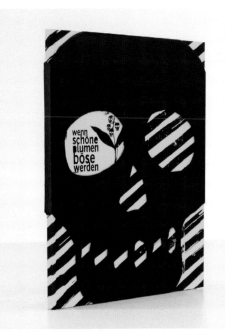

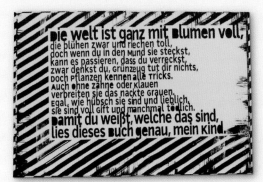
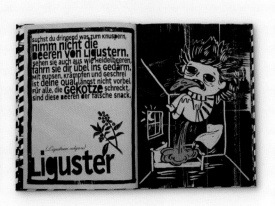

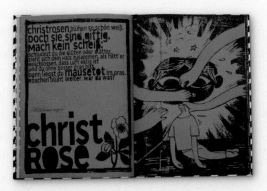
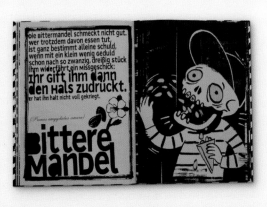

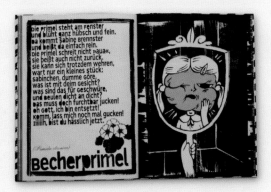
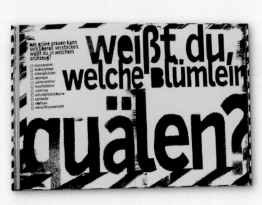

Gruner + Jahr/ Flora Garten "Book of Poison"

Collateral Design: Promotion

Writer
Claudia Oltmann
Illustrator
Veronika Kieneke
Typographer
Reiner Fiedler
Creative Director
Reiner Fiedler
Client
Gruner + Jahr/Flora Garten
Agency
Gürtlerbachmann/Hamburg

—

ID No. 12039D

A high-quality book about poison plants, it was used as an incentive for readers to extend their subscriptions to the magazine *Flora Garten*. "When Beautiful Flowers Become Evil: The Book of Poison," comes in a slip-case designed as a skull, which is supposed to warn children of poison plants. Complex illustrations made in lino-style combined with evil little poems and its own designed scraggy typography, make the book interesting for adults, too. It is not available in stores—those who want it need to extend their subscription, encouraging the trial subscribers of the magazine *Flora Garten* to become yearly subscribers.

Sephora & Firmenich "Lucid Dreams – Sephora Sensorium"

Spatial Design:
Indoor Spaces

Writer
Kate Cox
Designers
Ken Pelletier, Elena Manferdini, Gautam Rangan, Justin Lui
Agency Producer
Ron Cicero
Sound Designer
Patrick Cicero
Creative Director
Matt Checkowski
Client
Sephora ® Firmenich
Agency
The Department of the 4th Dimension/Los Angeles
–
ID No. 12041D

The Sephora Sensorium is the world's first interactive scent museum. The multifaceted and interactive sensory experiences go beyond just the act and perception of sniffing perfume. The finale, "Lucid Dreams," explores the physical act of smelling with an interactive mix of cinema, design and technology that creates visual stories based on how you sniff the fragrance.

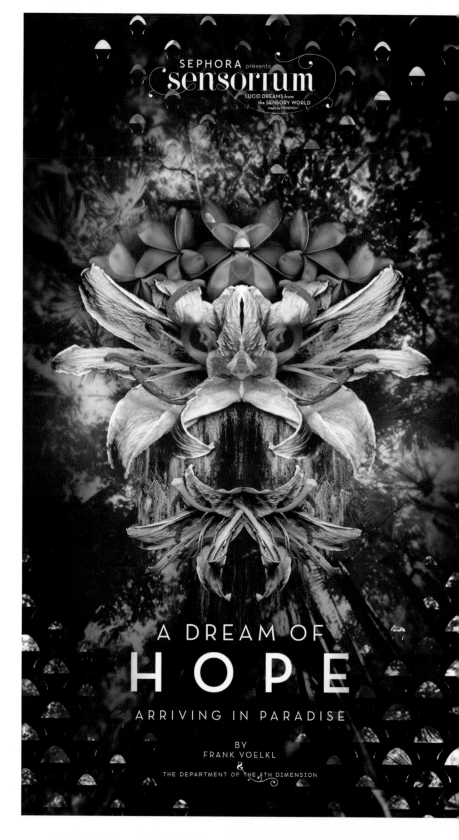

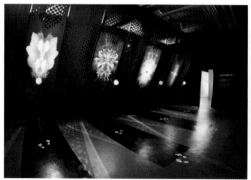

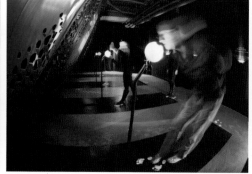

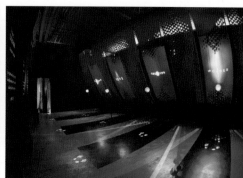

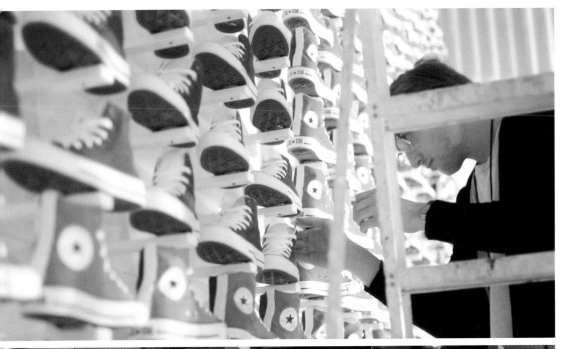

Converse EMEA "The Canvas Experiment"

Spatial Design:
Indoor Spaces

Art Director
Niklas Karlsson
Writer
Patrick Gardner
Designers
Martin Hammarberg,
Karl Nord
Photographers
Alexander Radsby,
Oskar Lundgren
Agency Producer
Patrik Sundberg
Creative Directors
Mark Chalmers, Tony Hogqvist
Client
Converse
Agencies
Perfect Fools/Stockholm,
Checkland Kindleysides
-
ID No. 12042D

Our goal was to elevate
and protect the Chuck
Taylor line through
Converse EMEA'S largest
activation for Spring
2011. The activity was
founded on two con-
cepts: "A blank Canvas
for self-expression" and
"independent enough not
to follow." Our solution
grew out of the success-
ful Converse Flag, a static
physical construction
of red, white and blue
Chuck Taylors in the
shape of an American
flag. The Flag gave us an
idea: it's exciting to turn
the shoes themselves
into content, but what
if instead of one content
type we could use them
to communicate any
engaging experience?
The result is The Canvas
Shoe Screen – a 4m x 5m
screen built out of shoes,
capable of displaying
low-resolution video in
real-time. The screen has
been traveling between
stores around Europe,
and films and pictures of
the experiment have been
widely shared in social
media.

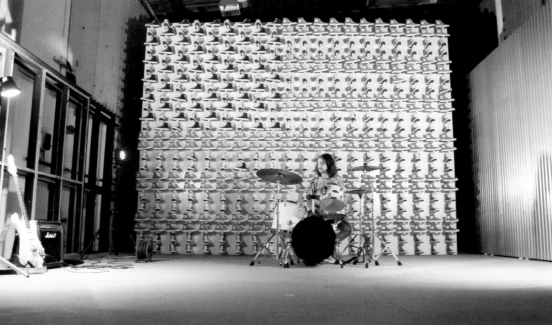

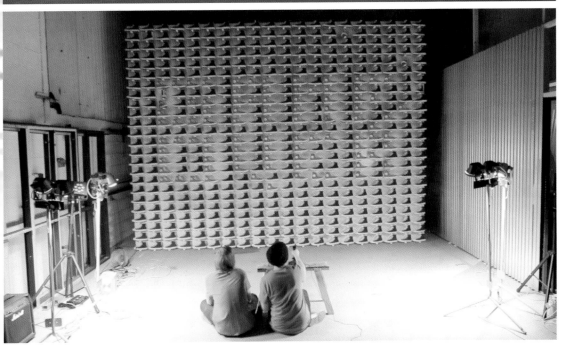

Deutsche Bank "The Brand-Space"

Spatial Design:
Indoor Spaces

Art Directors
Petra Trefzger, Eva Offenberg
Designers
Arne Michel, Christian Riekoff
Agency Producer
Gert Monath
Creative Director
Joachim Sauter
Client
Deutsche Bank
Agencies
ART+COM/Berlin,
Coordination/Berlin
–

ID No. 12043D

Deutsche Bank wanted to establish a permanent brand environment in their headquarters and embody their well-known logo within this space. The aim was to shape a venue where customers, employees and external visitors would be able to experience and to connect with the brand. Here all relevant aspects of the company's history, its business divisions and their contributions to society should be communicated to the visitor. To avoid permanent spatial logos that dominate the space with simple three-dimensional extrusions, we used the concept of anamorphosis. Abstract architectural structures have been designed to only reveal themselves as the logo when viewed from specific sweet spots. As the finance sector is very abstract to most people, we developed narrative formats to create a tangible experience. Parts of the logo sculptures are formed by incorporated media installations that allow the visitor to interact with the brand as well as to learn about it.

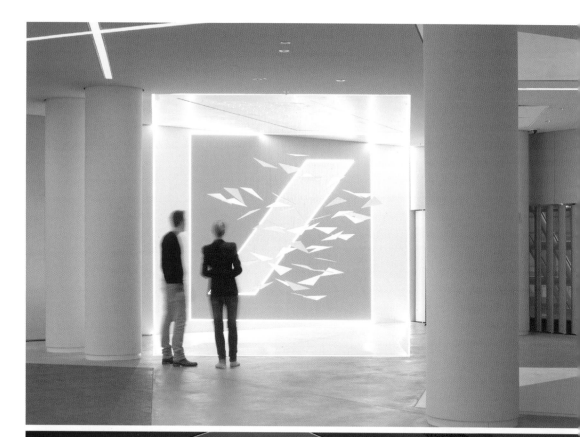

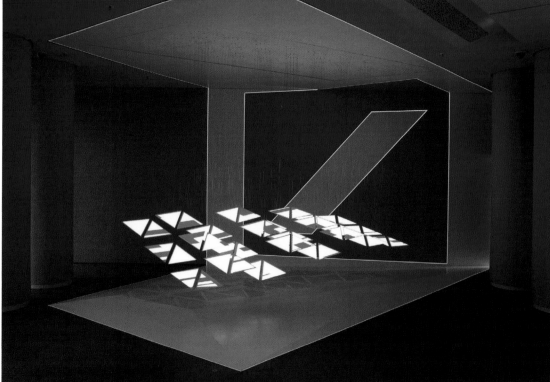

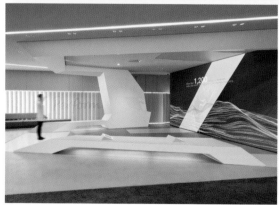

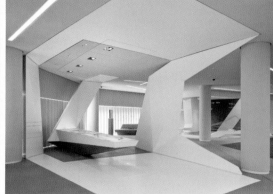

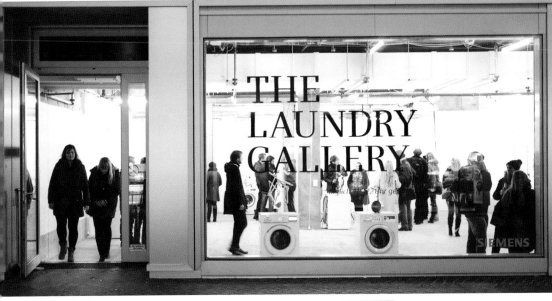

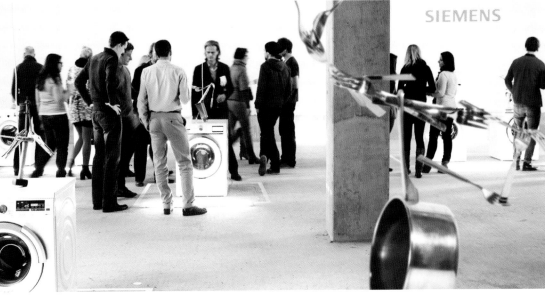

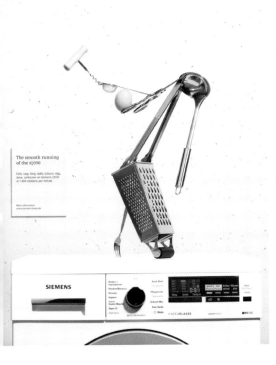

The smooth running of the iQ590

Fork, ring, tong, ladle, scissors, egg, sieve, corkscrew on Siemens iQ590 at 1,400 rotations per minute.

More information www.siemens-home.de

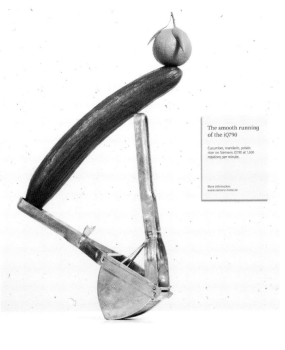

The smooth running of the iQ790

Cucumber, mandarin, potato ricer on Siemens iQ790 at 1,600 rotations per minute.

More information www.siemens-home.de

Siemens Electrogeräte "The Laundry–Gallery"

Spatial Design: Indoor Spaces

Art Directors
Sebastian Kamp, Bjoern Kernspeckt, Rene Gebhardt
Writer
Stefan Sohlau
Photographer
Szymon Plewa
Agency Producers
Nele Siegl, Daniel Klessig
Creative Directors
Martin Pross, Matthias Spaetgens, Robert Krause, Florian Schwalme, Mathias Rebmann, Markus Daubenbuechel
Client
Siemens Electrogeräte
Agency
Scholz & Friends/Berlin
—
ID No. 12044D

Objective: Siemens washing machine with anti–vibration is extremely smooth and doesn't vibrate even at fast spin–drying. We wanted to communicate this feature to our high–earning and design–addicted target group.

Concept: Using common household items, we built fragile sculptures and put them on the washing machines. Then we turned the machines on spin cycle. Eight of the sculptures were exposed in a temporary art gallery in the center of Berlin. The "Laun–dry Gallery" posters, an online film and advertise–ments in local magazines announced the art exhibit in advance, building anticipation.

Kamoi Kakoshi Co. "Mt Expo"

**Spatial Design:
Outdoor Spaces**

Art Director
Koji Iyama
Designers
Koji Iyama, Yoshiko Akado,
Mayuko Watanabe, Takenori
Sugimura, Saori Shibata
Creative Director
Koji Iyama
Client
Kamoi Kakoshi
Agency
iyamadesign/Tokyo
—

ID No. 12045D

Although masking tape is usually used as a curing tape on construction sites, 'mt' masking tape is popular as a household good. Because of their wide range of colors and patterns, customers enjoy using them for wrapping, interior decoration and art work. 'mt' masking tape's promotional limited exhibition travels Japan, and this time we planned to hold the biggest panoptic exhibition named 'mt expo' in Tokyo. To show visitors the new usage of mt masking tape, we taped up the gallery's wall and all over the front garden. In the garden, we located the decorated Mini Cooper, a traveling tray and a bike, which was covered by mt tape, and let them drive in the town.

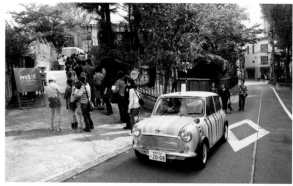

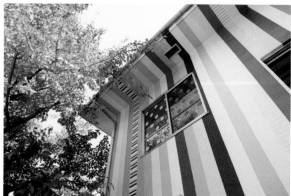

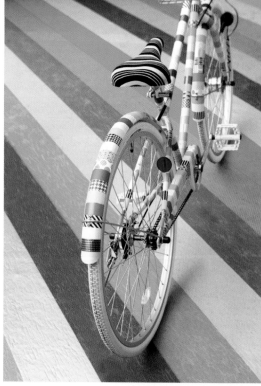

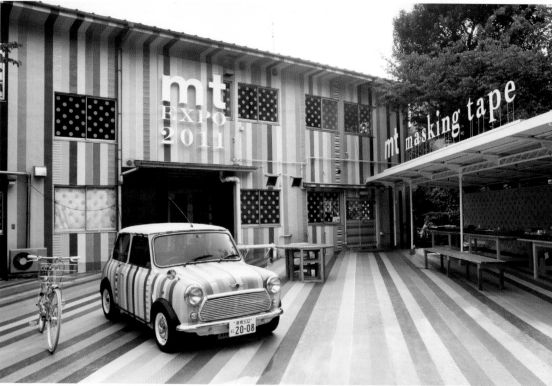

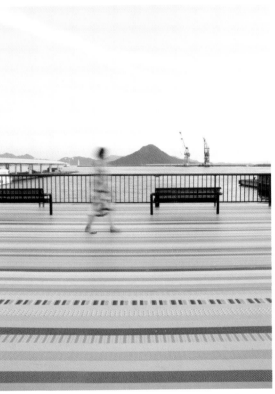

Kamoi Kako-shi Co. "Mt Ex Hiroshima"

**Spatial Design:
Outdoor Spaces**

Art Director
Koji Iyama
Designers
Mayuko Watanabe, Takenori Sugimura, Saori Shibata
Creative Director
Koji Iyama
Client
Kamoi Kakoshi
Agency
iyamadesign/Tokyo
—
ID No. 12046D

Although masking tape is usually used as a curing tape on construction sites, 'mt' masking tape is popular as a household good. Because of their wide range of colors and patterns, customers enjoy using them for wrapping, interior decoration and art works. 'mt' masking tape's promotional limited exhibition 'mt ex' travels Japan, and this time it was held in Hiroshima. The location was on the waterfront, and I tried to design the space to welcome customers who use the harbor. I taped 'mt' on the deck in front of the shop and covered the large space with colored stripes. This approach succeeded in exhibiting customers the new possibilities of mt. I also covered the wall by mt's new collection, so that customers are able to browse them and choose the tapes easily.

SDC du village "Aires Libres – Amherst Park Anamorphic Installation"

Spatial Design:
Outdoor Spaces

Art Director
Daniel Robitaille
Creative Director
Louis Gagnon
Client
SDC du Village/Aires Libres
Agency
Paprika/Montreal
—
ID No. 12047D

We continued our artistic exploration by planting a forest of tubes in Amherst Park, a treeless square located on a very busy pedestrian street in the heart of Montreal. We set up a forest of long red tubes ranging from 7 to 21 feet, some with bright white letters. By placing the tubes at specific points, we created an optical illusion giving the viewer the impression that all the letters were the same size. Together the letters form words and the words a sentence, itself part of a manifesto, the idea being that it's only when one sees everything as a whole that one can make sense of anything at all. "There will be a place for everyone of all liberties that will be granted to you."

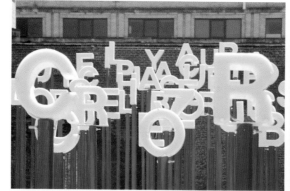
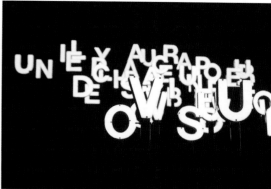
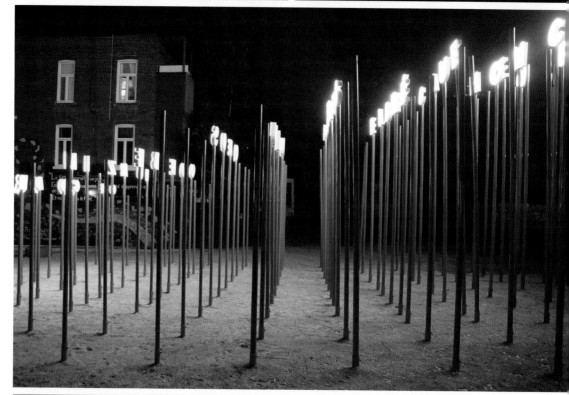
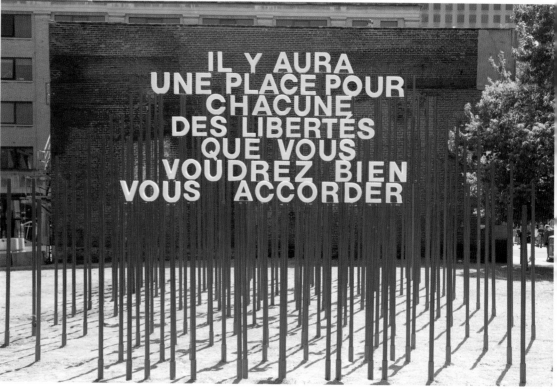

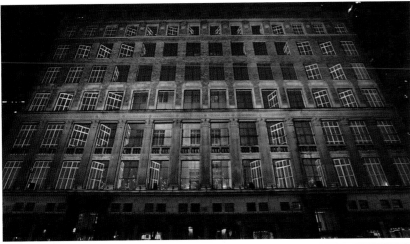

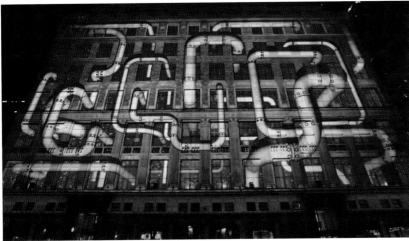

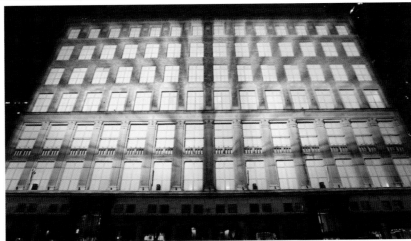

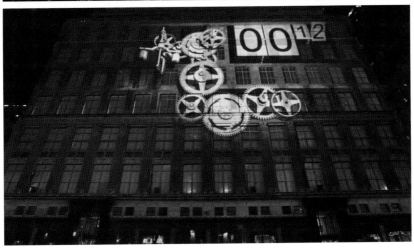

ONE SHOW

Saks Fifth Avenue "The Snowflake & The Bubble"

Outdoor Design:
Billboards – Single

Art Director
Martin West
Designer
Adam Seeley
Agency Producer
Leslie Hodgin-Oleyar
Sound Designer
Patrick Milne
Production Company
SP-Projects
Creative Director
Sean Reynolds
Client
Saks Fifth Avenue
Agency
Iris Worldwide/New York
—

ID No. 12048D

Fifth Avenue, NYC, the holidays – probably one of the most competitive retail environments in the world. So how do you stand out at this critical retail time of year? Our idea for Saks was simple – make the iconic store an entertain- ing spectacle and an unmissable NYC destina- tion for the holidays. To do this, we created the world's longest running 3D projection map- ping event. Every night for 6 weeks, from 5pm till 10pm, we brought Fifth Avenue to a virtual standstill. As the focus of Saks Fifth Avenue's holiday program, we created the festive story of the The Snowflake & The Bubble. Along with an original musical score, we brought the story to life on the facade of the flagship store for everyone to see. For those who couldn't be in NYC, we had QR codes on every Saks store nationwide, so you could experience it on your mobile device.

Caran d'Ache "Crayons"

Outdoor Design:
Billboards – Campaign

Art Directors
Paul Labun, Katja Schlosser
Illustrator
Isabelle Buehler
Creative Director
Philipp Skrabal
Client
Caran d'Ache
Agency
Wirz Werbung/BBDO/Zurich

—

ID No. 12049D

Caran d'Ache is Switzer-
land's oldest and largest
manufacturer of wooden
crayons. The brand is
known to every child in
the country, as well as
their parents and grand-
parents. The crayons
campaign is a reminder to
them all what they love or
used to love about Caran
d'Ache: the sheer joy of
creation, which anyone
no matter how advanced
their skills can relate to.

LET IT OUT.

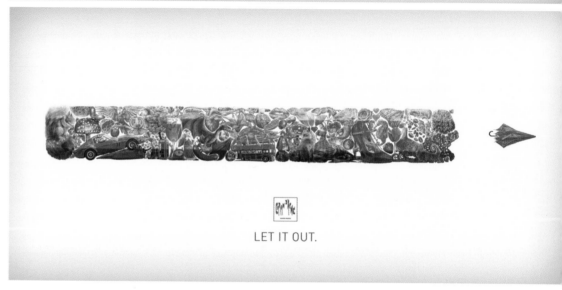

LET IT OUT.

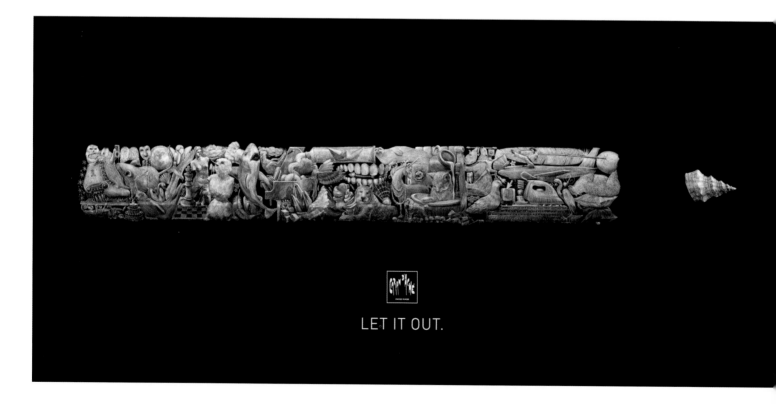

LET IT OUT.

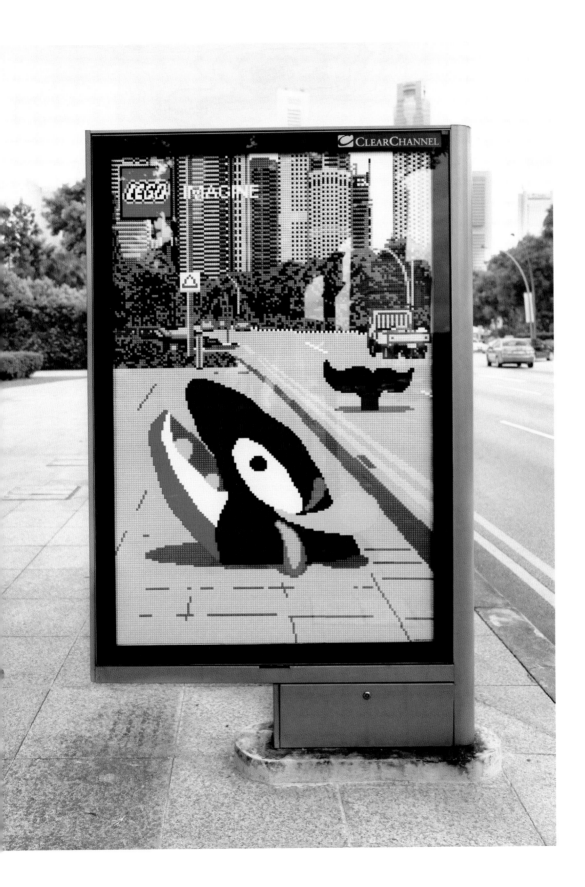

Lego Singapore "Whale"

Outdoor Design: Transit – Single

Art Directors
David Stevanov, Eric Yeo
Writers
Greg Rawson, Ross Fowler
Designers
Nicholas Foo, Jun Jie Too, Inessa Loh, Darshan Kadam
Illustrators
Andrew Tan Tsun Wen, David Stevanov, Greg Rawson
Creative Directors
Gavin Simpson, Robert Gaxiola, Eugene Cheong
Client
Lego
Agency
Ogilvy Malaysia/Kuala Lumpur
–
ID No. 12050D

Using 97,096 pieces of LEGO and three outdoor poster shells, we built posters entirely out of LEGO. When viewed from the right position, each image within the frame formed a seamless continuation of the scene outside. Each poster also featured colorful LEGO creatures interacting with their environment: the perfect way to show just how much more fun the world is with LEGO.

IBM "THINK Exhibit Posters"

Outdoor Design:
Transit – Campaign

Art Directors
Chris Van Oosterhout,
La Mosca, Sid Tomkins,
Carl de Torres, Sebastian
Onufszak, Mussashi Shintaku,
Marcos Ribeiro, Micky Huang,
Ramona Todoca, Johnny
Budden, Renato Rozenberg
Writers
Sam Mazur, Marcos Ribeiro,
Leandro Neves,
Rafael Campos
Creative Directors
Steve Simpson,
Susan Westre, Chris Van
Oosterhout, Jeff Curry,
Marcos Ribeiro, Sid Tomkins
Client
IBM
Agency
Ogilvy Worldwide
—
ID No. 12051D

In 2011, IBM turned 100.
To celebrate, they created
a public exhibit at New
York's Lincoln Center
called THINK—an inno-
vative exhibit that com-
bined art and science to
show how technology can
help make the world bet-
ter. How did we promote
this extraordinarily high-
tech event? We created
a series of posters that
harkened back to IBM's
storied design roots. The
brief was sent out to the
entire agency network.
And the response was
enormous. We received
over 160 submissions
from offices in New York,
Paris, Singapore, London
and Brazil. Eighteen
were chosen to appear
throughout Manhat-
tan—on bus shelters and
subways, on trains and
in wild postings—to spur
New Yorkers to stop by
and visit the exhibit.

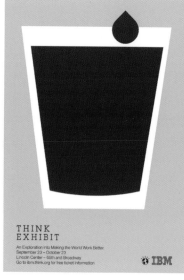

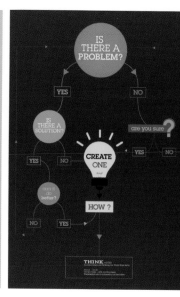

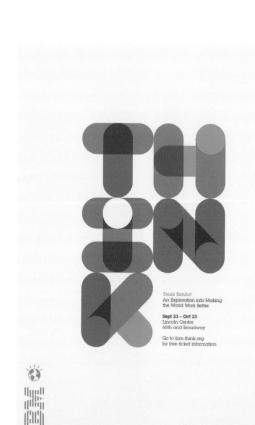

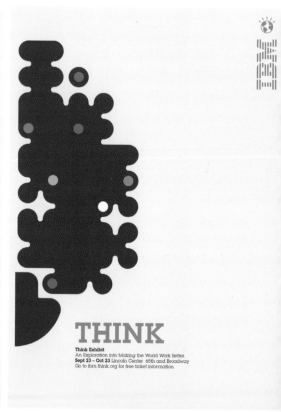

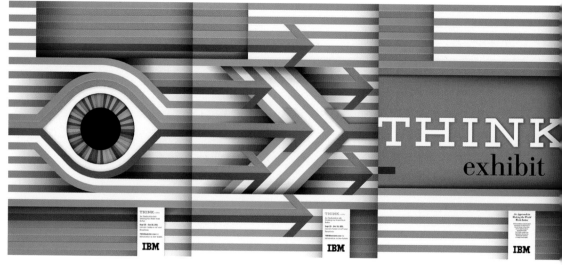

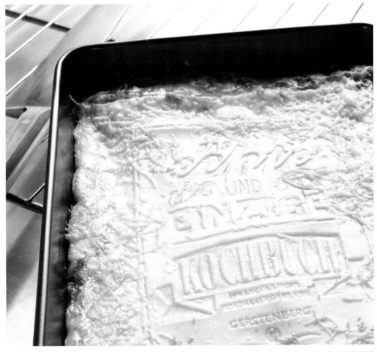

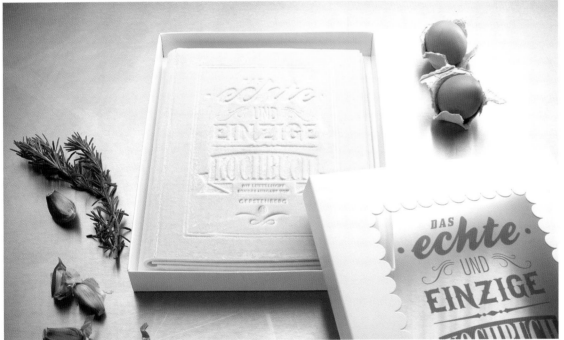

Gerstenberg Verlag "The Real Cookbook"

Publication Design: Book Cover Design

Art Directors
Reginald Wagner, Antje Hedde
Writer
Gereon Klug
Photographers
Jan Burwick, Christoph Himmel
Creative Directors
Antje Hedde, Katrin Oeding
Client
Gerstenberg Verlag
Agency
Kolle Rebbe/KOREFE/ Hamburg
—
ID No. 12052D

Also Awarded:
Bronze: Package Design: Single

Task: Develop a limited edition for the Gerstenberg Verlag, a publishing house that specializes in high quality cooking and art books. The book was to be sent to business customers as part of a customer loyalty campaign to generate extra attention for Gerstenberg range of cook book titles.

Idea: Make the world's first cookbook that truly deserves to be called that: you can actually cook and eat "The Only Real Cookbook." The pages are made of 100% fresh pasta dough, and the book comes packaged as a traditional lasagne dish.

Solution: Opened up and filled up page by page with sauce mixtures and garnished with cheese, the world's first real cookbook is a lasagne that you can put in the oven and bake at 200 C. The text imprinted in the four innermost dough pages contains cookery tips and ideas.

BMW "Culture"

Publication Design:
Book Cover Design

Art Director
Stefan Sagmeister
Designers
Manuel Buerger, Karim
Charlebois-Zariffa,
Richard The, Joe Shouldice
Client
BMW
Agency
Sagmeister/New York
—

ID No. 12054D

Culture moves. This book, about all the cultural activities of BMW, contains four hidden wheels, comes with a remote control and really does drive around the room.

All 1,500 printed books feature a different, individual cover design: When displayed together they form a giant white/blue graphic reminiscent of the famous BMW headquarters building in Munich.

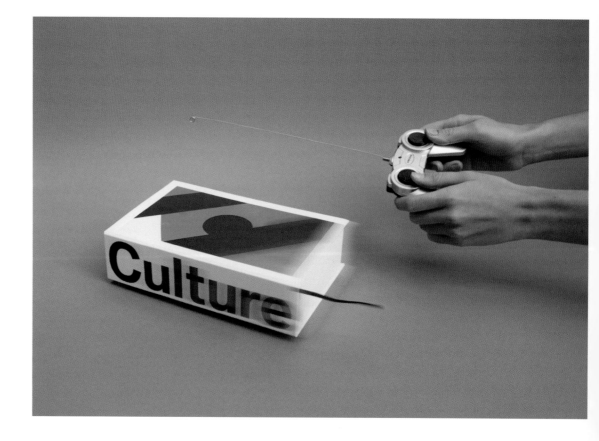

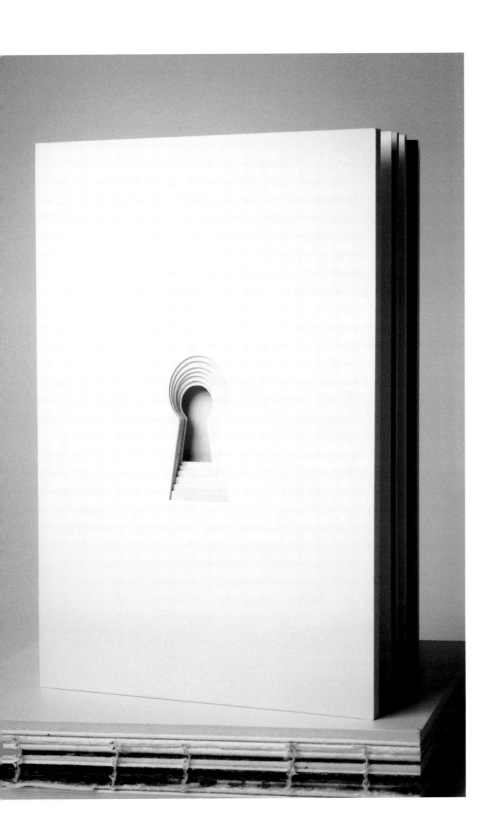

Pinacoteca
"Curiosism
Book"

Publication Design:
Book Cover Design

Art Director
Bruno Oppido
Writers
Eduardo Lima, Romero
Cavalcanti, Mariana Borga
Photographer
Joao Linneu
Typographer
Jomar Farias
Creative Directors
Fabio Fernandes,
Eduardo Lima
Client
Pinacoteca
Agency
F/Nazca Saatchi & Saatchi/
São Paulo
—

ID No. 12053D

After 12 years, Pinac-
oteca do Estado de Sao
Paulo, one of the most
important museums in
Latin America, decided to
change the exhibition of
its permanent collec-
tion. The second floor
of the building had to be
closed for one year for the
renovations.

To avoid distancing
visitors and to feed
their curiosity about
the changes, Pinacoteca
requested a campaign
from the agency. What
we delivered was an
artistic movement:
Curiosism. The cat that
lives inside each of us.

During the year, every-
thing that a regular exhi-
bition would have, such
as posters, installations
and a book, were created
around the Curiosity
theme.

KT&G Sang–sangmadang "Hangeul.Dream.Path"

Publication Design: Book Layout Design

Art Director
Kum-jun Park
Writer
Kum-jun Park
Designers
Kum-jun Park, Bon-hae Koo
Photographers
Kum-jun Park, Han Goo,
Sung-kwon Joe,
Byung-ha Ahn
Illustrator
Kum-jun Park
Typographer
Kum-jun Park
Creative Directors
Kum-jun Park, Jong-in Jung
Client
KT&G Sangsangmadang
Agency
601bisang/Seoul
—
ID No. 12055D

Dreams make a path, a path is a way of life, and life leads us to dream. A worn out, dated typewriter, the hands of a wall clock that crept around slowly to form the circumference of my childhood, musi–cal instruments that brought rhythms of the world to life, and rice stalks that show the cycle of life in its purest form. I gathered these traces of time engraved in everyday objects and nature. I unearthed dif–ferent stories and dreams that transcend time and space, and the memories associated with them, to observe them carefully, to caress them, to listen to them, and to hold them close. All the while, I dis–mantled and reassembled them in order to instill new energy into Hangeul. I became more and more captivated by the rich character of the Korean alphabet each moment.

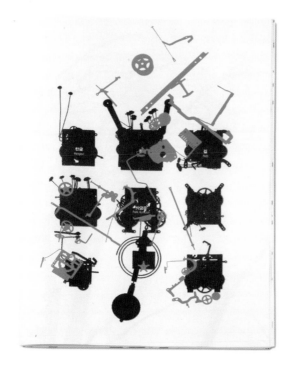

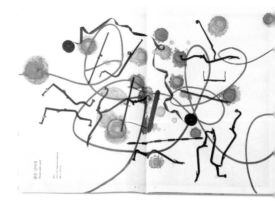

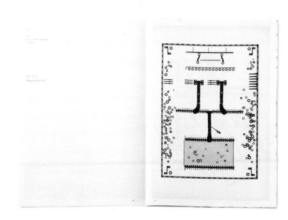

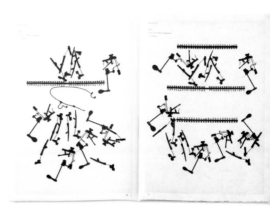

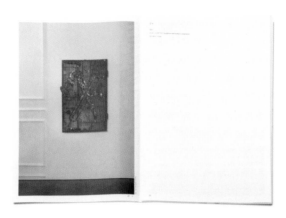

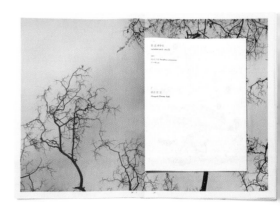

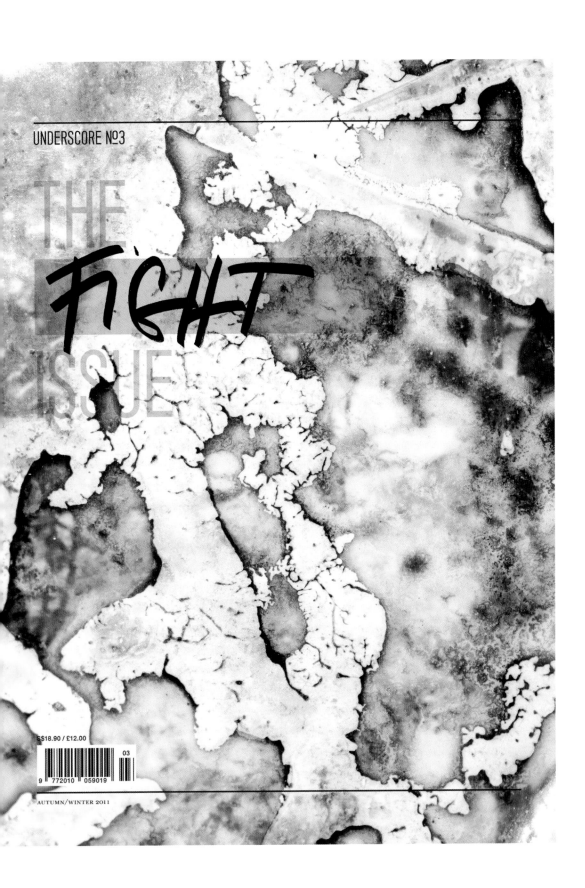

UNDERSCORE №3

THE
FIGHT
ISSUE

S$18.90 / £12.00

03

9 772010 059019

AUTUMN/WINTER 2011

Underscore "Underscore N°3: The Fight Issue"

Publication Design: Magazine Layout Design

Art Director
Jerry Goh
Designer
Stephanie Peh
Photographer
Jovian Lim
Creative Director
Justin Long
Client
Underscore
Agency
HJGHER/Singapore
—
ID No. 12056D

Underscore is an independent magazine attuned to a simple rhythm: quality of life. As another definition of Underscore is background music, music tracks were carefully selected to complete the reading experience. The soundtrack is free for download online. Underscore N°3: The Fight Issue confronts the constant and inevitable human fight to struggle, endure, withstand and persevere against all odds. The resilience of both people and nature are represented on the cover image, taken in Ishinomaki, Miyagi months after the earthquake to document a new reality in the aftermath of destruction. The world witnessed Japanese display of Gaman: strong forbearance and poise, in the aftermath of the biggest earthquake to ever strike Japan. Inspired by their fight, the last 16 pages of this issue were dedicated to Japanese creatives to speak from the heart.

MTV "Brasil Balloons"

**Broadcast Design:
Single**

Art Directors
Guga Ketzer, Andre Faria,
Dulcidio Caldeira
Writers
Guga Ketzer, Andre Faria,
Dulcidio Caldeira
Agency Producers
Sid Fernandes, Ana Luisa
Andre, Karina Vadasz
Producer
Egisto Betti
Production Companies
Raw Produtora de Audio,
Paranoid BR
Director
Dulcidio Caldeira
Creative Directors
Guga Ketzer, Cassio Moron,
Pedro Guerra, Marco Monteiro
Client
MTV Brasil
Agency
Loducca/São Paulo
—
ID No. 12058D

MTV was about to cel-
ebrate its 21st anniversary
in Brazil. We needed a
film that would com-
municate the auspicious
event and recall the
station's great moments,
positioning it to the audi-
ence with the concept
"The music never stops."
Party balloons are a uni-
versal icon for celebra-
tion. What if we used
the balloons to tell the
history of music in the
world and of MTV in Bra-
zil in the past 21 years?
We therefore created a
stop motion film in which
each frame was drawn
by hand on an individual
balloon.

Music, cinema and ani-
mation have always been
at the core of MTV's DNA.
This couldn't be differ-
ent in Brazil. The film
was shown on several
movie theaters and on
MTV itself, generating
thousands of comments
on specialized websites
and definitely positioning
MTV as the station where
music never stops.

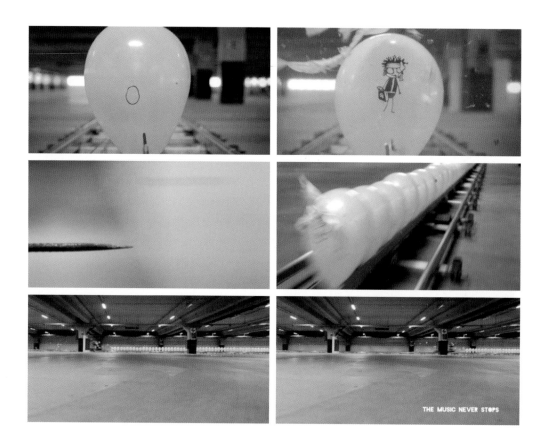

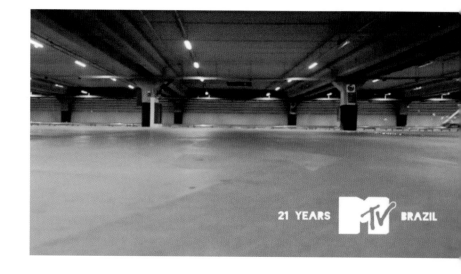

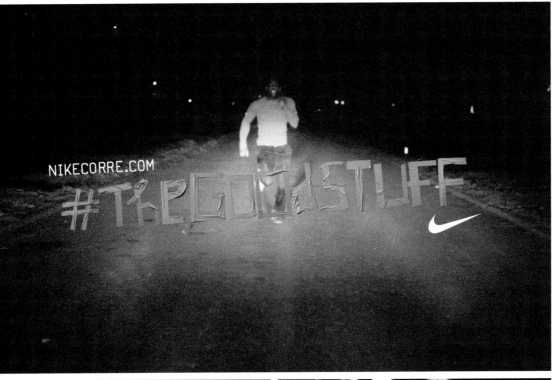

Nike
"Addiction"

**Broadcast Design:
Single**

Art Director
Rodrigo Castellari
Writers
Eduardo Lima, Pedro Prado
Agency Producers
Adriano Costa, Marcio Leitao
Production Companies
Delibistrot, Satelite,
Casablanca
Director
Jones+Tino
Creative Directors
Fabio Fernandes, Eduardo
Lima
Client
Nike
Agency
F/Nazca Saatchi & Saatchi/
São Paulo

ID No. 12059D

**To stimulate the practice
of running amongst the
youth, F/Nazca Saatchi
& Saatchi has created an
action for Nike entitled
#coisadaboa (#thegood–
stuff). The language of
the campaign explores
the addiction that run–
ning causes within its
practitioners and the
clear advantage that it
has over other addictions:
it is the only one that is
good for your body.**

Pinacoteca Museum "Le Curiosism"

Broadcast Design: Single

Art Director
Bruno Oppido
Writers
Eduardo Lima, Mariana Borga,
Romero Cavalcanti
Typographer
Jomar Farias
Agency Producers
Adriano Costa, Marcio Leitao
Producer
Kito Siqueira
Production Companies
Delicatessen Films, Pix
Animation, Vagalume Studios,
Satelite
Director
Jones + Tino
Creative Directors
Fabio Fernandes,
Eduardo Lima
Client
Pinacoteca Museum
Agency
F/Nazca Saatchi & Saatchi/
São Paulo

ID No. 12060D

The film *Le Curiosism* (Curiosities), a kind of manifesto on the campaign, celebrates the spirit of the curious and unveils the cat within all of us, inviting viewers to "satiate their feline" at the museum.

"A Curiosidade matou o gato"

Olhe atentamente: há um gato em cada um de nós.

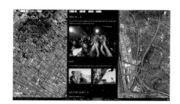
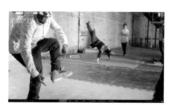

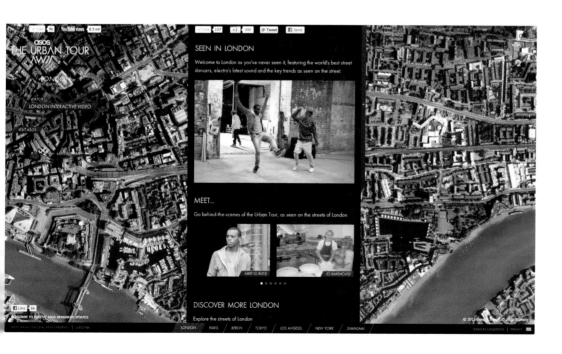

ASOS
"Urban Tour"

Broadcast Design: Campaign

Art Director
Dominic Goldman
Writer
David Kolbusz
Designer
Eric Chia
Agency Producers
Olivia Chalk, Susan Liu, Charlie Dodd
Production Companies
Pulse Films, Stink, MPC
Directors
Sebastian Strasser, Ben Newman
Creative Director
Dominic Goldman
Client
ASOS
Agency
BBH/London
—

ID No. 12061D

Young guys take pride in their appearance, but we learned that unlike girls they weren't that interested in the world of fashion. They drew their inspiration from popular culture, rather than the catwalk. Young men take their cues from bands, musicians, skaters, dancers and artists, rather than fashion models. Consequently, we created the ASOS Urban Tour – an online hub where you could see the ASOS A/WII collection through a cultural lens. The stars of the site were emerging street performers from around the world; real guys with genuine breathtaking talent.

We selected the best talent from a cross section of global cultural capitals – London, Paris, Tokyo, New York, LA, Berlin and Shanghai – and created an interactive experience that enabled guys to watch the men perform while dressed in the key items from that season. You could click on any dancer seen on the screen at any time, causing the performer to breakout of the action and showcase his clothing – which could be brought immediately using a built in e-commerce engine.

"MK IS"

Broadcast Design:
Campaign

Art Directors
Mark Haefele,
Frank van Rooijen
Writer
James Smith
Agency Producer
Lisa Wides
Producer
Julia Thorpe
Production Company
Now and Partners
Director
Daniel Siegler
Creative Directors
Mariana O'Kelly, Fran Luckin
Client
MK
Agency
Ogilvy/Johannesburg
-
ID No. 12062D

MK is a music televi-
sion channel featuring
only South African youth
bands. How do we get the
MK channel to resonate
with the youth market,
and have them choose MK
as the leading voice of the
local music scene, above
international bands?
Seeing that MK is a brand
that prides itself on defy-
ing definition, we created
three characters whose
successive stories played
out in real-time through
60 daily episodes/on-
air idents, allowing the
identity to evolve daily.
It offered viewers a voy-
euristic window into the
lives of the MK personas.
Each story featured dis-
tinct personalities, cir-
cumstances, supporting
characters and obstacles,
using formerly unknown
bands and artists as the
soundtrack to each,
allowing us to construct
a unique personality for
each character. The spirit
of the entire campaign
was summed up by its
ubiquitous title: MK IS…

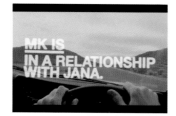
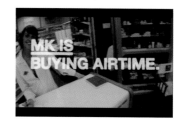
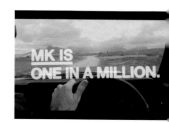

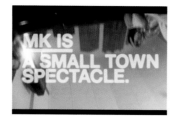
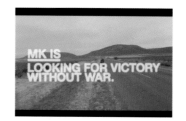
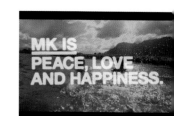

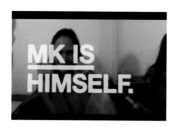
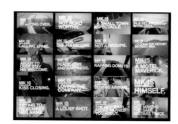
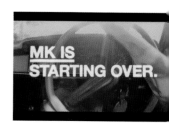

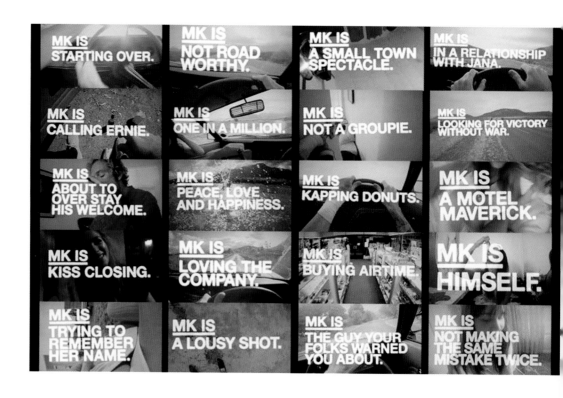

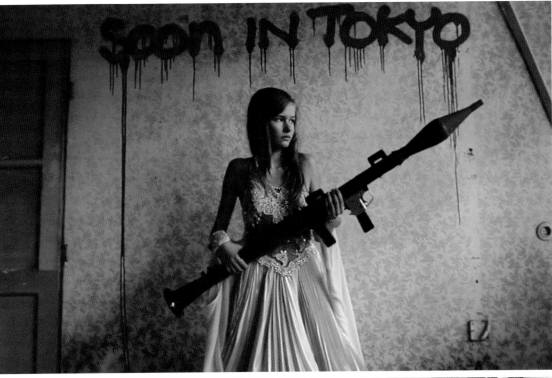

"OFFF Festival Barcelona 2011"

Broadcast Design: Title Sequence – Television

Designer
Si Scott
Producers
Jules Tervoort, Ania Markham, Pavla Burgetova Callegari, Klara Kralickova, Annejes van Liempd
Director
Mischa Rozema
Client
OFFF Festival
Agency
Savage/PostPanic/Prague
—
ID No. 12063D

OFFF is a post–digital culture festival and the opening titles sequence is one of the most prestigious projects for a selected director/studio every year. With no brief and an opportunity to make what PostPanic wanted, the 2011 opening titles reflect Mischa Rozema and Si Scott's dark thoughts on a possible future, inspired by the OFFF Festival's theme for 2011, "Year Zero." Directed by Mischa and shot on location in Prague with post carried out in Amsterdam at PostPanic, the film guides the viewer through a grim scenario embedded with the names of artists appearing at the 2011 OFFF Festival.

"International MINI Rocket– man Concept"

Broadcast Design: Animation

Art Director
Rolando Cordova
Writers
Gian Carlo Lanfranco,
Karl Dunn
Agency Producer
Niels Scheide
Sound Designers
Guy Amitai, Ignaz Bruens
Production Company
PostPanic
Director
Mischa Rozema
Creative Director
Jason Schragger
Client
MINI International
Agency
BSUR Agency/Amsterdam
—

ID No. 12064D

The MINI Rocketman is a concept car for a smaller MINI, with which MINI reinvents its roots for a new era. This product introduction video is especially created for a web–based audience of automotive journalists and MINI–fans to intro– duce them to the concept car and the vision that fueled it, including the 1959 and today's oil shortages. It celebrates as much the DNA of the MINI brand as it does the future forward design of the MINI Rocketman Concept, with a typical MINI twist. In the first 5 days after its launch on MINI's YouTube Channel it scored over 200,000 views and loads of positive support for this concept car. The most prestigious car related publications embraced the concept and spread it everywhere. With a short two–minute video, a great little car has found its way into the hearts of a highly critical and essential audience.

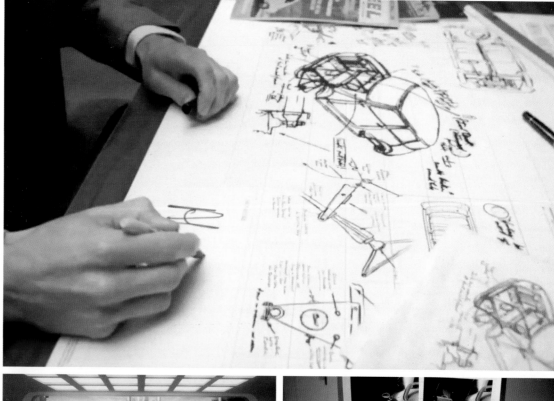

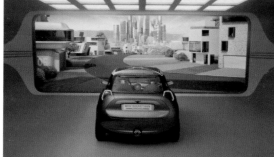

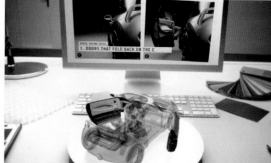

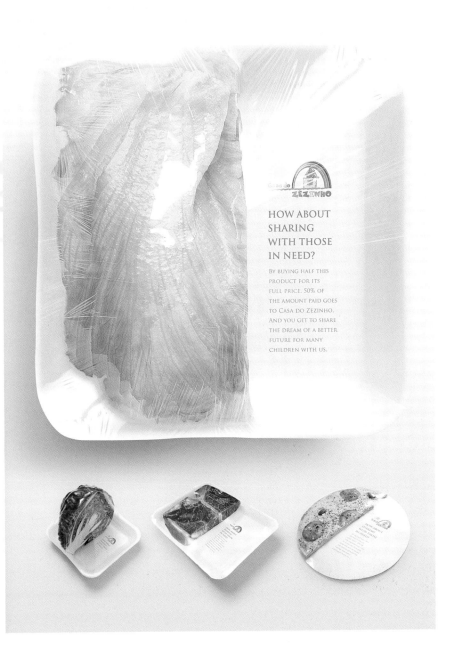

Casa do Zezinho "Share with Those Who Need"

Public Service: Outdoor and Posters – Single

Art Directors
Vinicius Sousa, Daniel Manzi
Writer
Fabio Ozorio
Creative Director
Luiz Sanches
Client
Casa do Zezinho
Agency
AlmapBBDO/São Paulo

ID-No. 12065D

The challenge was to generate donations for Casa do Zezinho, an NGO with a focus on low-income areas that guarantees basic necessities for needy children. The solution was through partnerships with local chains. Casa do Zezinho took the project Half For Happiness to supermarket shelves by selling food products divided in half and inviting customers to share with those in need. The mechanics was simple: by buying half the products at full price, 50% of the amount paid would go to Casa do Zezinho. The products were processed, packaged and distributed by the children of the NGO. So this was a playful, lighthearted approach designed to generate donations by approaching our targets at the right moment.

Dogwood Initiative "Oil Poster"

Public Service:
Outdoor and Posters –
Single

Art Director
Todd Takahashi
Writer
David Giovando
Photographer
Carson Ting
Creative Directors
Chris Staples, Ian Grais
Client
Dogwood Initiative
Agency
Rethink/Vancouver
–
ID No. 12066D

No Tankers is a non-profit organization dedicated to banning oil tankers from Canada's Pacific coast. Posters made with environmentally friendly, water-soluble ink were placed above wild postings around Vancouver. When it rained, the ink bled onto posters below, showing how oil spills affect everyone.

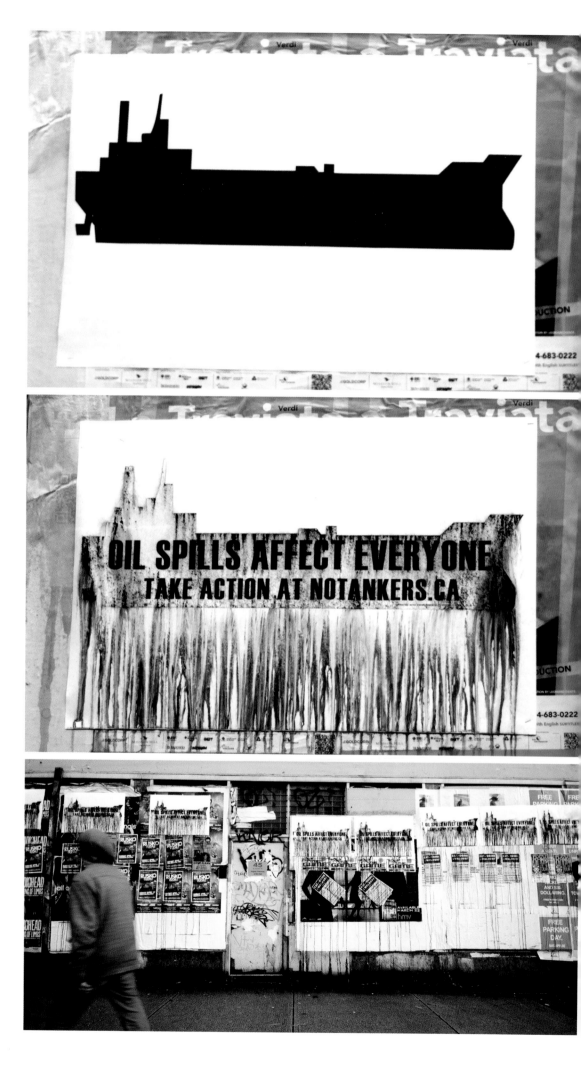

YOU ARE LOOKING AT EVERY WILD DOG LEFT IN SOUTH AFRICA.

To save the last 394 visit ewt.org.za

ENDANGERED
WILDLIFE TRUST

YOU ARE LOOKING AT EVERY NORTHERN WHITE RHINO LEFT ON THE PLANET.

YOU ARE LOOKING AT EVERY RIVERINE RABBIT LEFT ON THE PLANET.

Endangered Wildlife Trust (EWT) "The Last Ones Left"

Public Service: Outdoor and Posters – Campaign

Art Director
Lizali Blom
Writers
Jared Osmond, Lizali Blom
Photographers
Wildlife Photographers,
Image Collections, Mari Keyter
Creative Directors
Damon Stapleton,
Adam Weber, Miguel Nunes
Client
Endangered Wildlife Trust
Agency
TBWA\Hunt\Lascaris\
Johannesburg
—
ID No. 12067D

Endangered Wildlife Trust is a conservation group with multiple studies centered on wildlife. Their aim is to provide vital awareness concerning these species, but no one was responding to statistics. We had to find a way to make people see the animals behind the information. The problem is that stats have become part of the barrage of information faced by the public everyday. They're simply too easy to ignore. In order to increase the funds necessary for wildlife conservation, we had to increase the stopping power of statistics.

The Idea: Behind every number that makes up a statistic, there is a living animal. And it was from this insight that we conceptualized our idea. To "put faces to the figures."

Raising The Roof "Nothing But Potential"

Public Service:
Outdoor and Posters –
Campaign

Art Director
Anthony Chelvanathan
Writer
Steve Persico
Photographer
Anthony Chelvanathan
Creative Directors
Judy John, Lisa Greenberg
Client
Raising The Roof
Agency
Leo Burnett/Toronto

ID No. 12068D

Also Awarded:
Merit: Outdoor and Posters:
Single, Merit: Outdoor and
Posters: Single

People step over and walk by homeless youth without thinking twice, but how about a piece of paper with a message on it? We stuck these posters in places homeless youth are often ignored. When people stopped to read them they realized that the message was true and that maybe they should change the way they look at homeless youth. We used the media space that would make our message hit home the hardest. Using ambient posters allowed us to put our message in places that literally made people stop walking and look, which was the exact point. Why stop to engage with a poster but not a homeless human being? Indeed, the medium was the message.

As the posters were being put up people were already stopping to take notice. Proof we were disrupting culture and expectations. Beyond this, these posters (along with the rest of the cam–paign) helped Raising The Roof reach well beyond their goal of engaging 65,000 people to donate or act.

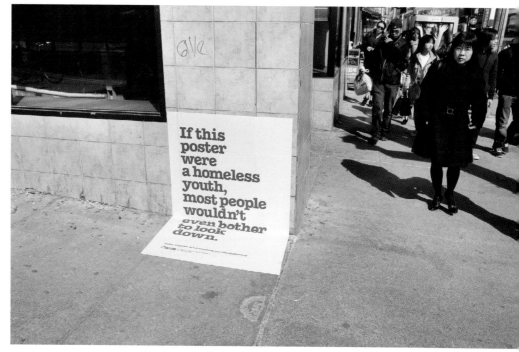

Mer

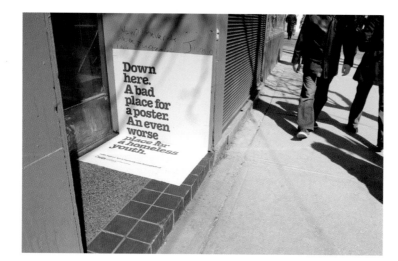

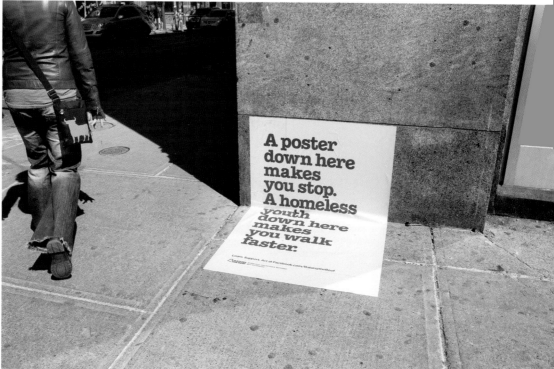

Merit

Escola Pana–mericana de Arte e Design "Coincidences"

Public Service: Outdoor and Posters – Campaign

Art Director
Andre Gola
Writer
Pernil
Creative Director
Luiz Sanches
Client
Escola Panamericana de Arte e Design
Agency
AlmapBBDO/São Paulo
—
ID No. 12069D

To advertise the art courses offered by the Panamericana School, we created posters whose visual points of departure are typical of the areas of math and science: statistics, calculations, physics studies. A small detail in each one of them was singled out and enlarged, showing that even in the coldness of numbers and graphs, it is possible to find art. It is all about how you see things.

"D&AD In Book and Nomination Awards"

Public Service:
Collateral – Single

Designers
Miles Marshall, Paula Talford
Creative Directors
David Turner,
Bruce Duckworth
Client
D&AD
Agency
Turner Duckworth/London/
San Francisco
—
ID No. 12070D

D&AD tasked us to create trophies for both the In Book and Nomination awards. The Slices needed to reflect the achievement each award represents without diluting the value of the coveted Yellow Pencil. The Slices were designed to replace the existing certificates. The shape and proportions are exactly the same as the Pencils. The hexagonal shape of both awards has the same footprint as the Pencil. The Slices use the iconic D&AD yellow and are made from wood. Presentation book boxes were created to hold and display the Slices. The box design echoes the D&AD annual and is an effective way to showcase each award. The unique and special awards that are destined to line the shelves of the world's top creatives.

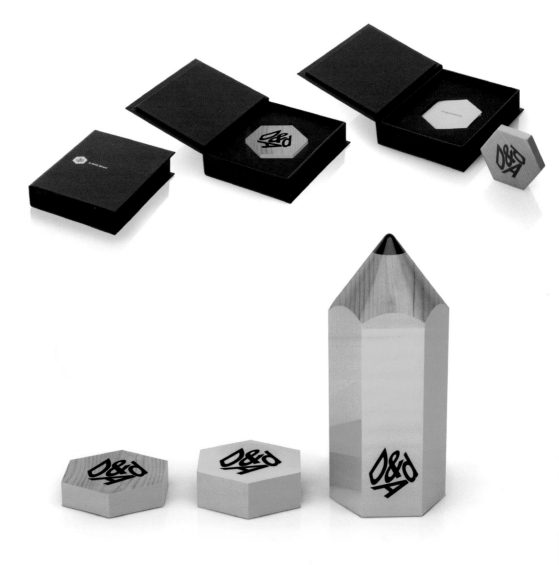

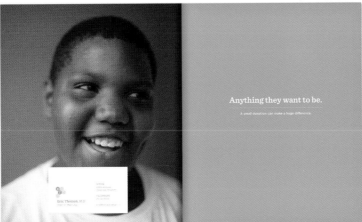

What will they be
when they grow up?

Anything they want to be.

A small donation can make a huge difference.

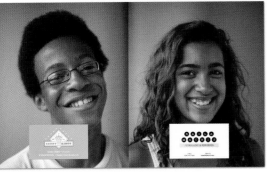

100%

1:1

160 84 98%

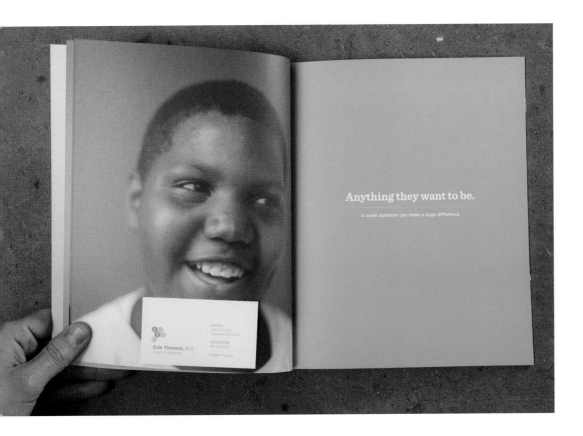

Anything they want to be.

A small donation can make a huge difference.

Open Doors Academy "What will they be when they grow up?"

**Public Service:
Collateral – Single**

Art Director
Ken Hejduk
Writer
Roger Frank
Designers
Christian Woltman,
Andy Hendricks
Photographers
Paul Sobota
Creative Directors
Roger Frank, Ken Hejduk
Client
Open Doors Academy
Agency
Little Jacket/Cleveland
–
ID No. 12072D

The booklet is an annual
report for Open Doors
Academy, an organization
that helps kids learn skills
that prepare them for
academics and life.

"UNICEF: Good Shirts"

Public Service:
Collateral – Campaign

Art Director
Dave Brown
Writer
Ian Hart
Illustrators
Christine Gignac, Justin Gignac
Creative Directors
John Patroulis, Ari Weiss
Client
UNICEF
Agency
BBH/New York

—

ID No. 12071D

UNICEF's Good Shirts was a project designed to help millions in the famine stricken Horn of Africa. We created 12 Good Shirts ranging in price for any budget. On each shirt a symbol of aid was depicted. The shirt then costs the exact price of the aid item. So, if someone donated $23.40 they received a shirt with a measles vaccine on it. And if someone donated $300,000 they received a t-shirt with a cargo flight. The Horn of Africa got hundreds of thousands of dollars in aid and good people get comfy 100% cotton t-shirts. We all win.

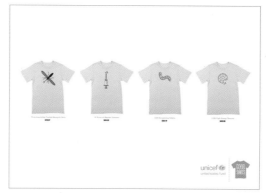

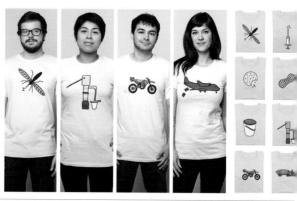

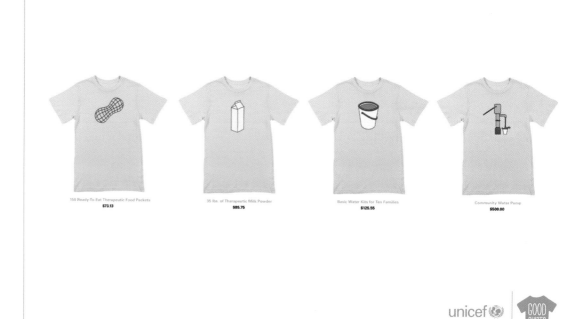

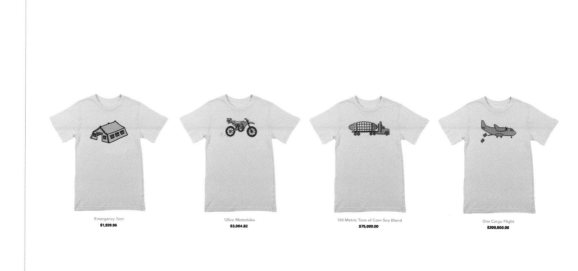

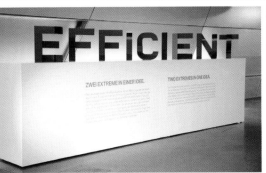
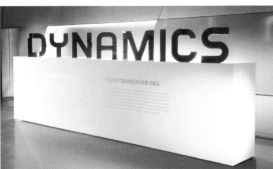

BMW "Effi–cient Dynamics Sculpture"

Craft:
Typography in Design – Single

Agency Producer
Bianca Schreck
Production Company
INCH Design-Service
Creative Directors
Alexander Schill, Maik Kaehler, Christoph Nann
Client
BMW Group
Agency
Serviceplan/Munich
▬

ID No. 12073D

The technology package BMW Efficient Dynam–ics, which every BMW is equipped with, combines two complete antitheses: reduced consumption and even more performance in one. We visualized this antithesis in a breathtak–ing 8 meter sculpture for the BMW Welt in Munich. Seemingly abstract forms make contrary messages if viewed from differ–ent perspectives. Seen from the one side, you read "EFFICIENT." If you change the position, you read "DYNAMICS." So we make an extraordinary fact visible in an extraor–dinary exhibition piece.

Billboard Brasil "Transfertype"

Craft:
Typography in Design –
Single

Art Directors
Marcos Medeiros,
Marcos Kothlar
Writer
Andre Kassu
Creative Director
Luiz Sanches
Client
Billboard Brasil
Agency
AlmapBBDO/São Paulo
—

ID No. 12075D

Also Awarded:
Bronze: Collateral Design:
Promotion

Artists are made of
stories. Magazines are
made of letters. Music.
Read what it's made of. A
Billboard magazine cam-
paign. Six artists were
chosen. And typologies
were created for each of
them. Each letter tells a
part of the story of each
artist. Influences, record
covers, music videos,
their biography. A cam-
paign with details worth
discovering.

An insert in *Billboard*
magazine, this ad brought
a family of fonts on trans-
fers that consumers could
apply wherever they
wanted. Customization
meets *Billboard's* musical
expertise.

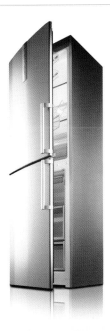

If you have icebergs in your fridge, they are missing somewhere else.

The NoFrost-Technology prevents icing in the freezer and saves energy. So icebergs remain in Antarctica.

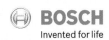 **BOSCH**
Invented for life

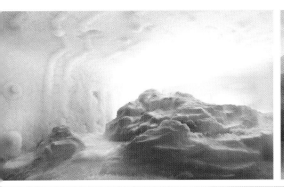
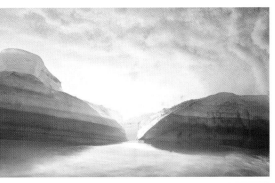

BSH Deutsch-land "Icebergs"

Craft:
Photography in Design – Campaign

Art Directors
Veit Moeller, Mario Loncar
Writers
Daniel Boedeker, Mario Loncar
Photographer
Szymon Plewa
Creative Directors
Daniel Boedeker, Bastian Meneses von Arnim
Client
BSH Deutschland
Agency
DDB Tribal Group/Berlin
—
ID No. 12076D

Objective: To raise aware-ness that the new Bosch freezer with NoFrost-Technology saves a lot of energy and is good for the environment. NoFrost-Technology works to prevent ice buildup in the freezer compartment – unlike many common fridges. This saves energy in the long term, because most people do not defrost often enough.

A simple yet convincing thought: If you have ice-bergs in your fridge they are missing somewhere else, because wasted energy raises our output of carbon dioxide, which raises the temperature and causes the icebergs to melt. To dramatize this fact, we photographed frozen freezer compart-ments in a documentary look to make them appear like arctic landscapes.

Austria Solar "The Solar Annual Report 2011"

Craft:
Printing and Paper Craft – Single

Art Director
Matthaeus Frost
Writer
Moritz Dornig
Designer
Mathias Noesel
Creative Directors
Alexander Schill, Christoph Everke, Alexander Nagel, Cosimo Moeller
Client
Austria Solar
Agency
Serviceplan/Munich
–

ID No. 12077D

Also Awarded:
Merit: Book Layout Design,
Merit: Direct Mail

Solar energy is the main business of our client Austria Solar. That's why we thought about how we could put this energy to paper. The result: the first annual report powered by the sun. Its content remains invisible until sunlight falls on its pages. "The Solar Annual Report 2011 – powered by the sun"

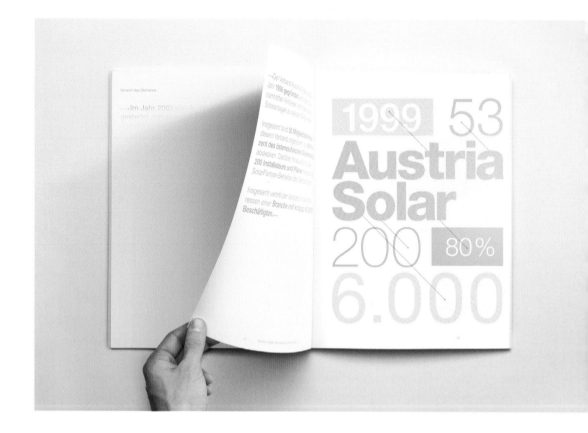

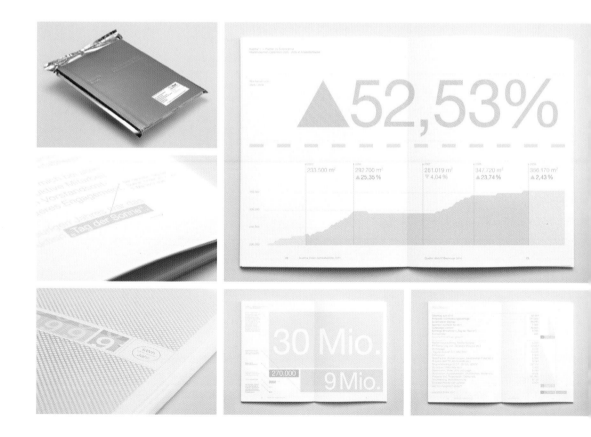

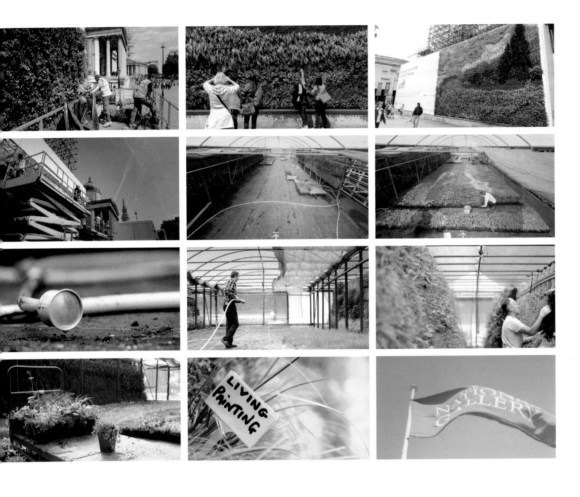

GE "Living Masterpiece"

Sustainability in Design: Single or Campaign

Art Directors
Ant Nelson, Mike Bond
Writers
Mike Sutherland, Bern Hunter
Agency Producers
Adam Walker, Chloe Robinson
Production Company
ANS Nursery
Client
GE
Agency
Abbott Mead Vickers BBDO/
London
—

ID No. 12079D

GE might be a big business, but it's not a boring business. Its brand and business philosophy is, "Imagination At Work," and this should be applied to the creative communications, too. Therefore, the idea was to create a piece of work that delivers the message that GE is helping the National Gallery to reduce its carbon footprint in an imaginative and engaging way.

To highlight GE's and The National Gallery's commitment to a greener world we created the world's first "Living Masterpiece." Using over 8,000 plants, we recreated one of The National Gallery's most famous paintings, Van Gogh's 'A Wheatfield, with Cypresses.' Over a four-month period the plants were grown and then installed onto a huge 22-meter site outside the gallery in the middle of Trafalgar Square.

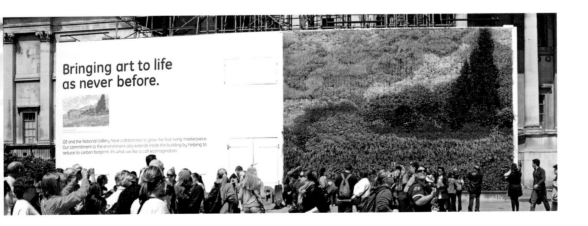

Unilever "Evolution of Washing"

Sustainability in Design: Single or Campaign

Writer
Brett Netherton
Designers
Talyn Perdikis, Carla Kreuser
Agency Producers
Di Fraser, Julie Gardiner
Production Company
Mila & Co
Creative Directors
Joanne Thomas,
Ross Chowles
Client
Unilever
Agency
The Jupiter Drawing Room
South Africa/Cape Town

ID No. 12080D

The product, a new laundry detergent, comes in recyclable bottles and is more biodegradable. So all our work needed to keep to the same standards of eco-friendliness. In a special job creation scheme, we used old bottles to hand-make 750 waterlilies, 50 fish, 300 dragonflies and 1,500 seagulls for a central installation at a premier shopping mall. The design of each article minimized waste material, cable ties meant no toxic glues, and the internal LED lights were ecologically sensitive. Printed elements were done on chlorine-free, 50% recycled paper where proceeds are donated to organizations that feed the needy. All cloth was unbleached canvas. And press releases were put on USB clothes pegs to save trees.

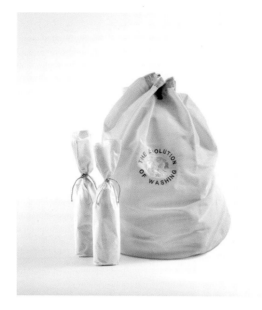

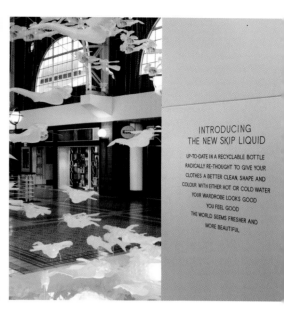

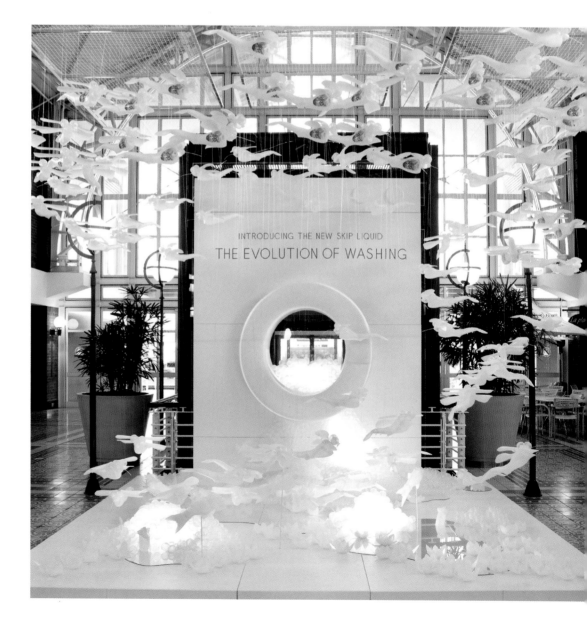

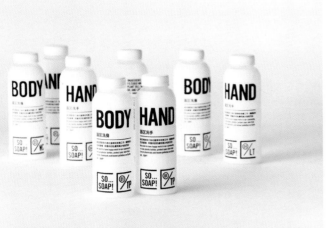

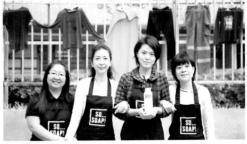

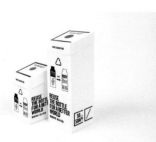

SLOW (Sustainable Lifestyle & Organic Work) "So…Soap!"

Sustainability in Design: Single or Campaign

Designers
Siumak, Ray Cheung
Photographer
Thomas Lee
Creative Directors
Hung Lam, Eddy Yu
Client
SLOW
Agency
CoDesign/Hong Kong

ID No. 12081D

So..Soap! is a community organic soap production scheme with a goal of generating jobs for disadvantaged women by relaunching a labor oriented industry. The title, So…Soap! means "Genuine Soap" as well as "Soap for Society." So…Soap! products are made with 100% natural ingredients, which are not only good for our skin, but also for our earth.

"Austria Solar Annual Report"

—

Edwin van Gelder
Mainstudio/Amsterdam

The Austria Solar annual report reassured me that print is still very much alive! The main business of the client is solar energy, and the agency translated this directly into the concept of the annual report. The report's content remains invisible until sunlight falls on its pages, since it is entirely printed with UV reactive ink. I love how this design concept ties in perfectly with the client's content— solar energy on paper.

It is a beautiful way of using innovative technology to add an extra dimension. Not just a gimmick, but a clever solution that truly adds value. Another big plus is that execution is very refined, both technically and design-wise. Finally, I really like the packaging. A sealed silver envelope that reflects the sun, and also reminds me of the old packaging of photo paper and polaroids.

—

ID No. 12001D

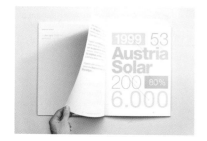

Committee of Organ Donation in Lebanon "Gift a Life"

—

Bradford Lawton
BradfordLawton/Texas

As any designer will tell you, a great logo is not an easy thing to create. Most try too hard and literally miss the "mark." This logo by DDB Dubai for Committee of Organ Donation in Lebanon is a great example of a logo that is simple, elegant and to the point. And it sends a very serious, life saving message in a lighthearted manner. I suspect anyone would find it difficult to look at this image without a smile forming on their face or experiencing a warm feeling in their heart. What a gift to the viewer.

—

ID No. 12007D

Fresh N Friends' "Obstfiguren"

—

Juan Frontini
MTV/Buenos Aires

There was a lot of really good work. And I'm happy that Austria Solar's Annual Report made Best of Show because it's simply amazing. But I was particularly attracted by another simple and brilliant work. It was Fresh N Friends' Fruit Figures (Obstfiguren). Maybe it's because I am a father of a kid who doesn't eat fruit. Maybe it's because I thought, why didn't anyone think of this before? Or maybe it's just because it's great. Whatever reason, that's my judge's choice.

—

ID No. 12018D

Yoshida Hideo Memorial Foundation "The Ultra Asian"

—

Diti Katona
Concrete Design
Communications/Toronto

When I first saw this piece, I had no idea what it was but it didn't matter. It made me smile. And, it made me want to understand it. The size, the colors, the composition and choice of paper all made me want to explore the intricate illustrated collage. In a room filled with competitive materials, all vying for attention, it was a testament that this piece – with such complexity – could captivate my attention. It is on the one hand complicated and involved, but at the same time effortless. The bridging of modern and traditional elements conveys an incredible kinetic sense of change and vibrancy.

—

ID No. 12030D

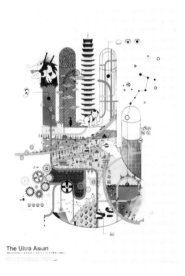

The Ultra Asian

Scott Holding
"Evolve Skate"
—

Chris Lee
Asylum Creative/Singapore

My pick for Judge's Choice would be the set of posters by Ogilvy Melbourne for Evolve Skate. This series of beautifully crafted posters shows ceilings of grand old architecture being inverted to look like skate parks. The idea is simple and the photography is very well executed—it reminded me of Hiroshi Sugimoto's theaters, and for me, to be able to marry art and design into a piece was irresistible.

—

ID No. 12033D

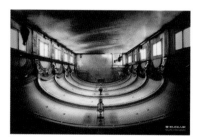

Sephora & Firmenich
"Sephora Sensorium"
—

Hélène Godin
Sid Lee/Montreal

Many projects stood out for me this year, but my top pick was the Sephora Sensorium project. The Sensorium Museum experience is a total immersion into the world of odors, charged with instinct and emotion. The project is the result of marrying different creative disciplines, seamlessly merging technology, multimedia, architecture, writing and design.

This project, for me, shines a light on the future of our industry: the creation of immersive experiences. It also shows that the contribution of design to a project is not simply a result of following instructions: design plays a key role in the creative process, from the genesis of the conception to the final execution. Perfumers and designers collaborated together at the early stage of the process for the Sensorium project to concoct a unique and immersive experience. This project undoubtedly touched my sense of smell, but even more than that, my love of design.

—

ID No. 12041D

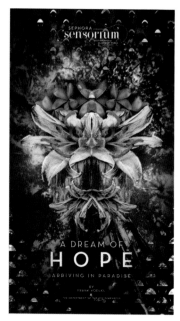

Siemens
"The Laundry Gallery"
—

Malcolm Buick
Violette Design/New York

As mediums for telling stories become ever greater, and the line between what is real and what is not is hard to distinguish between, design experiences are tasked to answer to fully encompassing 360 degree ideas that take into account sight, sound, smell and touch. Creative solutions that encompass, and blend digital with real life, are the solutions that become ever more exciting for me. All of the work this year was wonderful, and I would like to point out that creative coming out of the East (Singapore, China) was really quite beautiful. However, the creative solutions that answered to my above rant were Siemens (installation piece, The Laundry Gallery) and the Sephora experience.

Their solutions brought together a mix of disciplines from engineering to design, all working together to create a beautiful, seamless end result -- a true art and science blend. If I had to pick one of those, the Laundry was a fun, smartly designed idea that had the right balance of humor and thoughtful design.

—

ID No. 12044D

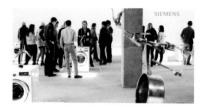

MTV "Balloons"

Pum Lefebure
Design Army/Washington, DC

MTV Brazil "Balloons" is one of those simple yet brilliant ideas. It's hard not to watch it from start to end as there's such a buildup of anticipation as each balloon pops and the next fabulous illustration transitions to something even weirder than the previous ... and it's synced to that semi-annoying music. Love it.

ID No. 12058D

Levi's Identity
–

Michael Jager
JDK/Vermont

With my mind still swimming with
design-soaked saturation following
three wonderful days of design
pondering, one image continues to
emerge in my mind's eye. Though
there are many pieces of design that
masterfully crisscross the transmedia
mayhem that we all exist within, and
that take us on a hero's experiential
journey, simplicity in form and content
still impacts. I appreciate and respect
the ability for an identity, imbued
with nearly two centuries of meaning,
to open up an emotional connection in
a modern and evolved context, and
masterfully use design restraint
to amplify its power to do so. The Levi's
– redux – "batwing" identity in all
its raging red glory and its violated
rebel registration mark of authenticity
achieves an amazing emotional synapse
– so smart, so confident. It is solid,
timeless design – now!

–

ID No. 12107D

Hong Kong Taekwondo Federation "The 19th ITF Taekwondo Championship"
–

Kenjiro Sano
MR_DESIGN/Tokyo

The poster for the Taekwondo Championship
is an amazingly lucid typographic poster that
is representational and abstract at the same
time. The structure is intriguing in that each
poster represents each character and spells
out the word "Taekwondo." Each letter/
poster represents players fighting vigorously.
Audiences would have felt the same excite-
ment when they saw those posters in a row,
and I'm sure that the players felt the same.
This series of posters would have made this
championship even more attractive. It is a
simple and dynamic poster series that returns
to the principles of graphic design.

–

ID No. 13593

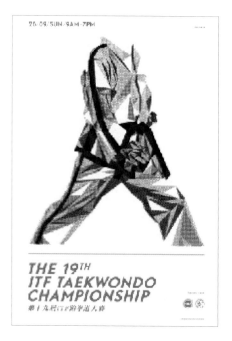

The Deli Garage
"Parmesan Pencils"

Paul Groves
V&cie/Paris

It's always very refreshing to see
work that brings together beautiful
crafted design with a wonderful touch
of humor. The range of Deli Garage
products does just this, combining tools
found in an everyday garage applied
to artisanal delicacies. Chocolate paste
disguised as wood glue, parmesan
cheese as pencils, pasta as nuts and
bolts, the list goes on and on. A brand
that is not based on a powerful logo but
a strong typographic and illustrative
style, and a color palette of white, black
and gold. A wonderfully crafted graphic
and structural packaging. Fun and
simple. I loved it.

ID No. 22281

MERIT

Branding:
Booklet/Brochure

Art Director
Kenjiro Sano
Designer
Masashi Murakami
Photographers
Fumito Katamura,
Nacasa & Partners
Creative Director
Kenjiro Sano
Client
Panasonic Corporation
Agency
Daiko Advertising/Osaka
—
ID No. 12082D

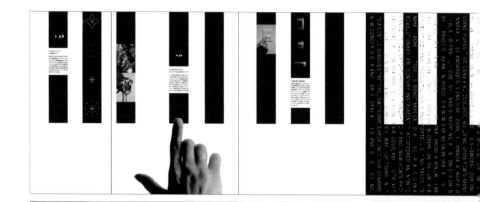

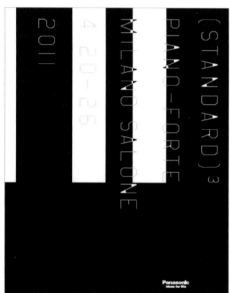

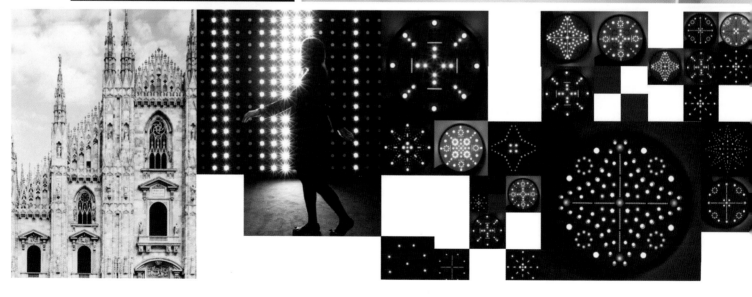

MERIT

Branding:
Booklet/Brochure

Art Director
Daisaku Nojiri
Writer
Junpei Watanabe
Designer
Asuka Adachi
Photographers
Satoshi Iwai, Hiroya Kitai,
Hiroshi Harada
Creative Director
Daisaku Nojiri
Client
KDDI Corporation
Agency
Ground/Tokyo
-

ID No. I2083D

MERIT

Branding:
Booklet/Brochure

Art Director
Mattias Frodlund
Designer
Hanna Moe
Photographer
Mattias Lindbaeck
Creative Director
Mattias Frodlund
Client
Liljevalchs
Agency
Morris Pinewood/Stockholm

ID No. 12084D

MERIT

Branding:
Logo Design

Art Directors
Richard Belanger,
Marc-Andre Rioux,
Isabelle Allard
Creative Director
Barbara Jacques
Client
McCord Museum
Agency
Cossette/Montreal
–
ID No. 12085D

MERIT

Branding:
Logo Design

Art Directors
Isabelle Allard,
Louis Chapdelaine
Designers
Isabelle Allard,
Louis Chapdelaine
Typographer
Isabelle Allard
Creative Director
Barbara Jacques
Client
Resolute - Forest Products
Agency
Cossette/Montreal
–
ID No. 12086D

MERIT

Branding:
Logo Design

Art Director
Zak Rutledge
Writer
Jeremy Spencer
Creative Director
Adam Greenhood
Client
Rhythm for a Reason
Agency
Esparza Advertising/
Albuquerque
-

ID No. 12087D

MERIT

Branding:
Logo Design

Art Directors
Bruno Luglio, Leif Johannsen
Creative Directors
Marcell Francke,
Patrick Matthiensen
Client
Philharmoniker Hamburg
Agency
kempertrautmann/Hamburg

ID No. 12088D

MERIT

Branding:
Logo Design

Art Director
Michael Lin
Designers
Jessica Minn,
Martin Kovacovsky
Creative Director
Nicolas Aparicio
Client
DC Comics
Agency
Landor Associates/
San Francisco
●

ID No. 12089D

MERIT

Branding:
Logo Design

Art Directors
Viral Pandya, Manoj Deb
Writers
Vaibhav Pandey, Viral Pandya
Designer
Viral Pandya
Typographer
Ajay Yadav
Creative Directors
Viral Pandya, Sabu Paul,
Guneet Pandya, Manoj Deb,
Prathap Suthan
Client
Rembrandt Law Company
Agency
Out of the Box/New Delhi
●

ID No. 12091D

®✳©™

MERIT

Branding:
Logo Design

Designer
Steve Sandstrom
Creative Director
Steve Sandstrom
Client
Tenth Caller
Agency
Sandstrom Partners/Portland
–
ID No. 12092D

MERIT

Branding:
Logo Design

Art Director
Anthony Annandono
Designer
Anthony Annandono
Creative Directors
Jeffrey Keyton, Jim deBarros
Client
MTV
Agency
MTV Off-Air Creative/
New York
–
ID No. 12093D

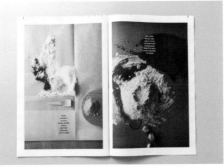

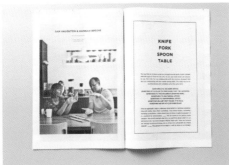

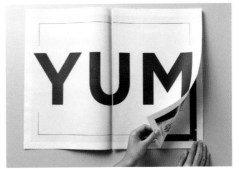

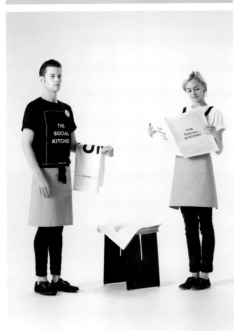

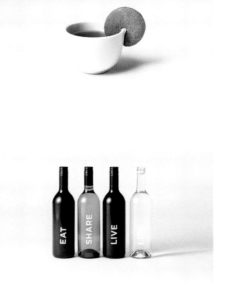

MERIT

**Corporate Identity:
Campaign**

Writers
Pradeep Sharma, Dean Poole,
Shabnam Shiwan, Ben Corban
Designers
Shabnam Shiwan,
Aaron Edwards, Dean Poole,
Janson Chau
Photographers
Toaki Okano, David St George
Creative Director
Dean Poole
Client
Fisher & Paykel
Agency
Alt Group/Auckland
-
ID No. 12094D

MERIT

Corporate Identity:
Campaign

Client
Apotek Hjärtat
Agency
BVD/Stockholm
—
ID No. 12095D

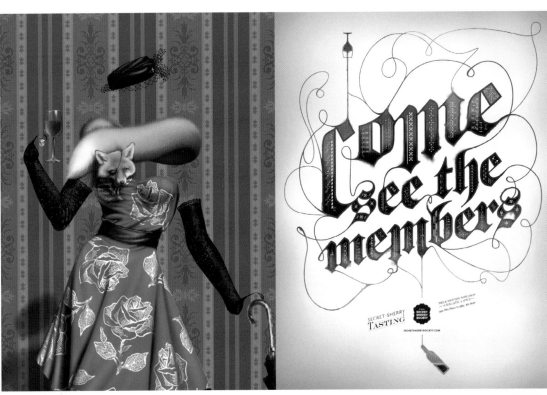

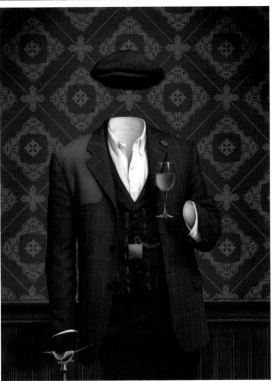

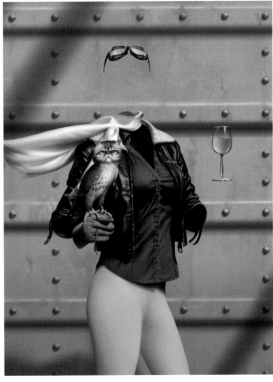

MERIT

**Corporate Identity:
Campaign**

Art Director
Kristi Flango
Writer
Sara Bergy
Designer
Simson Chantha
Creative Director
Steve Cullen
Client
Sherry
Agency
Creature/Seattle

ID No. 12096D

MERIT

Corporate Identity:
Campaign

Art Director
Yoshihiro Yagi
Writer
Haruko Tsutsui
Designers
Toshimitsu Tanaka,
Ayano Higa
Photographer
Takaya Sakano
Creative Director
Morihiro Harano
Client
Menicon
Agencies
Dentsu/Tokyo, Drill, PARTY
–
ID No. 12097D

Magic

1day Menicon Flat Pack

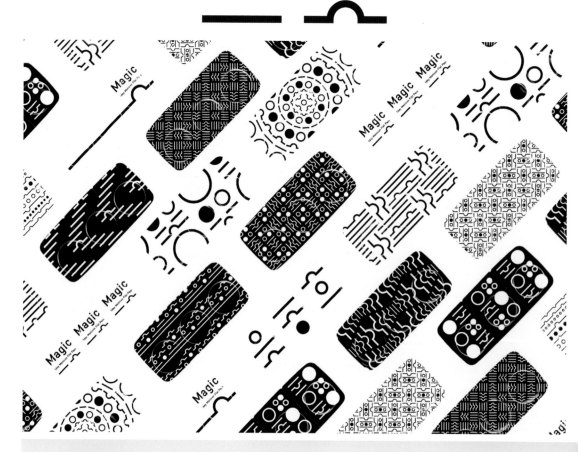

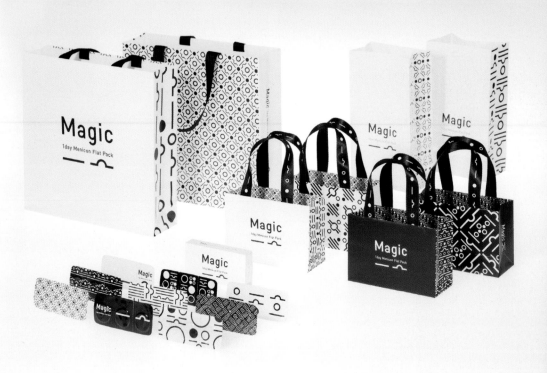

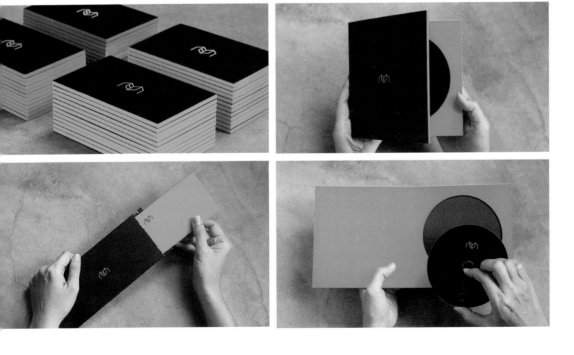

MERIT

**Corporate Identity:
Campaign**

Art Directors
Linus Chen, Leng Soh
Designers
Linus Chen, Leng Soh
Creative Director
Pann Lim
Client
Neon Sound
Agency
Kinetic/Singapore
–
ID No. 12098D

MERIT

Corporate Identity:
Campaign

Writer
Jen Jordan
Designers
Tosh Hall, Lia Gordon
Illustrator
Michael Goodman
Typographer
Jessica Minn
Creative Director
Tosh Hall
Client
Advanced Ice Cream
Technologies
Agency
Landor Associates/
San Francisco
▬
ID No. 12099D

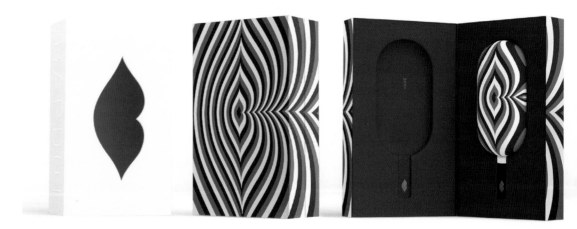

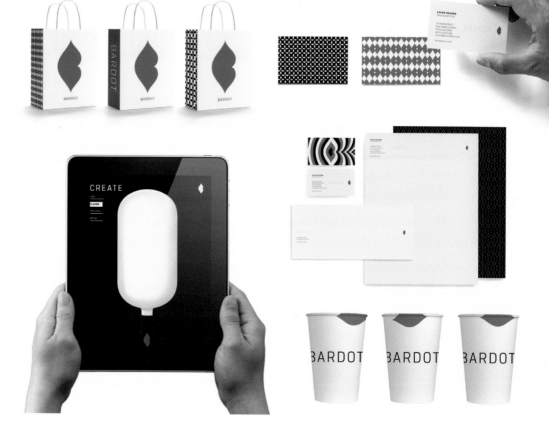

MERIT

Corporate Identity:
Campaign

Art Director
Michael Lin
Designers
Jessica Minn,
Martin Kovacovsky
Creative Director
Nicolas Aparicio
Client
DC Entertainment
Agency
Landor Associates/
San Francisco
-
ID No. 12100D

Corporate Identity:
Campaign

Designer
Serhat Ferat
Creative Director
Peter Neumeister
Client
Swedish Institute
Agency
Neumeister Strategic Design/
Stockholm
—
ID No. 12101D

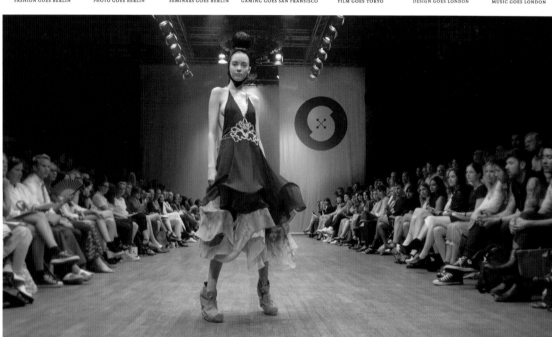

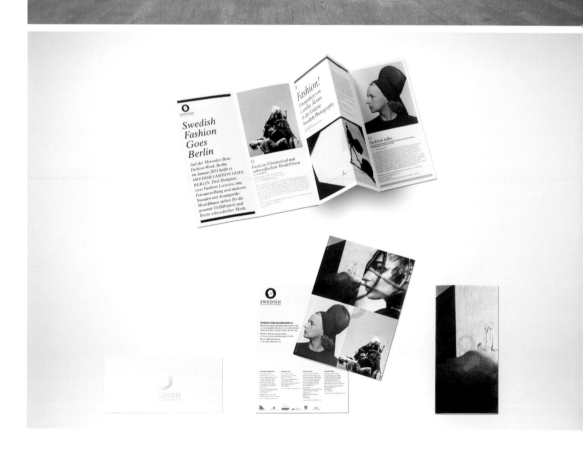

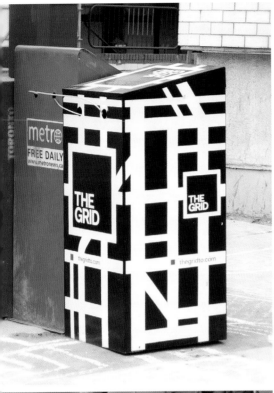
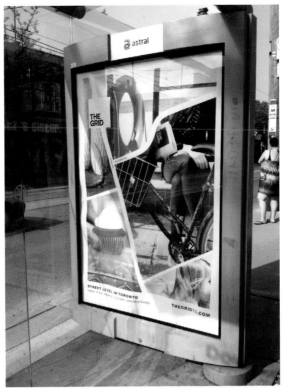

MERIT

Corporate Identity:
Campaign

Art Directors
Irene Pau, Lisa Nakamura
Writer
Adam Bailey
Designer
Jeff Harrison
Photographer
Sean J. Sprague
Creative Directors
Chris Staples, Ian Grais
Client
The Grid
Agency
Rethink/Vancouver

—

ID No. 12102D

MERIT

Corporate Identity:
Campaign

Art Director
Jessica Walsh
Designers
Xavi Garcia, Michael Freimuth,
Stephane Elbaz
Creative Director
Stefan Sagmeister
Client
EDP
Agency
Sagmeister/New York
-
ID No. 12103D

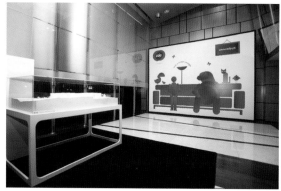

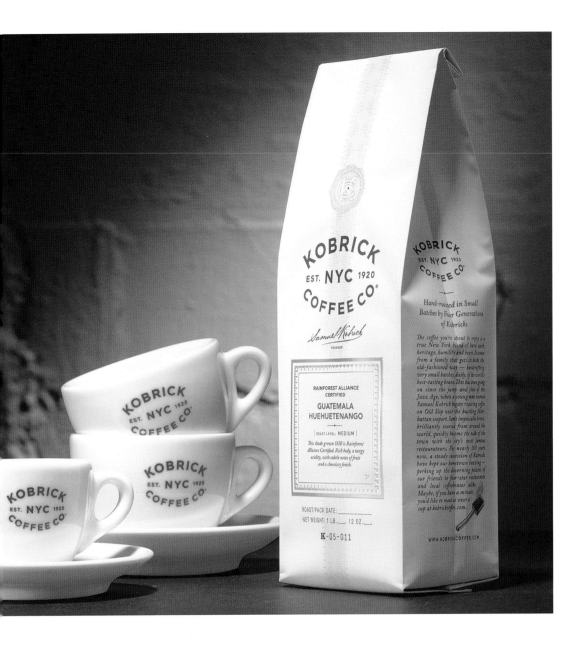

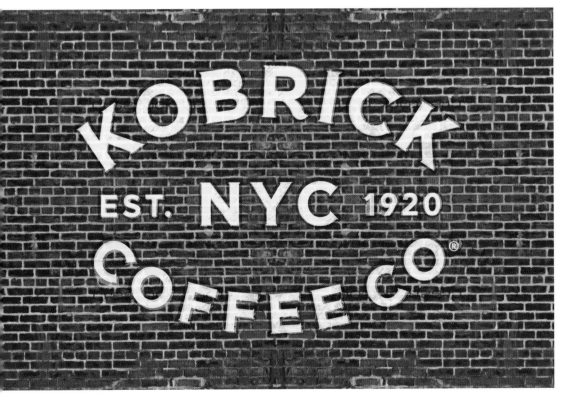

MERIT

Corporate Identity:
Campaign

Designer
Steve Sandstrom
Illustrator
Howell Golson
Creative Director
Steve Sandstrom
Client
Kobrick Coffee
Agency
Sandstrom Partners/Portland
—
ID No. 12104D

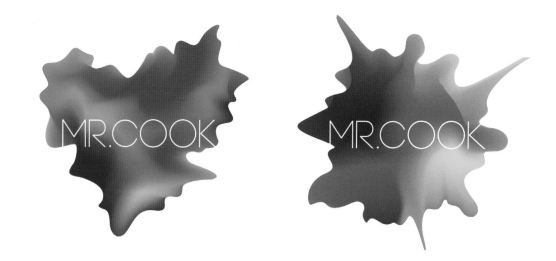

MERIT

**Corporate Identity:
Campaign**

Designer
Wendy Cho
Creative Director
Vanessa Ryan
Client
Mr. Cook
Agency
SML/Small Medium Large/
Waterloo
—
ID No. 12105D

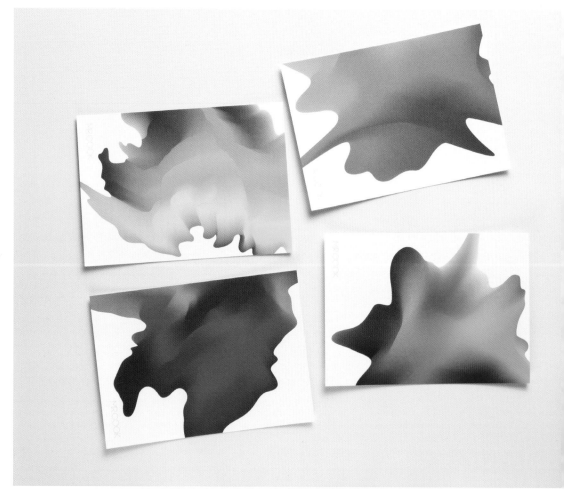

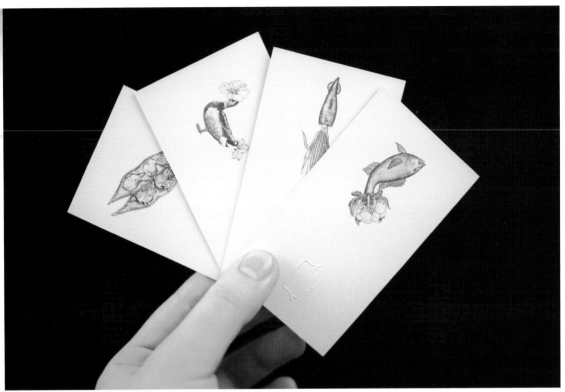

MERIT

**Corporate Identity:
Campaign**

Writer
Lynette Chiu
Designers
Jeremy Huen, Mandy Chan
Illustrator
Vincent Wong
Creative Director
Maxime Dautresme
Client
Atelia
Agency
Substance/Hong Kong
—
ID No. 12106D

MERIT

Corporate Identity:
Campaign

Designers
Britt Hull, Brian Steele
Creative Directors
David Turner,
Bruce Duckworth,
Sarah Moffat
Client
Levi Strauss
Agency
Turner Duckworth Design/
San Francisco
—
ID No. 12107D

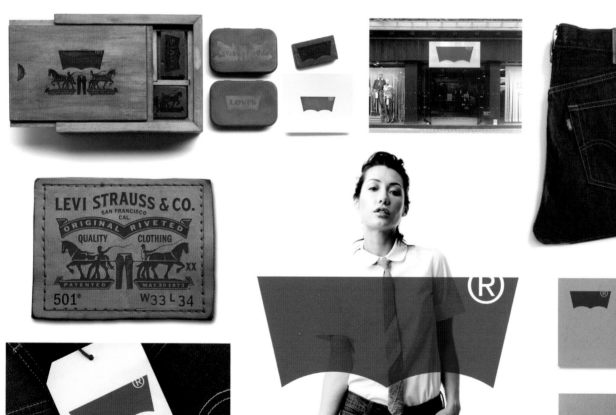

MERIT

**Corporate Identity:
Campaign**

Client
Belkin
Agency
Wolff Olins/New York
—
ID No. I2108D

MERIT

Corporate Identity:
Individual Item

Art Director
Ross Nieuwenhuizen
Writer
Mike Pearson
Designer
Kirsten Townsend
Producer
Clinton Mitri
Creative Directors
Mike Schalit, Ivan Johnson,
Alexis Beckett
Client
Oude Meester Brandy
Agency
140 BBDO/Cape Town
-
ID No. 12109D

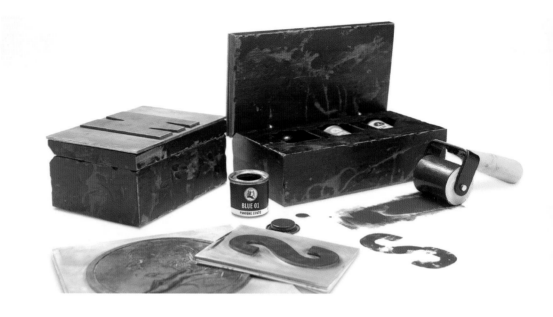

MERIT

Corporate Identity:
Individual Item

Art Director
Mandar Acharekar
Writers
Hemant Shringy,
Mandar Acharekar
Creative Directors
Amit Akali, Malvika Mehra,
Karan Rawat, Rohit Malkani,
Bhavesh Kosambia,
Aarati Kakkad
Client
Colston Julian
Agency
Grey Worldwide/Mumbai
-
ID No. 12110D

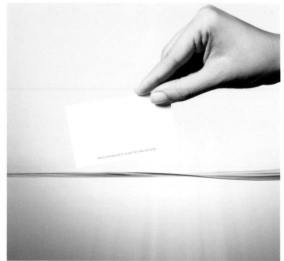
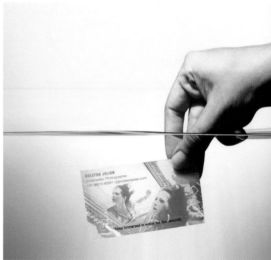

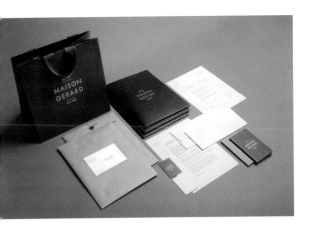

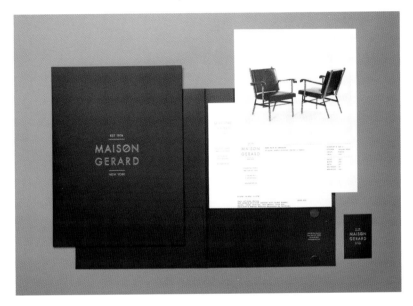

MERIT

**Corporate Identity:
Individual Item**

Creative Director
Mother New York
Client
Maison Gerard
Agency
Mother/New York
–
ID No. 12111D

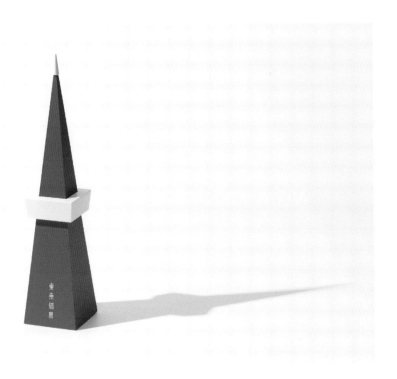

MERIT

Package Design – Single

Art Director
Katsuhiko Suzuki
Designers
Kotaro Hirano, Yuki Sugiyama,
Hiroki Tatebayashi
Photographers
Yasuko Furukawa,
Kozaburo Iwakiri, Yusuke Oka
Creative Director
Kazufumi Nagai
Client
Hakuhodo + Design Project
Agency
Hakuhodo/Tokyo
–
ID No. 12113D

MERIT

Package Design – Single

Art Directors
Pann Lim, Claire Lim
Writers
Claire Lim, Aira Lim
Photographer
John Nursalim
Illustrator
Renn Lim
Creative Director
Pann Lim
Client
Holycrap.sg
Agency
Kinetic/Singapore
—

ID No. 12114D

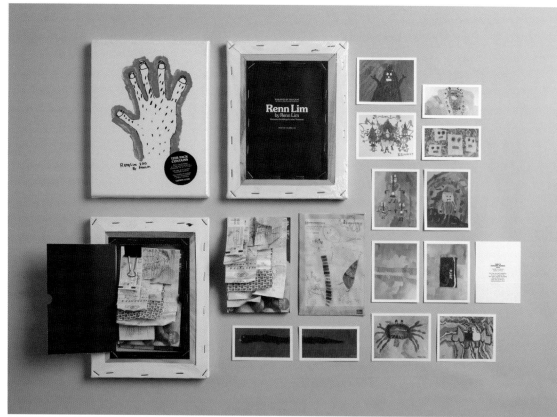

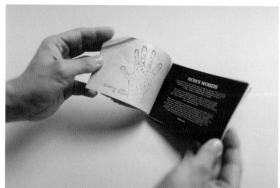

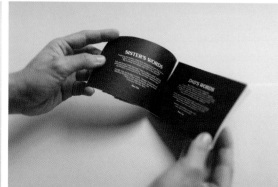

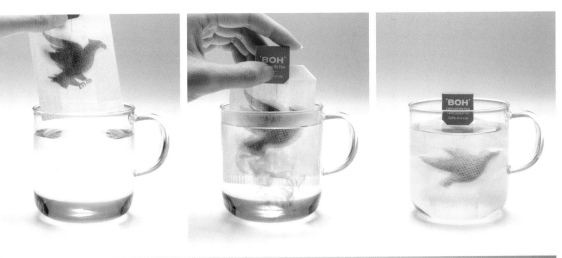

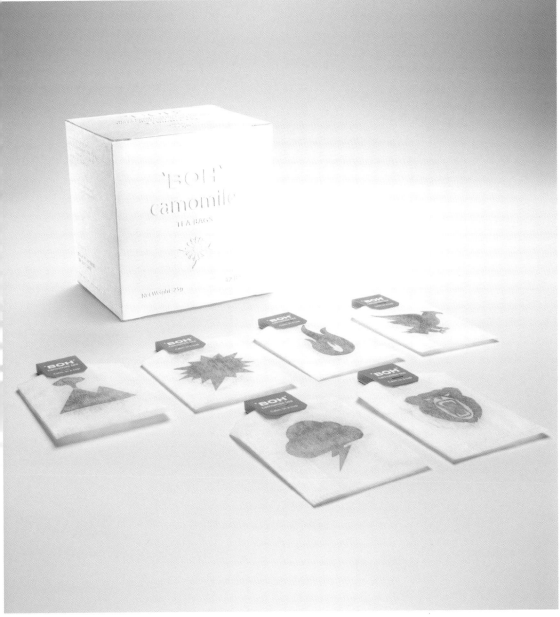

MERIT

Package Design – Single

Art Directors
Choo Chee Wee, Pauline Ang
Writers
Farrokh Madon, Ahmad Fariz
Designer
Ellie See
Photographer
Jesse Choo
Creative Directors
Farrokh Madon, Henry Yap,
Marzuki Maani, Neil Leslie
Client
Boh Plantation
Agency
M&C Saatchi/Kuala Lumpur

ID No. 12115D

MERIT

Package Design – Single

Designers
Raimundo Favacho,
Patricia Ebner
Client
B
Agency
Pereira & O'Dell/
San Francisco
—
ID No. 12116D

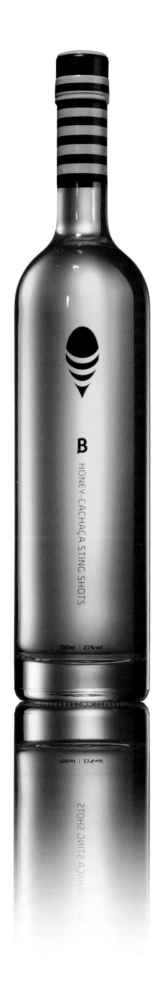

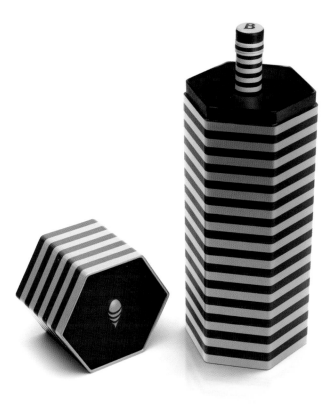

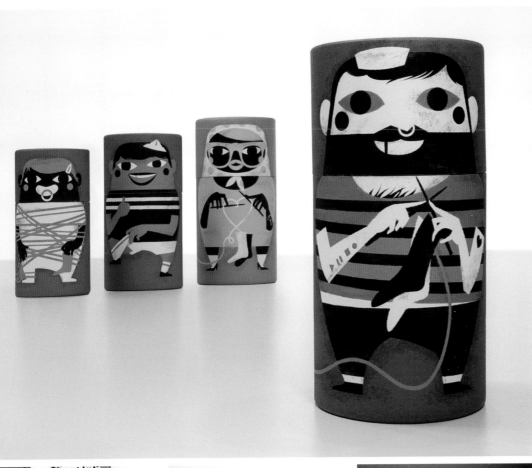

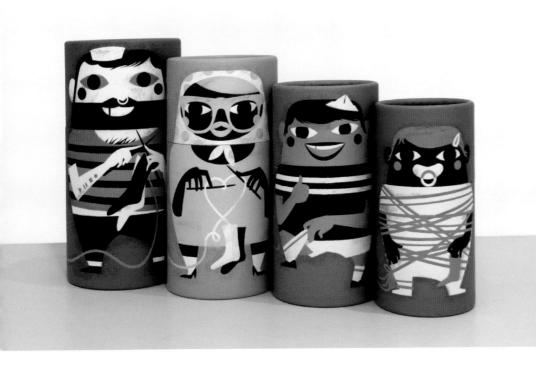

MERIT

Package Design Campaign

Art Director
Veronika Kieneke
Writer
Matthias Hardt
Designer
Veronika Kieneke
Illustrator
Veronika Kieneke
Client
Closed
Agency
Gürtlerbachmann/Hamburg

ID No. 12117D

MERIT

**Package Design –
Campaign**

Art Directors
Purva Bakalkar, Siddhi Yadav
Writer
Purva Bakalkar
Designer
Siddhi Yadav
Illustrator
Siddhi Yadav
Creative Directors
Prasoon Joshi, Denzil
Machado, Abhinav Tripathi
Client
Perfeti Van Melle
Agency
McCann Worldgroup/Mumbai
-

ID No. 12118D

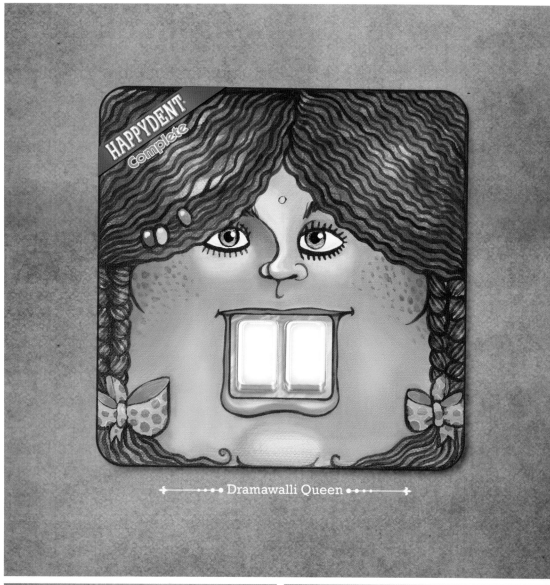

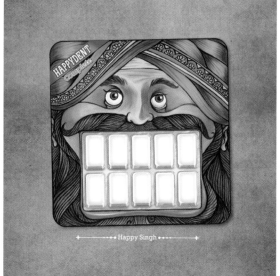

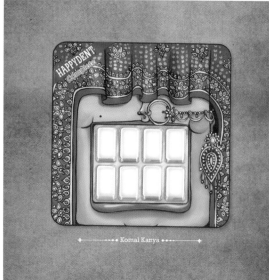

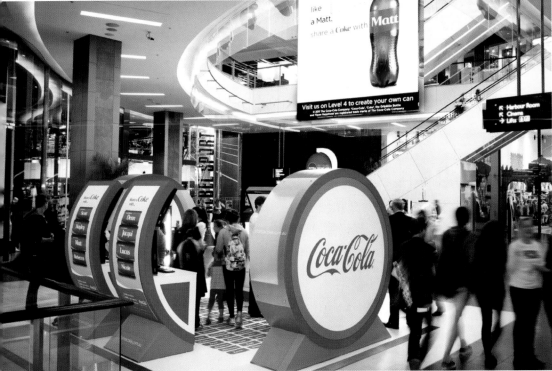
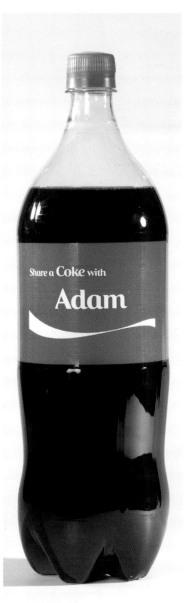
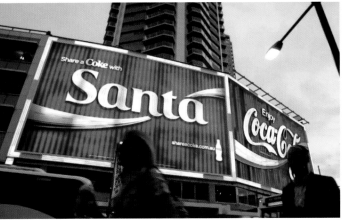
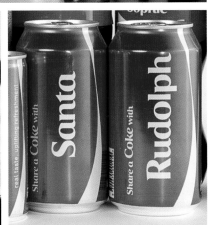

MERIT

**Package Design –
Campaign**

Art Directors
Jakub Szymanski, Liam Hillier,
Luke Acret
Writers
Omid Amidi, Alex Stainton
Creative Directors
Chris Ford, Brian Merrifield,
Boris Garelja
Client
Coca-Cola
Agency
Ogilvy & Mather/Sydney
–
ID No. 12119D

MERIT

**Industrial Design/
Product Design**

Art Director
Kenjiro Sano
Designer
Masashi Murakami
Client
MR_DESIGN
Agency
MR_DESIGN/Tokyo
—
ID No. 12120D

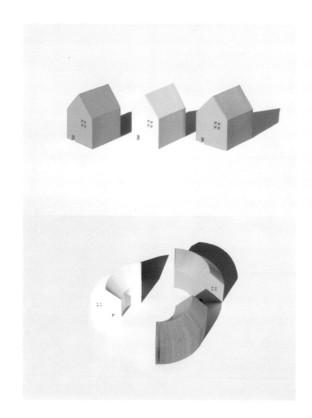
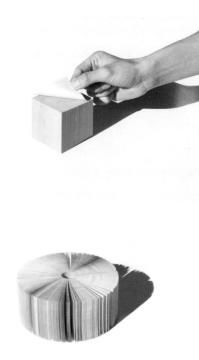

MERIT

**Collateral Design:
Posters – Single**

Art Director
Andres Moncayo
Illustrator
Andres Moncayo
Creative Directors
Pablo Acosta, Carlos Orozco,
Juan Manuel Gaitan
Client
Bumba - Aldor
Agency
Leo Burnett Colombia/Bogota
—
ID No. 12121D

MERIT

**Collateral Design:
Posters – Single**

Art Director
Anthony Chelvanathan
Writer
Steve Persico
Photographer
Mark Zibert
Creative Directors
Judy John, Heather
Chambers, Lisa Greenberg
Client
Procter & Gamble - Bounty
Agency
Leo Burnett/Toronto
–
ID No. 12122D

MERIT

**Collateral Design:
Posters – Single**

Art Director
Anthony Chelvanathan
Writer
Steve Persico
Photographer
Mark Zibert
Creative Directors
Judy John, Heather
Chambers, Lisa Greenberg
Client
Procter & Gamble - Bounty
Agency
Leo Burnett/Toronto
–
ID No. 12123D

MERIT

**Collateral Design:
Posters - Single**

Art Director
Yasuhide Arai
Writers
Nobuhiko Suzuki,
Tsutomu Tamura
Designer
Yasuhide Arai
Client
yueni
Agency
Nippon Design Center/Tokyo
▬

ID No. 12124D

iPad Smart Cover

MERIT

**Collateral Design:
Posters – Campaign**

Client
Apple
Agency
Apple/Cupertino
—
ID No. 12128D

MERIT

Collateral Design:
Posters – Campaign

Illustrators
Dani Loureiro, Jade Klara
Creative Director
Jake Bester
Client
Marmite
Agency
Big Wednesday/Cape Town
—
ID No. 12129D

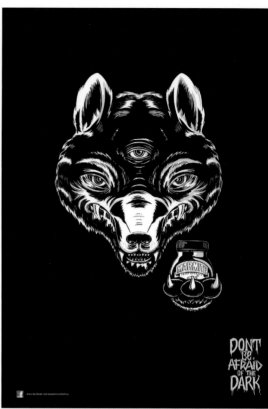

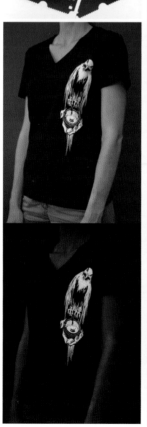
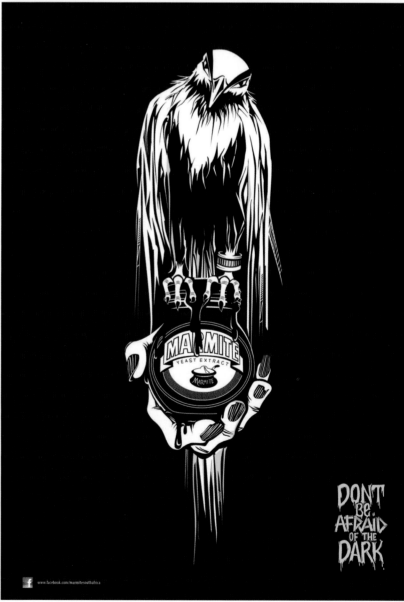

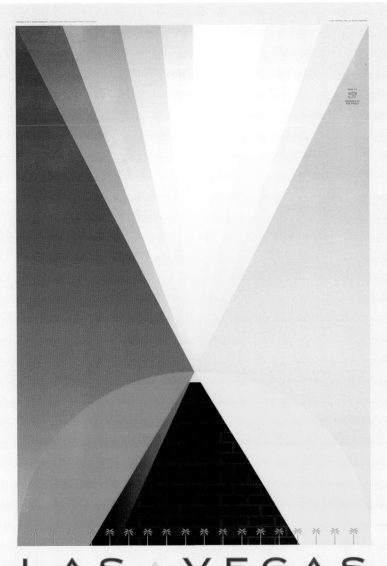

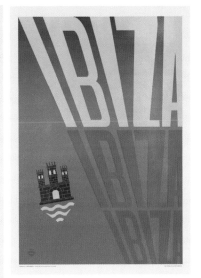

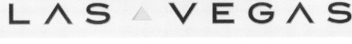

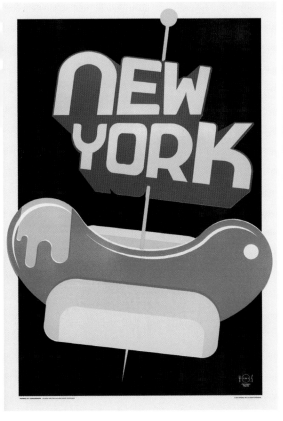

MERIT

Collateral Design:
Posters – Campaign

Art Director
Adam Deer
Designer
Ramon Vasquez
Illustrator
Mick Marston
Creative Director
Steve Cullen
Client
Expedia
Agency
Creature/Seattle
—
ID No. 12130D

MERIT

Collateral Design:
Posters – Campaign

Art Director
Carlos Wigle
Writer
Aron Fried
Designer
Juan Carlos Pagan
Illustrator
Rami Niemi
Creative Directors
Matt Eastwood, Menno Kluin
Client
Art Director's Club
Agency
DDB/New York
–

ID No. 12131D

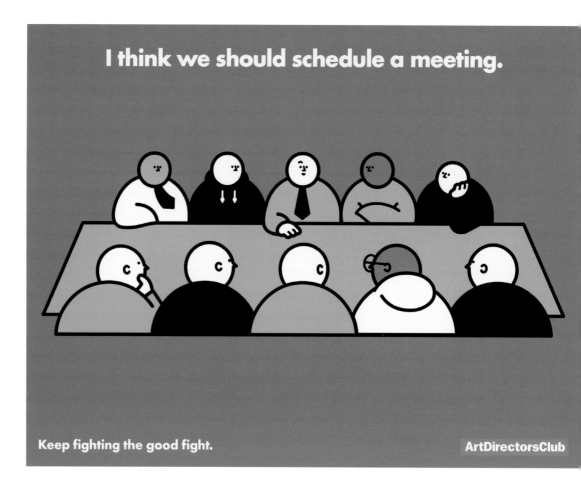

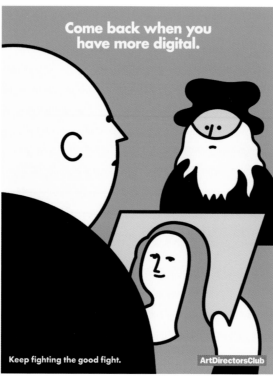

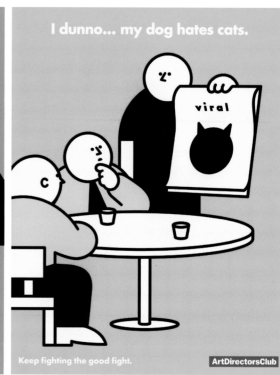

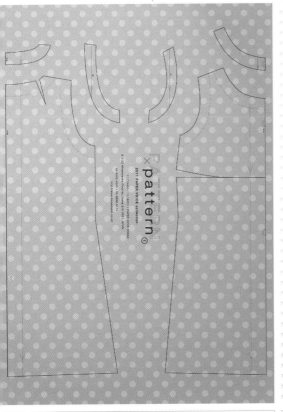
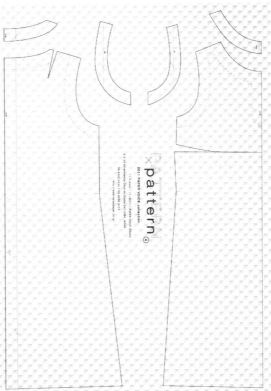
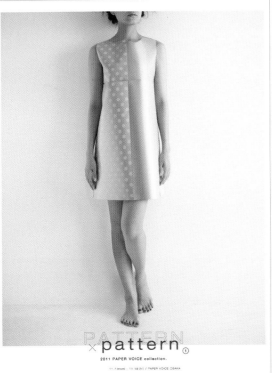
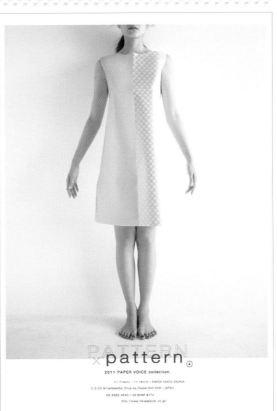

MERIT

**Collateral Design:
Posters – Campaign**

Art Director
Masaki Nishiyama
Writer
Yukari Matsumoto
Designer
Ryo Matsumoto
Photographer
Mitsuru Kouyama
Illustrator
Masao Asano
Client
Heiwa Paper
Agency
Dentsu/Osaka
—
ID No. 12132D

Collateral Design:
Posters – Campaign

Art Director
Yoshihiro Yagi
Writer
Haruko Tsutsui
Designers
Minami Otsuka, Takuya Iimura
Photographer
Honoka Sueyoshi
Creative Director
Yuya Furukawa
Client
Yoshida Hideo Memorial
Foundation
Agency
Dentsu/Tokyo
—
ID No. 12134D

Get Back, Tohoku. / One line connects us all.

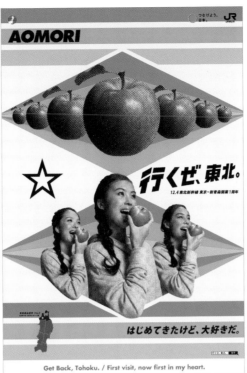

Get Back, Tohoku. / First visit, now first in my heart.

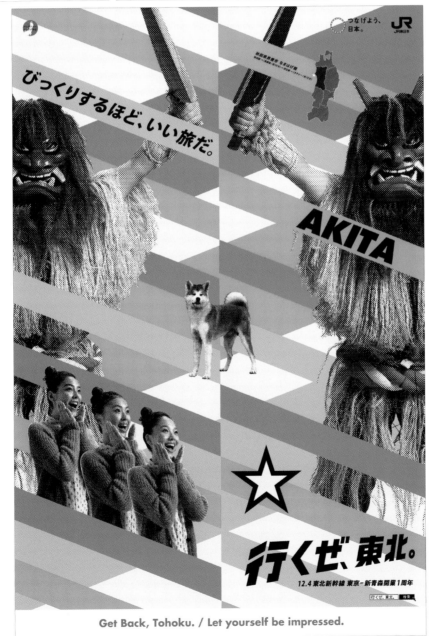

Get Back, Tohoku. / Let yourself be impressed.

MERIT

**Collateral Design:
Posters – Campaign**

Art Director
Yoshihiro Yagi
Writers
Hiroshi Ichikura,
Waca Sakamoto
Designers
Daisuke Hatakeyama,
Rumiko Kobayashi
Photographer
Yasutoshi Fujiwara
Creative Directors
Yukio Oshima,
Takuma Takasaki
Client
East Japan Railway Company
Agencies
Dentsu/Tokyo, DOF
–
ID No. 12133D

MERIT

Collateral Design:
Posters – Campaign

Art Director
Chris Northam
Writer
Evan Roberts
Illustrator
Various AFL Players
Creative Director
Ben Coulson
Client
Australian Football League
Agency
George Patterson Y&R/
Melbourne
-
ID No. 12135D

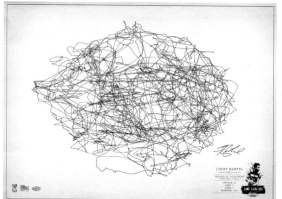

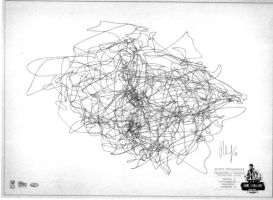

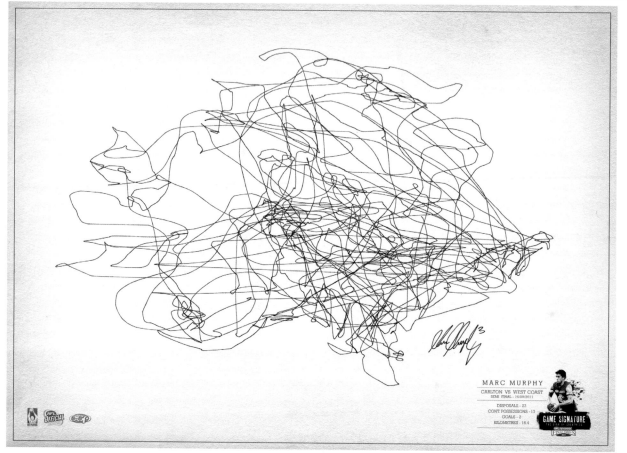

THE MORE YOU TEXT, THE MORE YOU CAN PROTECT.
Text Coca-Cola package codes to donate. ArcticHome.com

MERIT

**Collateral Design:
Posters – Campaign**

Art Director
Chris von Ende
Writer
Mike Ward
Designer
Eing Omathikul
Creative Directors
Dave Loew, Jon Wyville
Client
Coca-Cola
Agency
Leo Burnett/Chicago
—
ID No. 12136D

Collateral Design:
Posters – Campaign

Designer
Ty Mattson
Client
Showtime
Agency
Mattson Creative/Irvine
—
ID No. 12137D

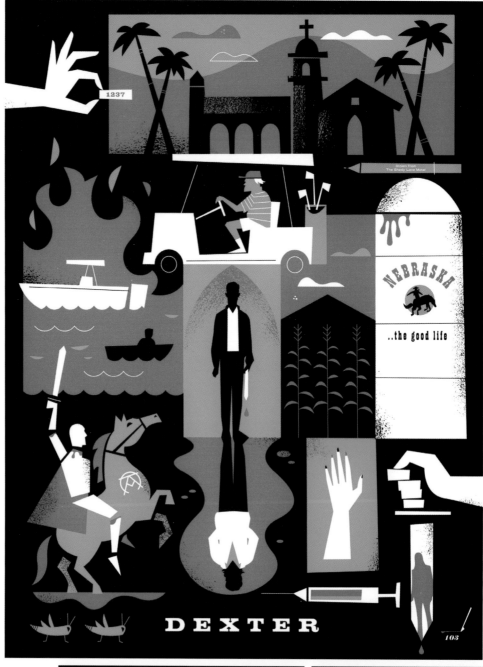

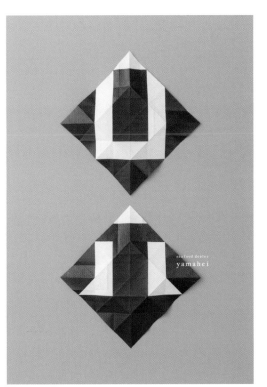

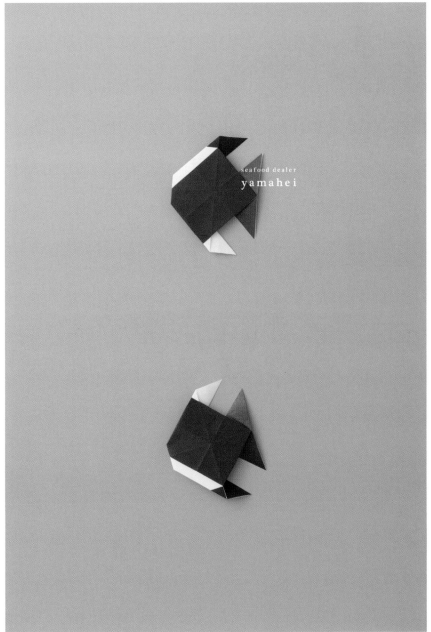

MERIT

**Collateral Design:
Posters – Campaign**

Art Director
Yoshinari Mokutani
Designer
Yoshinari Mokutani
Photographer
Masumi Horiguchi
Client
Yamahei Shoten
Agency
Mokutani Design/Kawasaki
—
ID No. 12138D

**Collateral Design:
Posters – Campaign**

Art Directors
Todd McCracken, BJ Galinato,
Jeremy Lim, Dang Thuong Do,
Jay Furby, Joe Harris
Writers
Todd McCracken, Du Tang,
Martin Sutcliffe, Jay Furby
Designers
Marko Klijn, Priyan Jayamaha,
Sandesh Codhadu, Andrew
Stewart, Christian Greet,
Matt Tan, Chevy McGoram
Creative Director
Todd McCracken
Client
Tamiya
Agency
Ogilvy & Mather Vietnam/
Ho Chi Minh City
–

ID No. 12139D

Also Awarded:
Merit: Transit: Campaign

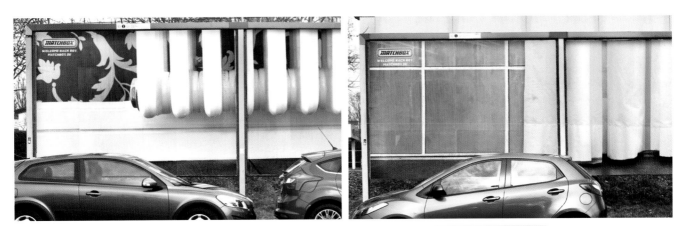

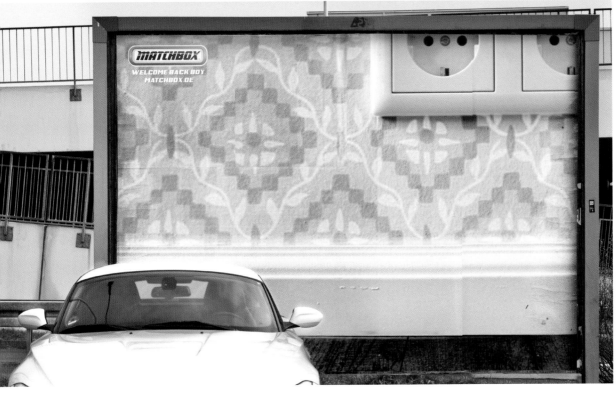

MERIT

**Collateral Design:
Posters – Campaign**

Art Directors
Andreas Wagner,
Lisa Reissner
Writers
Lisa Reissner,
Dr. Stephan Vogel
Photographer
Jo Bacherl
Creative Directors
Dr. Stephan Vogel,
Helmut Meyer
Client
Mattel
Agency
Ogilvy Germany/Frankfurt
–
ID No. 12140D

MERIT

Collateral Design:
Posters – Campaign

Art Director
Daniel Robitaille
Creative Director
Louis Gagnon
Client
Domison
Agency
Paprika/Montreal
—
ID No. 12141D

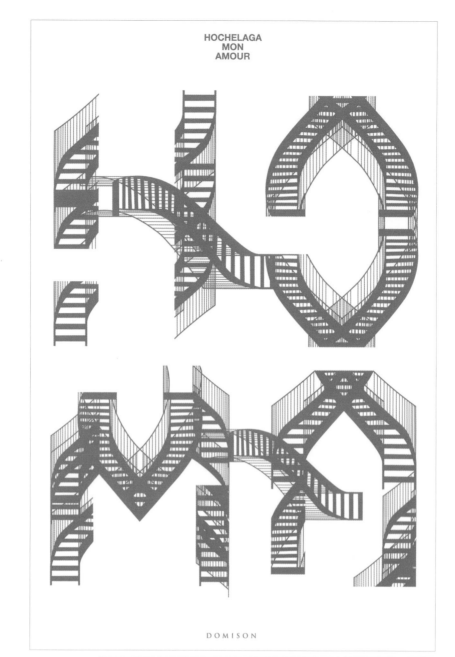

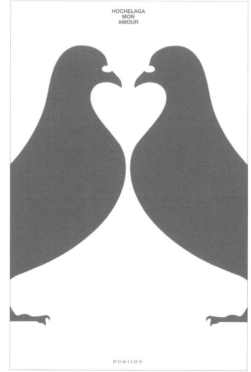

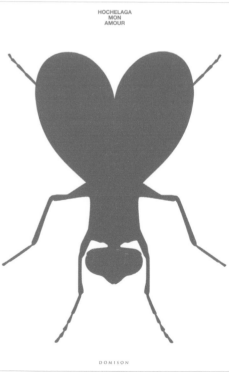

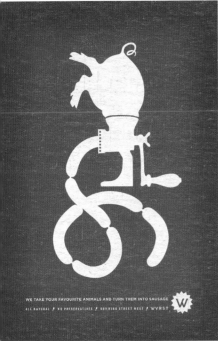

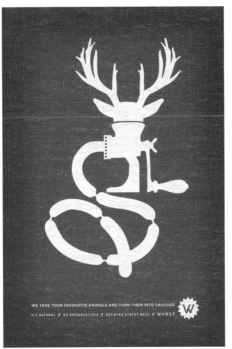

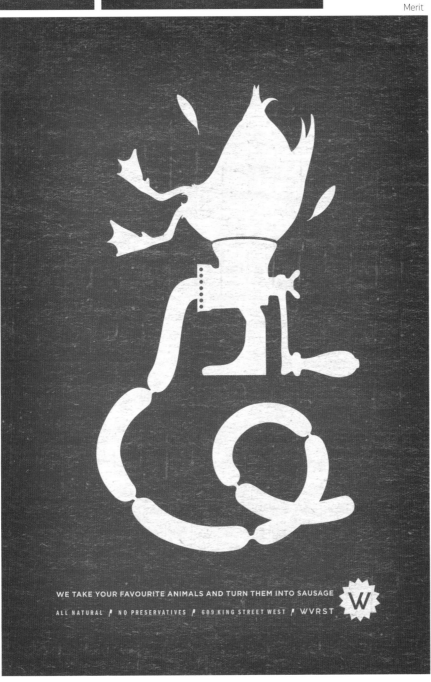

MERIT

**Collateral Design:
Posters – Campaign**

Art Director
Mike Lee
Writer
Alexis Bronstorph
Designer
Mike Lee
Illustrators
Mike Lee, Glenn Thurman
Typographer
Esther Sanchez
Creative Director
Lance Martin
Client
WVRST
Agency
TAXI Canada/Toronto
—
ID No. 12142D

Also Awarded:
Merit: Posters: Single,
Merit: Posters: Single

MERIT

**Collateral Design:
Posters – Campaign**

Art Director
Steven Tyler
Writers
Gerhard Pretorius,
Jonathan Pepler
Creative Director
Graham Warsop
Client
BirdLife
Agency
The Jupiter Drawing Room
Utopia/Cape Town
–

ID No. 12144D

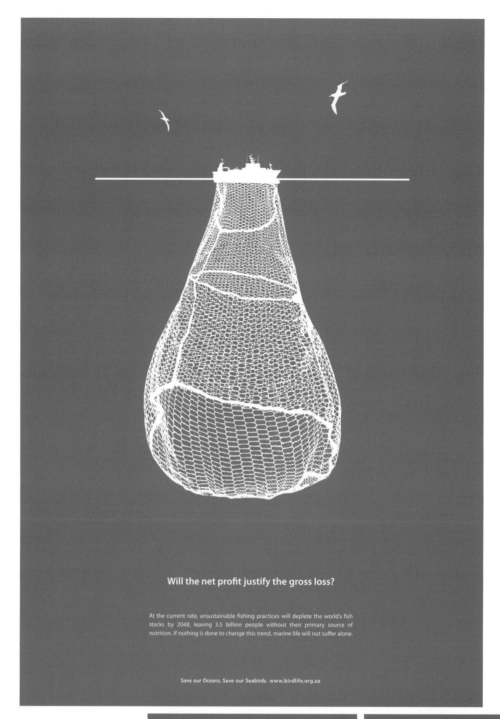

Will the net profit justify the gross loss?

At the current rate, unsustainable fishing practices will deplete the world's fish stocks by 2048, leaving 3.5 billion people without their primary source of nutrition. If nothing is done to change this trend, marine life will not suffer alone.

Save our Oceans. Save our Seabirds. www.birdlife.org.za

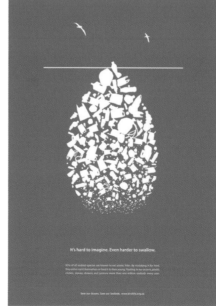

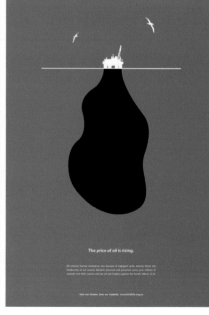

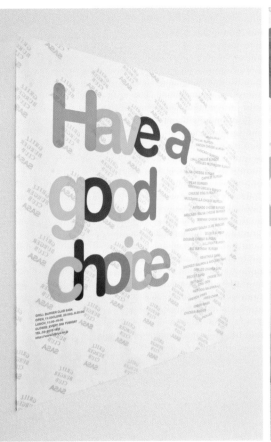
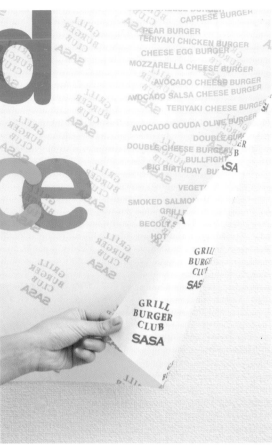

MERIT

**Collateral Design:
P.O.P. and In-Store –
Single**

Art Director
Kenichi Matsumoto
Designer
Kenichi Matsumoto
Client
Grill Burger Club SASA
Agency
E. Co./Tokyo
—
ID No. 12145D

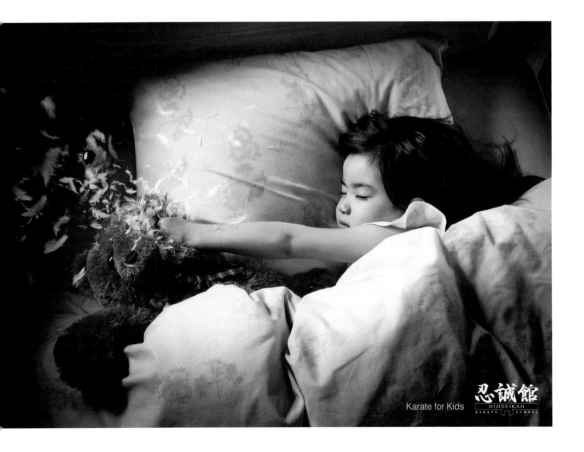

MERIT

**Collateral Design:
P.O.P. and In-Store –
Single**

Art Director
Takeshi Iwamoto
Writer
Kei Oki
Creative Director
Masayoshi Soeda
Client
Ninseikan Karate School
Agency
Grey/Tokyo
—
ID No. 12147D

MERIT

**Collateral Design:
P.O.P. and In-Store –
Single**

Art Directors
Bruno Rubeiro, Pedro Izique,
Diego Machado
Writers
Eduardo Marques, Hugo Veiga
Creative Directors
Anselmo Ramos,
Eduardo Marques
Client
Magazine Luiza
Agency
Ogilvy Brasil/São Paulo
—
ID No. 12148D

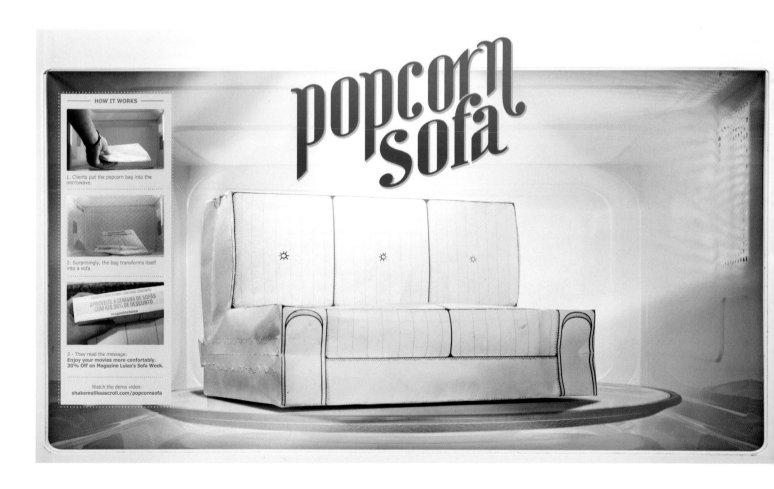

MERIT

**Collateral Design:
P.O.P. and In-Store
Campaign**

Art Directors
Basab Tito Majumdar
Writers
Ajay Gahlaut,
Vikash Chemjong
Typographer
Basab Tito Majumdar
Creative Directors
Ajay Gahlaut,
Vikash Chemjong,
Basab Tito Majumdar
Client
Soliance Pharma Products
Agency
Brand David/New Delhi
—
ID No. 12149D

MERIT

**Collateral Design:
P.O.P. and In-Store –
Campaign**

Art Director
Yoshiki Uchida
Designers
Yoshiki Uchida,
Atushi Sugiyama
Creative Director
Yoshiki Uchida
Client
Koyama Kanamono
Agency
Cosmos/Tokyo
–
ID No. 12150D

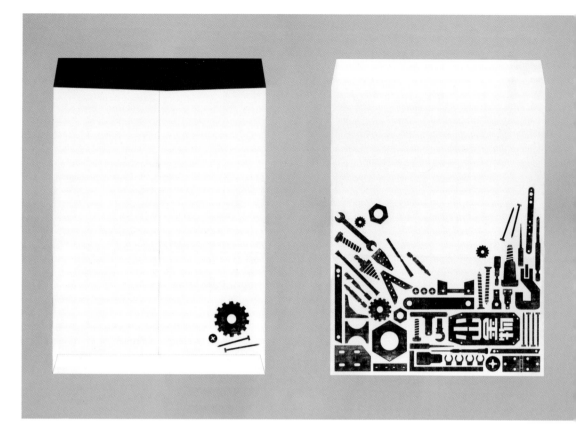

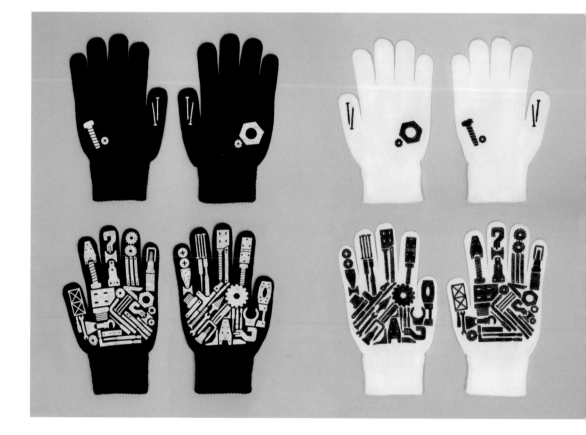

For far. For near.
bifocal glasses ⌾⌾ WASHIN

For far. For near.
bifocal glasses ⌾⌾ WASHIN

MERIT

**Collateral Design:
P.O.P. and In–Store –
Campaign**

Art Director
Ken Mitani
Writer
Masanori Tagaya
Creative Director
Masayoshi Soeda
Client
Washin Optical
Agency
Grey/Tokyo
—
ID No. 12151D

MERIT

**Collateral Design:
P.O.P. and In-Store –
Campaign**

Art Director
Rishi Chanana
Writers
Pratheek, Nandini Nair
Designer
Rishi Chanana
Illustrators
Rishi Chanana, Milind More
Creative Directors
Rahul Sengupta,
Rishi Chanana, Nandini Nair
Client
Imagine
Agency
TBWA\India/Mumbai
–
ID No. 12152D

Also Awarded:
Merit: Posters: Campaign

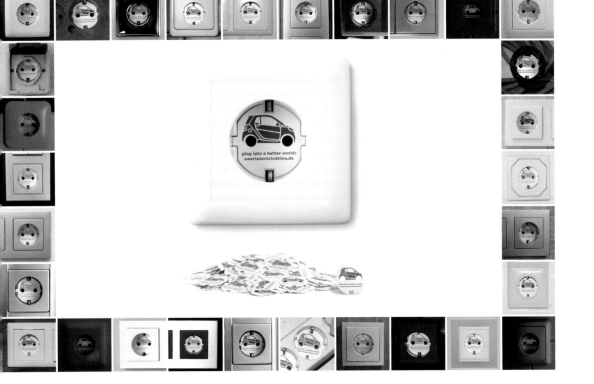

MERIT

**Collateral Design:
Promotion**

Art Director
Gisela Demary
Writer
Helmut Bienfuss
Illustrator
Gisela Demary
Creative Directors
Christian Mommertz,
Ton Hollander,
Wolfgang Schneider
Client
Daimler/Smart
Agency
BBDO Proximity/Duesseldorf
-
ID No. 12153D

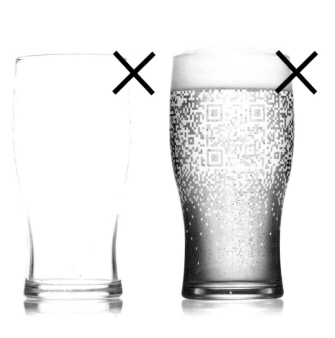

MERIT

**Collateral Design:
Promotion**

Art Director
Danilo Boer
Writer
Adam Reeves
Designers
Craig Duffney, Danilo Boer
Creative Director
David Lubars
Client
Diageo/Guinness
Agency
BBDO/New York
-
ID No. 12154D

**Collateral Design:
Promotion**

Art Directors
Preeti Verma,
Satish Sethumadhavan
Writer
Karunasagar Sridharan
Photographer
Nirav Mehta
Creative Directors
Bobby Pawar, KB Vinod
Client
Union Bank of India
Agency
DDB Mudra/Mumbai
—

ID No. 12155D

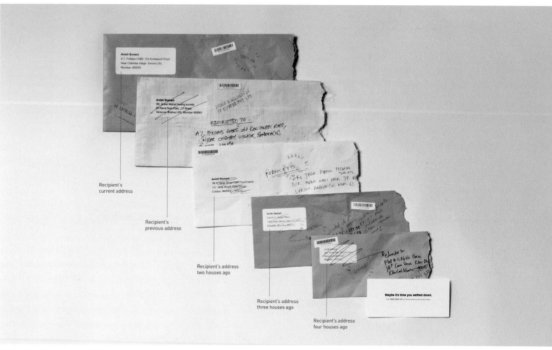

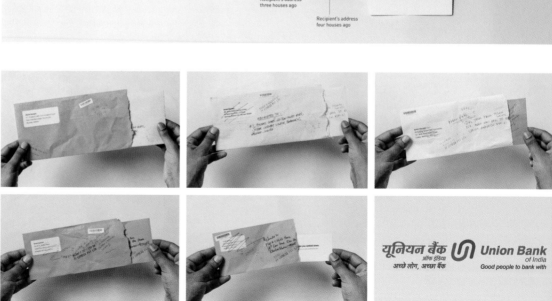

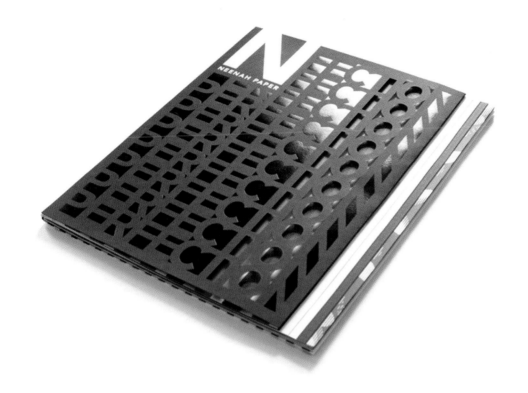

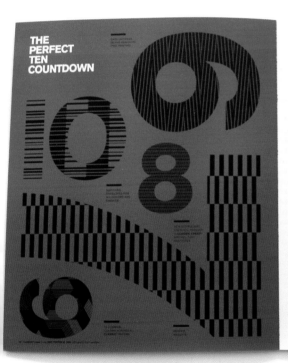

THE
PERFECT
TEN
COUNTDOWN

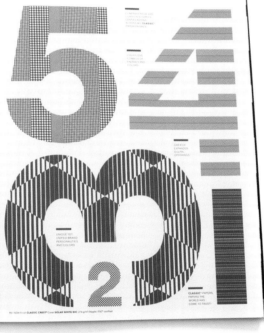

PERFECT

PERFORMANCE

IT ALL
COMES
TOGETHER

MEET THE
ADDITION OF THE
PERFECT
TEN

MERIT

**Collateral Design:
Promotion**

Art Directors
Pum Lefebure, Tom Wright
Writer
S.W. Smith
Designer
Lucas Badger
Photographer
Cade Martin
Creative Directors
Pum Lefebure, Jake Lefebure
Client
Neenah Paper
Agency
Design Army/Washington, DC
—
ID No. 12156D

Collateral Design:
Promotion

Art Director
Roman-Geoffrey Lukowski
Writers
Mareike Woischke,
Jens Scholtiski
Photographer
Emir Haveric
Creative Directors
Ralf Heuel, Ralf Nolting,
Sven Rumpf
Client
Volkswagen
Agency
Grabarz & Partner/Hamburg
–

ID No. 12158D

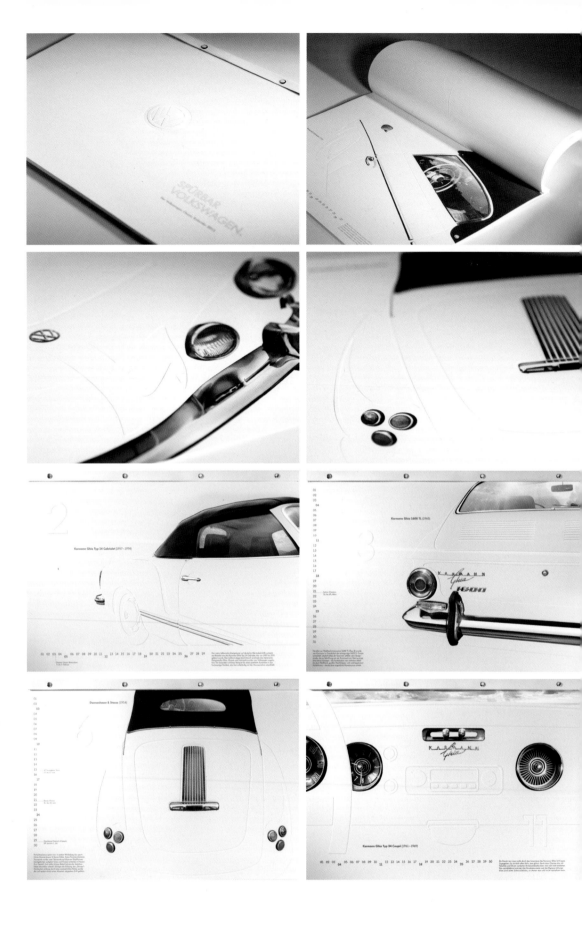

MERIT

**Collateral Design:
Promotion**

Art Director
Merle Schroeder
Writer
Jana Puetz
Designer
Merle Schroeder
Client
Gruner + Jahr /National
Geographic
Agency
Gürtlerbachmann Werbung/
Hamburg
—
ID No. 12137D

MERIT

**Spatial Design:
Indoor Spaces**

Art Director
Koji Iyama
Designers
Yoshiko Akado,
Mayuko Watanabe,
Takenori Sugimura,
Saori Shibata
Creative Director
Koji Iyama
Client
Kamoi Kakoshi
Agency
iyamadesign/Tokyo

ID No. 12159D

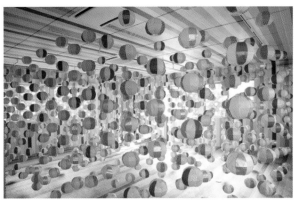

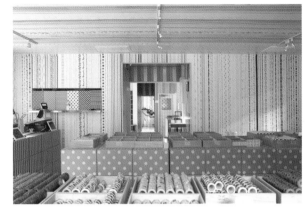

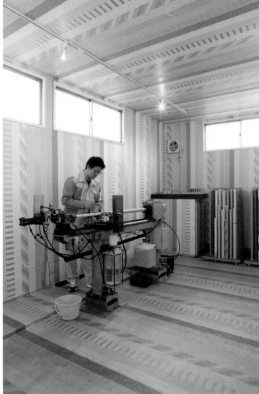

MERIT

**Spatial Design:
Outdoor Spaces**

Art Director
Koji Iyama
Designers
Mayuko Watanabe,
Takenori Sugimura,
Saori Shibata
Creative Director
Koji Iyama
Client
Kamoi Kakoshi
Agency
iyamadesign/Tokyo
-
ID No. 12160D

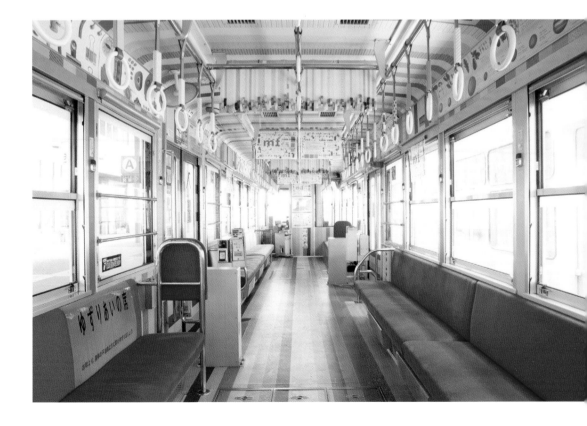

MERIT

**Spatial Design:
Outdoor Spaces**

Art Directors
Andres Lopez, Camilo Ruano,
Daniel Mora
Writer
Julian Gutierrez
Photographer
Javier Crespo
Agency Producers
David Alvarado, Freddy
Rivero, Leonardo Miranda
Creative Directors
John Raul Forero, Juan Jose
Posada, Mauricio Guerrero,
Diego Cardenas
Client
Mattel
Agency
Ogilvy & Mather/Colombia
-
ID No. 12161D

Also Awarded:
Merit: Transit Single

MERIT

**Outdoor Design:
Billboards – Single**

Art Directors
Addie Gillespie, Mia Thomsett
Writers
Addie Gillespie, Mia Thomsett
Agency Producer
April Haffenden
Creative Directors
Rob Sweetman, Bryan Collins
Client
McDonald's Restaurants
of Canada
Agency
Cossette/Vancouver
-
ID No. 12162D

MERIT

**Outdoor Design:
Billboards – Single**

Art Director
Glen D'Souza
Writer
Michael Takasaki
Designer
Dr. Patrick Hickey
Agency Producers
Beth MacKinnon, Terri Vegso,
Liz Walker
Creative Directors
Mark Biernacki, Steph Mackie
Client
Warner Brothers
Pictures Canada
Agency
Lowe Roche/Toronto

ID No. 12163D

"Octopus", spaghetti and tomato sauce on wallpaper, Boris 2011

WMF would like to thank all the children for 125 years of unrestrained enjoyment. 125 years of children's cutlery from WMf

"Snail", chocolate syrup and cherry compote on wood floor, Emma 2011

WMF would like to thank all the children for 125 years of unrestrained enjoyment. 125 years of children's cutlery from WMf

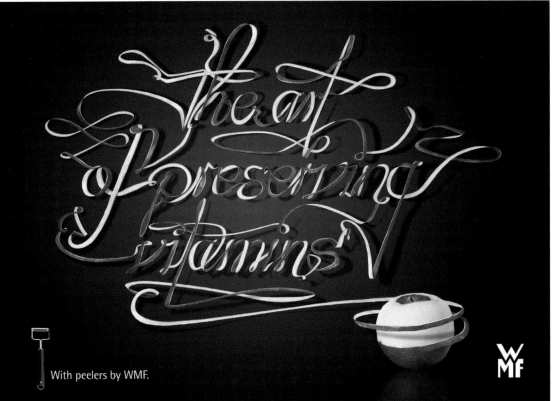

The art of preserving vitamins

With peelers by WMF.

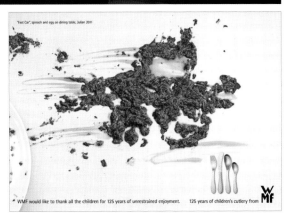

"Fast Car", spinach and egg on dining table, Julian 2011

WMF would like to thank all the children for 125 years of unrestrained enjoyment. 125 years of children's cutlery from WMf

MERIT

**Outdoor Design:
Billboards – Campaign**

Art Directors
Julian Heidt, Thomas Thiele
Writer
Dieter Kolaja
Designer
Julian Heidt
Creative Directors
Tim Krink, Ulrike Wegert
Client
WMF
Agency
KNSK Werbeagentur/
Hamburg
–
ID No. 12164D

MERIT

**Outdoor Design:
Billboards – Campaign**

Art Director
Soen Becker
Writers
Jan Hoffmeister, Tim Esser
Designer
David Soukup
Creative Directors
Markus Kremer,
Thomas Heyen,
Arno Lindemann,
Bernhard Lukas
Client
Mercedes-Benz Vans
Agency
Lukas Lindemann Rosinski/
Hamburg
—
ID No. 12165D

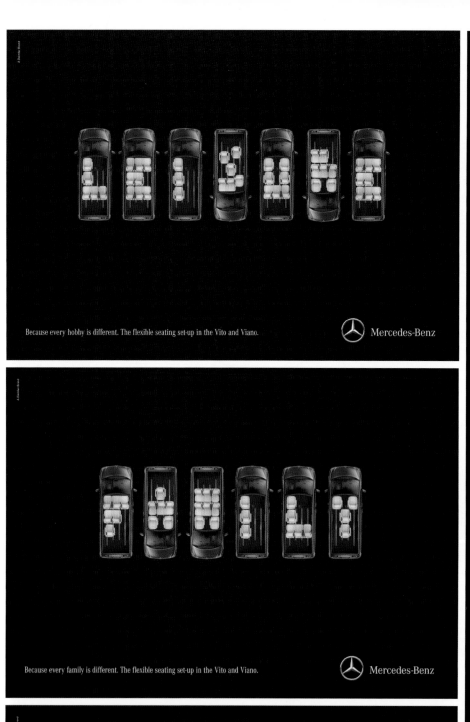

Because every hobby is different. The flexible seating set-up in the Vito and Viano.

Because every family is different. The flexible seating set-up in the Vito and Viano.

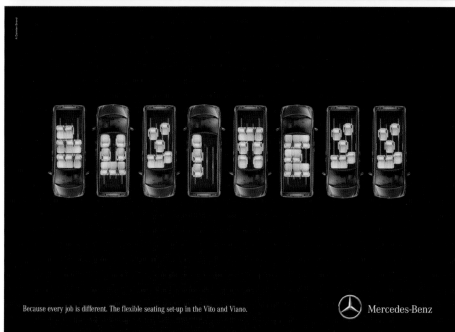

Because every job is different. The flexible seating set-up in the Vito and Viano.

MERIT

Outdoor Design:
Transit– Single

Art Director
Takeshi Iwamoto
Writer
Kei Oki
Photographers
Jun Matarai, Getty Images
Creative Director
Masayoshi Soeda
Client
Washin Optical
Agency
Grey/Tokyo
—
ID No. 12167D

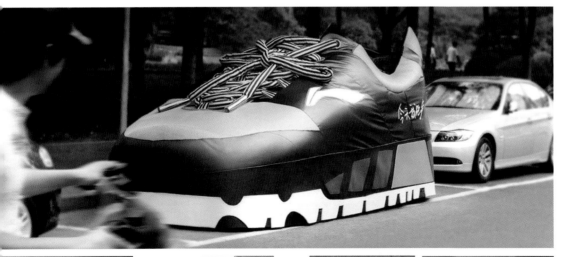

MERIT

Outdoor Design:
Transit– Single

Art Director
Ian Cai
Writers
Gordon Hughes,
Amanda Yang, Joy Zou
Photographers
Alan Chow, Andy Wee
Illustrator
Colin Lu
Agency Producer
William Huen
Creative Directors
Gordon Hughes, Fish Feng,
Amanda Yang
Client
Li Ning
Agency
Leo Burnett/Shanghai
—
ID No. 12168D

MERIT

Outdoor Design:
Transit – Single

Art Director
Kaan Beyhan
Writer
Uluc Cagri Kabatas
Creative Directors
Ilkay Gurpinar, Evren Dograr
Client
MINI
Agency
TBWA\İstanbul
–
ID No. 12171D

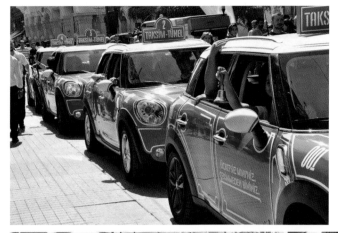

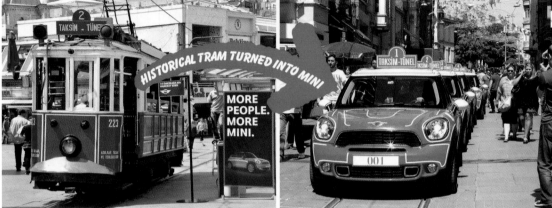

MERIT

Outdoor Design:
Transit – Single

Art Director
Mooren Bofill
Writer
Nick Asik
Agency Producer
Eileen Smith
Creative Directors
Zak Mroueh, Joseph Bonnici,
Mark Francolini
Client
Simply Orange
Agency
Zulu Alpha Kilo/Toronto
–
ID No. 12172D

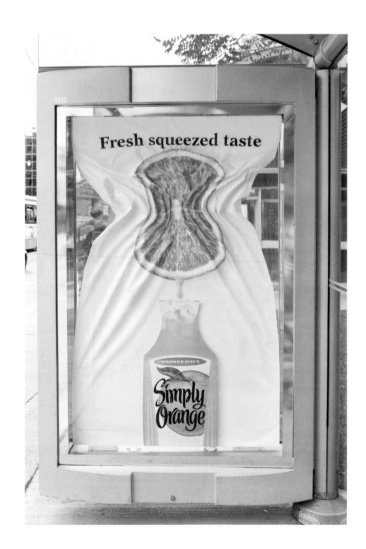

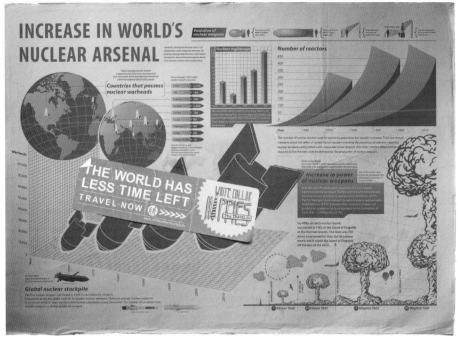

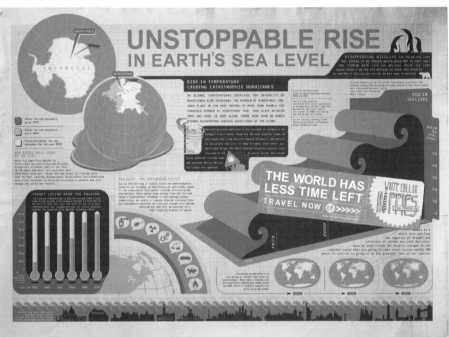

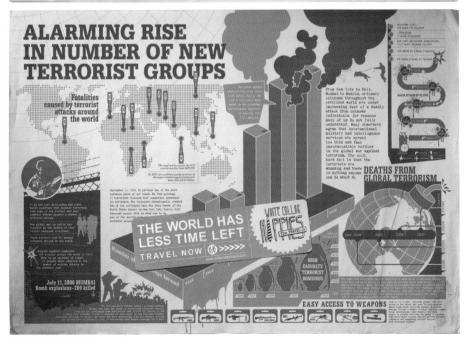

MERIT

**Outdoor Design:
Transit– Campaign**

Art Directors
Rajdeepak Das, Sandeep
Sawant, Manasi Sankhe
Writers
Yohan Daver, Rajdeepak Das,
Josy Paul
Photographer
Avadhut Hembade
Creative Directors
Josy Paul, Rajdeepak Das,
Sandeep Sawant
Client
White Collar Hippies
Agency
BBDO India/Mumbai
–
ID No. 12173D

MERIT

Outdoor Design:
Transit – Campaign

Art Director
Yasushi Arikawa
Writer
Masanori Tagaya
Photographer
Satoru Emoto
Creative Director
Masayoshi Soeda
Client
Washin Optical
Agency
Grey/G2/Tokyo
–
ID No. 12174D

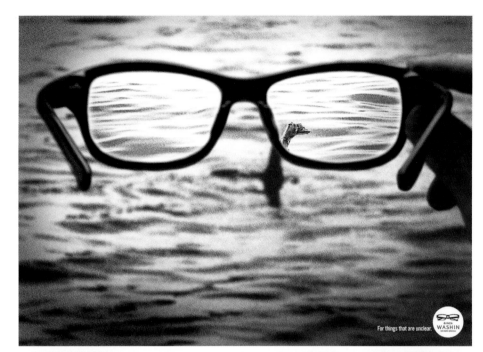

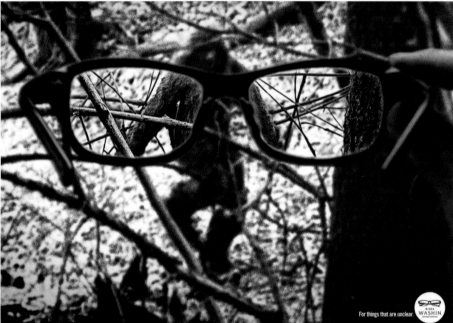

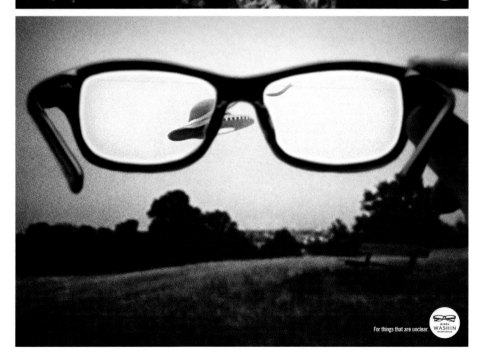

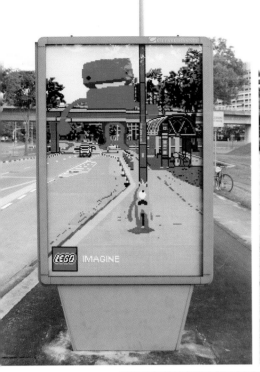
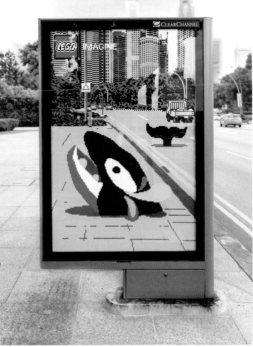

Merit

MERIT

**Outdoor Design:
Transit Campaign**

Art Directors
David Stevanov, Eric Yeo
Writers
Greg Rawson, Ross Fowler
Designers
Nicholas Foo, Jun Jie Too,
Inessa Loh, Darshan Kadam
Illustrators
Andrew Tan Tsun Wen,
David Stevanow, Greg Rawson
Creative Directors
Gavin Simpson,
Robert Gaxiola,
Eugene Cheong
Client
Lego Singapore
Agency
Ogilvy Malaysia/Kuala Lumpur

ID No. 12176D

Also Awarded:
Merit: Transit: Single

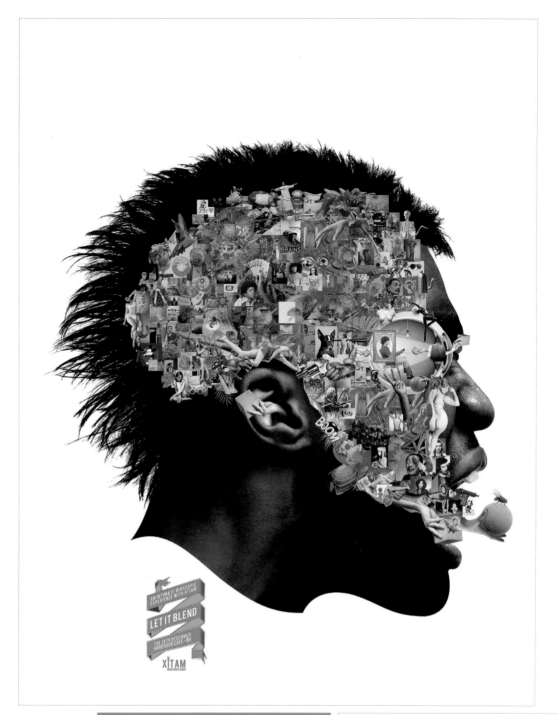

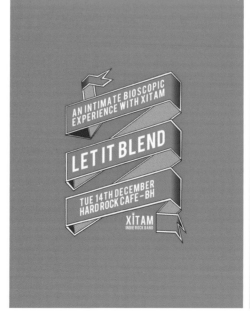

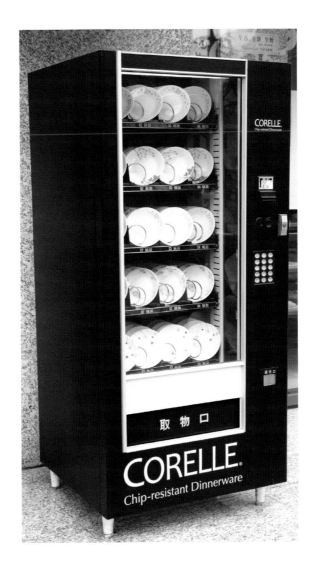

MERIT

Outdoor Design:
Street Furniture

Art Directors
Marx Zhu, David Yang,
Kevin Ji, Attlee Ku
Writers
Rocky Hao, Celia Zhang
Photographer
Feng Wang
Agency Producer
Betty Yu
Creative Directors
Cheeguan Yue, Attlee Ku,
Rocky Hao
Client
World Kitchen
Agency
Grey/China
-
ID No. 12178D

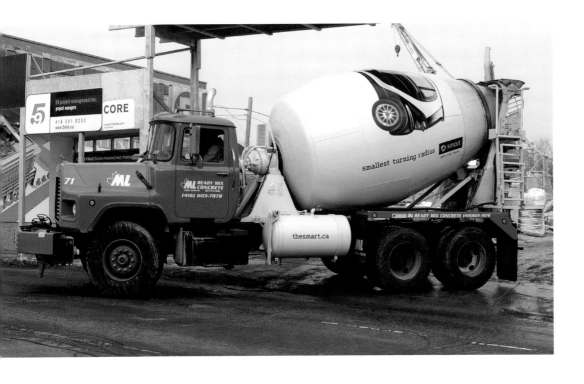

MERIT

Outdoor Design:
Street Furniture

Art Directors
Rene Rouleau,
Andrew Mowbray
Writer
Rene Rouleau
Photographer
Don Dixon
Creative Directors
John Gagne, Peter Ignazi,
Carlos Moreno, Rene Rouleau
Client
Smart Canada
Agency
Proximity Canada/BBDO/
Toronto
-
ID No. 12179D

MERIT

Outdoor Design:
Street Furniture

Writer
Mike Blackmore
Agency Producers
Ben Sharpe, Tara Greguric
Creative Directors
Lance Martin,
Jeff MacEchearn
Client
MINI Canada
Agency
TAXI Canada/Toronto
—
ID No. 12180D

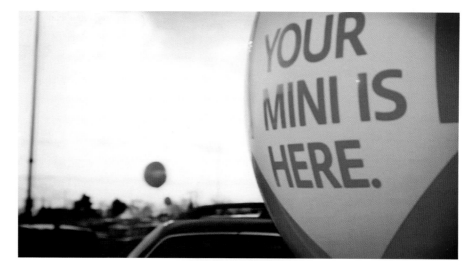

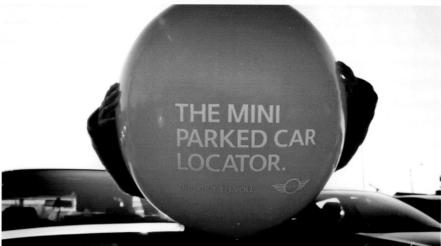

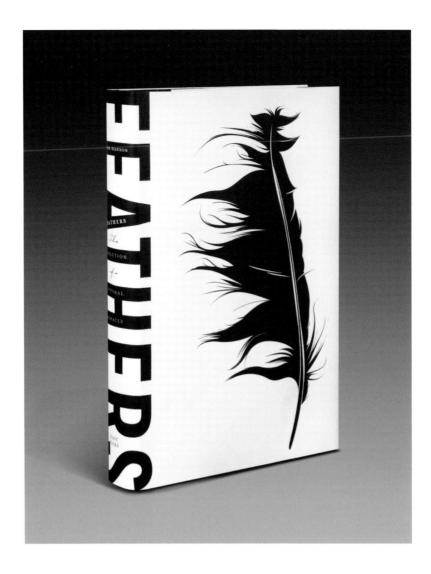

MERIT

**Publication Design:
Book Cover Design**

Art Director
Nicole Caputo
Client
Basic Books
Agency
Basic Books/Perseus Books
Group/New York
—
ID No. 12181D

MERIT

**Publication Design:
Book Cover Design**

Art Director
Alexander Norvilas
Writers
Marc Freitag, David Wegener,
Vicky Jacob-Ebbinghaus,
Stefan Golde, Estelle Raschka
Illustrators
Alexander Roetterink,
Reginald Wagner,
Julika Dittmers, Adam Bunte
Typographer
Jule Dittmers
Creative Directors
Doerte Spengler-Ahrens,
Jan Rexhausen, Felix Fenz
Client
ALIVE
Agencies
Jung von Matt /Hamburg,
Rocket & Wink
—
ID No. 12182D

**Publication Design:
Book Layout Design**

Art Directors
Andreas Kittel,
Gaioo Phunwut
Designer
Martin Bergstrom
Creative Director
Lisa Careborg
Client
Röhsska Museum
Agency
Happy Forsman ® Bodenfors/
Gothenburg
—
ID No. 12183D

MERIT

**Publication Design:
Book Layout Design**

Writers
Susan Credle, Alisa Wolfson,
Jason McKean,
David Schermer
Designers
Jason McKean, Kyle Poff,
Dan Forbes
Photographers
Luke Williams,
Natalia Kowaleczko,
Jason Frohlichstein,
Casey Martin,
Eing Omathikul,
Kine Ugelstad
Illustrators
Luke Williams,
Natalia Kowaleczko,
Jason Frohlichstein,
Casey Martin,
Eing Omathikul,
Kine Ugelstad
Creative Director
Alisa Wolfson
Client
Leo Burnett
Agency
Leo Burnett/Chicago
—
ID No. 12184D

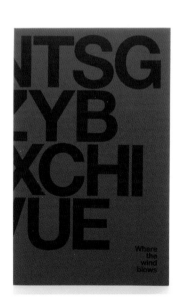

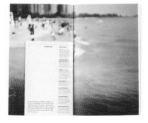

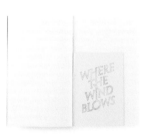

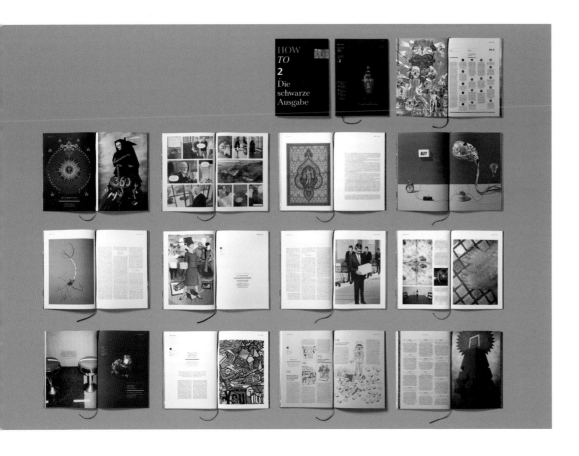

MERIT

Publication Design:
Magazine Layout Design

Art Directors
Catrin Farrenschon,
Helmut Meyer
Writers
Ogilvy, Various
Designer
Helmut Meyer
Photographers
Jo Bacherl, Oliver Blohm
Illustrators
Various Illustrators
Creative Directors
Helmut Meyer, Delle Krause
Client
Ogilvy Germany
Agency
Ogilvy Germany/Frankfurt
—
ID No. 12186D

MERIT

Direct Mail:
Single or Campaign

Writer
Samantha Koenderman
Designers
Kelda van Heerden,
Paul Hinch, Collette
Wasielewski, Ryan Wynn
Photographer
David Chancellor
Illustrator
Ello, Black Koki
Creative Director
Jean du Plessis
Client
Antalis
Agency
Grid Worldwide Branding
Design/Johannesburg
—
ID No. 12187D

MERIT

**Direct Mail:
Single or Campaign**

Art Directors
Hiroyuki Nakazato,
Takahiro Sakai
Client
KSC Corporation
Agency
I&S BBDO/Tokyo
–
ID No. 12188D

MERIT

**Direct Mail:
Single or Campaign**

Art Director
Noothan P.R
Writers
Niranjan Kaushik,
Amol Kulkarni
Designer
Noothan P.R
Photographer
Ajay Ram
Illustrator
Noothan P.R
Typographer
Noothan P.R
Creative Directors
Prasoon Joshi, Denzil
Machado, Niranjan Kaushik
Client
Young President Organization
Agency
McCann Worldgroup India/
Mumbai
–
ID No. 12189D

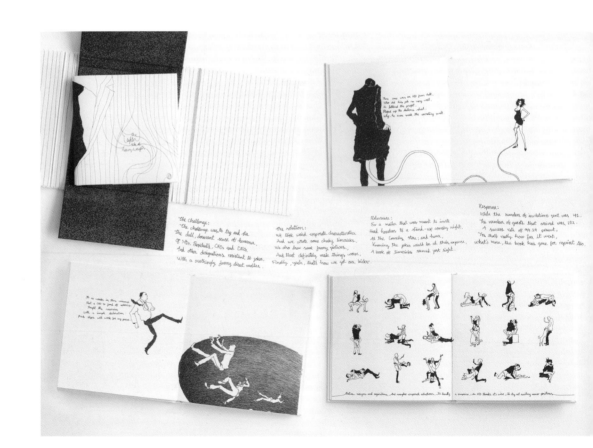

Every 28 years, calendars repeat themselves. That`s why we recycle this copy of 1984 and give it to you along with our very best wishes for 2012.

Ökopool is the green ad combination. Its three titles WoZ, Nebelspalter and Hochparterre reach 346,000 environmentally conscious people. A good reason not to wait for 28 years to book an ad. Kilian Gasser is looking forward to receiving your call: +41 43 810 83 63. www.oeko-pool.ch

ÖKOPOOL
THE GREEN ADPOOL.

A ROLLING STONES CALENDAR 1984

Every 28 years, calendars repeat themselves. That`s why we recycle this copy of 1984 and give it to you along with our very best wishes for 2012.

Ökopool is the green ad combination. Its three titles WoZ, Nebelspalter and Hochparterre reach 346,000 environmentally conscious people. A good reason not to wait for 28 years to book an ad. Kilian Gasser is looking forward to receiving your call: +41 43 810 83 63. www.oeko-pool.ch

ÖKOPOOL
THE GREEN ADPOOL.

MERIT

**Direct Mail:
Single or Campaign**

Art Director
Marcel Schlaefle
Writer
Andreas Hornung
Creative Directors
Markus Ruf, Danielle Lanz
Client
Oekopool
Agency
Ruf Lanz/Zurich
-
ID No. 12190D

Direct Mail:
Single or Campaign

Art Director
Wolfgang Nagel
Writer
Christoph Bohlender
Creative Directors
Alex Schill, Mike Rogers,
Wolfgang Nagel
Client
AOK-Bundesverband
Agency
Serviceplan/Munich
-
ID No. 12191D

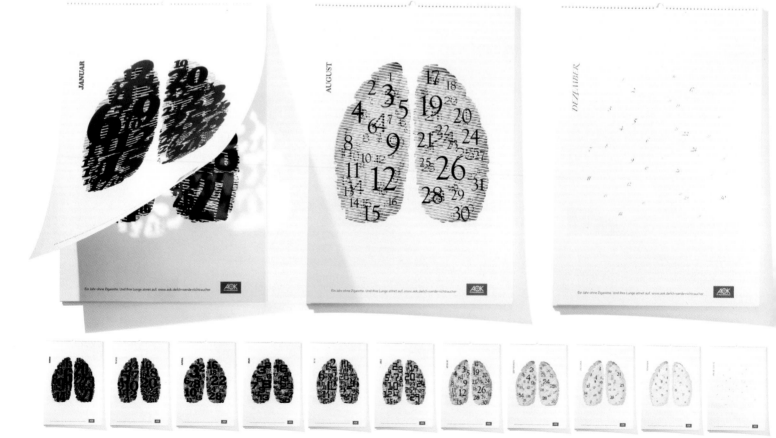

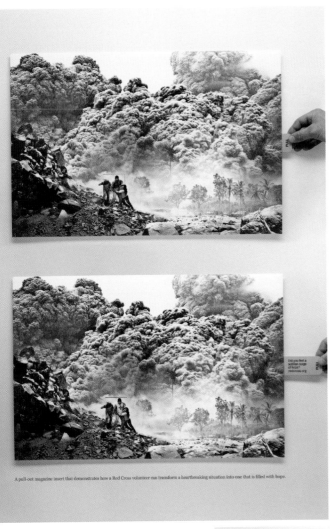

A pull-out magazine insert that demonstrates how a Red Cross volunteer can transform a heartbreaking situation into one that is filled with hope.

MERIT

**Direct Mail:
Single or Campaign**

Art Director
Kalpesh Patankar
Writer
Shahir Zag
Designer
Kalpesh Patankar
Photographer
David DeVeson
Creative Directors
Shahir Zag, Kalpesh Patankar
Client
Red Cross Lebanon
Agency
Y&R/Dubai
—
ID No. 12193D

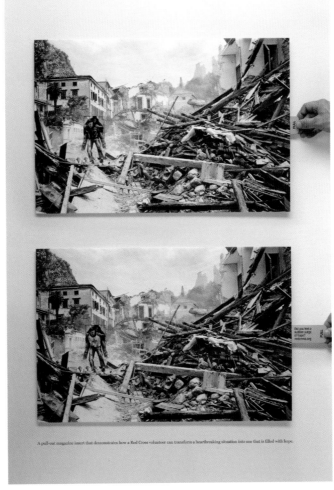

A pull-out magazine insert that demonstrates how a Red Cross volunteer can transform a heartbreaking situation into one that is filled with hope.

MERIT

**Direct Mail:
Single or Campaign**

Art Director
Kalpesh Patankar
Writer
Shahir Zag
Designer
Kalpesh Patankar
Photographer
David DeVeson
Creative Directors
Shahir Zag, Kalpesh Patankar
Client
Red Cross Lebanon
Agency
Y&R/Dubai
—
ID No. 12194D

MERIT

**Broadcast Design:
Single**

Art Director
Fabiano De Queiroz Tatu
Writer
Thiago Espeche
Agency Producer
Gisele Campos
Producer
Hilton Raw
Production Companies
Fat Bastards, Raw Audio,
Casablanca
Director
Pedro Becker
Creative Directors
Fabio Fernandes, Eduardo
Lima, Theo Rocha
Client
SESC_Videobrasil
Agency
F/Nazca Saatchi & Saatchi/
São Paulo
—
ID No. 12195D

MERIT

**Broadcast Design:
Single**

Art Directors
Bruno Luglio, Leif Johannsen
Production Company
Audioforce
Creative Directors
Marcell Francke,
Patrick Matthiensen
Client
Philharmoniker Hamburg
Agency
kempertrautmann/Hamburg
—
ID No. 12196D

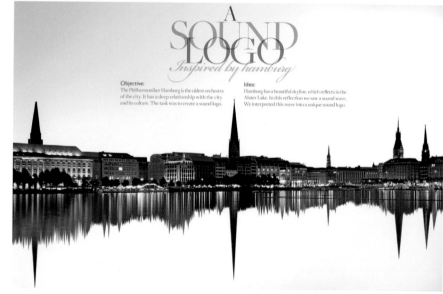

MERIT

**Broadcast Design:
Campaign**

Client
Sequoia
Agency
Marcel/Paris
—
ID No. 12197D

MERIT

MERIT

Broadcast Design:
Animation

Art Director
Kim Haxton
Writers
Nick Sonderup,
Ginger Robinson
Designer
Henry De Leon
Agency Producer
Jesse Brihn
Producers
Jennifer Sofio Hall,
Heather Johann
Production Company
Elastic
Director
Andy Hall
Creative Directors
David Lubars, Linda Honan
Client
American Red Cross
Agency
BBDO/New York
–

ID No. 12198D

MERIT

Broadcast Design:
Animation

Art Director
Nick Klinkert
Writers
Tom Kraemer,
Chris Beresford-Hill
Designers
Lauren Indovina,
Jon Saunders, Naomi Chen
Agency Producers
Amy Wertheimer, Rani Vaz
Producers
Lucia Grillo, Crystal Campbell,
Anu Nagaraj, Patrick Milling
Smith, Brian Carmody,
Lisa Rich, Allison Kunzman,
Laura Thoel, Donald Taylor
Production Companies
Psyop, Smuggler
Directors
Marco Spier, Marie Hyon
Creative Directors
David Lubars, Greg Hahn,
Mike Smith
Client
FedEx
Agency
BBDO/New York
–

ID No. 12199D

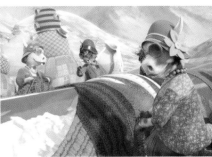

MERIT

**Broadcast Design:
Animation**

Art Director
Freda Raubenheimer
Writer
Jeanine Vermaak
Agency Producers
Bronwyn James,
Ananda Swanepoel
Production Companies
Black Ginger, Shy The Sun,
Cab Films
Creative Director
Pepe Marais
Client
Clover
Agency
Joe Public/Rivonia
-
ID No. 12200D

MERIT

**Broadcast Design:
Animation**

Art Director
Souen Le Van
Writer
Martin Rocaboy
Agency Producers
Pierre Marcus, Cleo Ferenczi
Producer
Herve Lopez
Director
Philippe Grammaticopoulos
Creative Directors
Sebastien Vacherot,
Anne De Maupeou,
Veronique Sels
Client
France 24
Agency
Marcel/Paris
-
ID No. 12201D

MERIT

Public Service:
Outdoor and Posters –
Single

Art Director
Jim Root
Writer
Sandy DerHovsepian
Illustrator
Christian Northeast
Creative Directors
Chris Jacobs, Chris Buhrman
Client
Penfield Children's Center
Agency
Cramer - Krasselt/Milwaukee
–

ID No. 12202D

MERIT

Public Service:
Outdoor and Posters –
Single

Art Director
Makarand Patil
Writer
Kartik Aiyar
Creative Directors
Makarand Patil, Kartik Aiyar,
Shehzad Yunus
Client
Committee of Organ Donation
in Lebanon
Agency
DDB/Dubai
–

ID No. 12203D

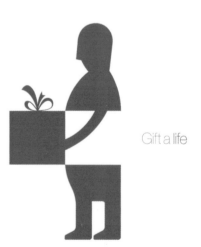

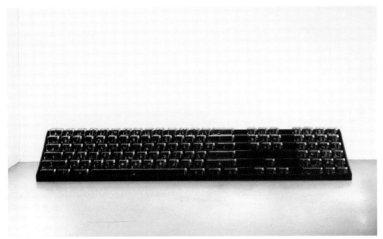

MERIT

**Public Service:
Outdoor and Posters –
Single**

Art Directors
Jody Xiong, William Zhang,
Jack Xuan
Writers
Leo Liu, Jody Xiong
Designer
Jody Xiong
Photographers
Nicholas Siau, King Zhang,
Alex Chen
Illustrator
Jody Xiong
Creative Directors
Michael Dee, Jody Xiong
Client
Family Care For Grassroots
Community
Agency
DDB China Group/Shanghai
—
ID No. 12204D

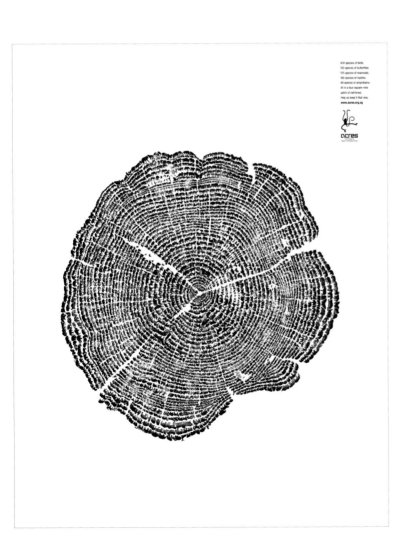

MERIT

**Public Service:
Outdoor and Posters –
Single**

Art Directors
Gary Lim, Aaron Koh
Writer
Khairul Mondzi
Illustrators
Gary Lim, Aaron Koh
Creative Directors
Neil Johnson, Joji Jacob,
Thomas Yang
Client
ACRES: Animal Concerns
Research & Education Society
Agency
DDB/Singapore
—
ID No. 12205D

MERIT

**Public Service:
Outdoor and Posters –
Single**

Designers
Eric Chan, Andries Lee
Photographer
Kitty Chan
Creative Director
Eric Chan
Client
CO-1 School of Visual Arts
Agency
Eric Chan Design/Hong Kong
—
ID No. 12206D

Also Awarded:
Merit: Typography in Design:
Single

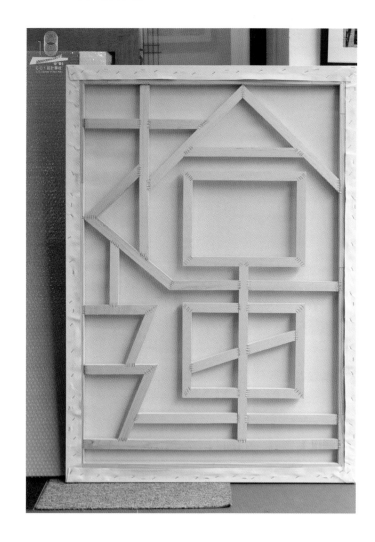

MERIT

**Public Service:
Outdoor and Posters –
Single**

Art Directors
Chris Valencius, Nick Spahr
Writer
Spencer Riviera
Illustrator
Rod Hunt
Creative Director
Erik Vervroegen
Client
Aides
Agency
Goodby, Silverstein
& Partners/San Francisco
—
ID No. 12207D

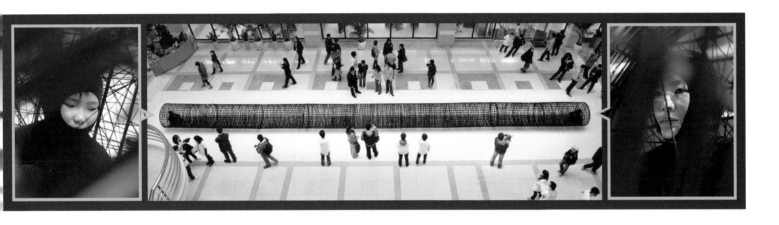

MERIT

**Public Service:
Outdoor and Posters –
Single**

Art Directors
Amanda Yang, Gordon
Hughes, Forest Young,
Handsome Wong, Ken Lee
Writers
Amanda Yang, Jason Su,
Dandan Lee
Designers
Forest Young, Ken Lee,
Bonny Sheng, Chengtao Mu
Photographers
Peter Wu, Jerry Lee
Illustrators
Colin Lu, Jun Xu, Fey Zhang
Creative Directors
Amanda Yang, Gordon
Hughes, Forest Young
Client
Shanghai QingCongQuan
Autism Foundation
Agency
Leo Burnett/Shanghai
–

ID No. 12208D

MERIT

**Public Service:
Outdoor and Posters –
Campaign**

Art Director
Koji Iyama
Designer
Koji Iyama
Client
Tokachi Poster Award
Executive Committee
Agency
iyamadesign/Tokyo
-
ID No. 12211D

MERIT

**Public Service:
Outdoor and Posters –
Campaign**

Art Director
Koji Iyama
Designer
Koji iyama
Client
Tokachi Poster Award
Executive Committee
Agency
iyamadesign/Tokyo
—

ID No. 12212D

MERIT

**Public Service:
Outdoor and Posters –
Campaign**

Art Director
Murilo Melo
Writer
Julio D'Alfonso
Typographer
Mario Niveo
Creative Director
Marcelo Reis
Client
Fiat
Agency
Leo Burnett Tailor Made/
São Paulo
–
ID No. 12213D

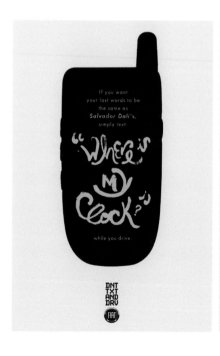

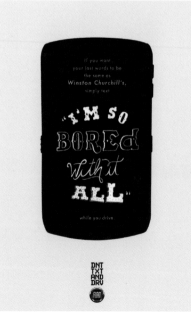

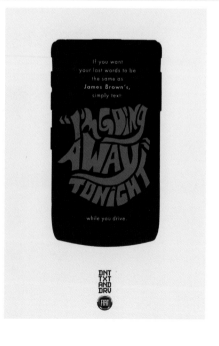

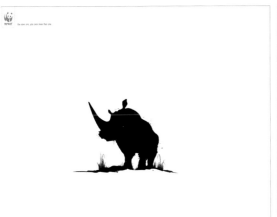

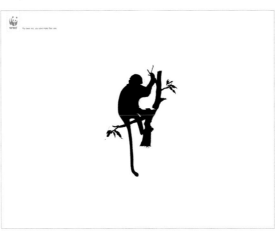

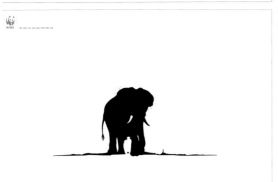

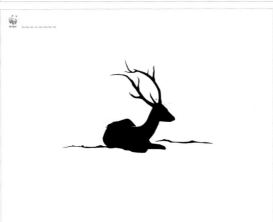

MERIT

Public Service:
Outdoor and Posters –
Campaign

Art Directors
Sheehij Kaul,
Shailender Mahajan
Writers
Ajay Gahlaut,
Suparv Chodmarda
Designer
Sheehij Kaul
Illustrator
Sheehij Kaul
Creative Directors
Ajay Gahlaut, Nitin Srivastava,
Shailender Mahajan,
Jossy Raphael
Client
WWF India
Agency
Ogilvy & Mather/New Delhi
—
ID No. 12214D

MERIT

Public Service:
Outdoor and Posters –
Campaign

Art Director
Waldemar Franca
Writer
Marcia Lima
Designer
Waldemar Franca
Illustrator
Waldemar Franca
Creative Directors
Waldemar Franca,
Marcia Lima
Client
Belo Horizonte City Hall
Agency
Perfil252/Belo Horizonte
–
ID No. 12215D

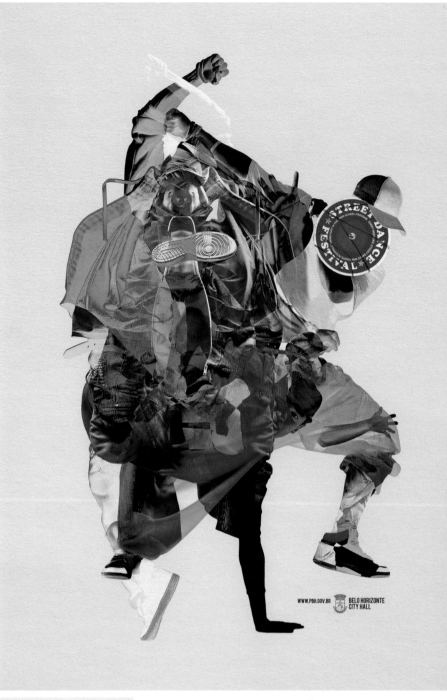

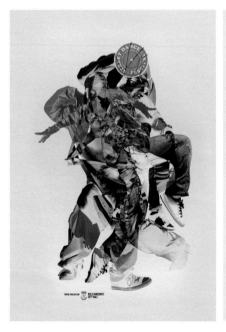

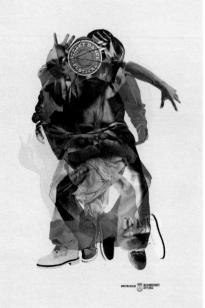

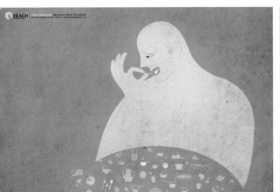
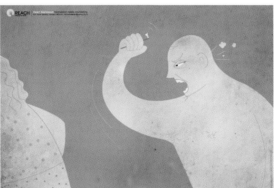
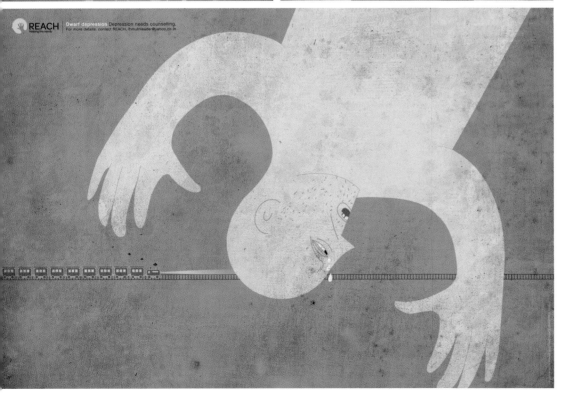

MERIT

**Public Service:
Outdoor and Posters –
Campaign**

Art Director
Shailesh Khandeparkar
Writer
Shailesh Khandeparkar
Designer
Shailesh Khandeparkar
Illustrator
Shailesh Khandeparkar
Creative Director
Shailesh Khandeparkar
Client
Loving Hand Ministries
Agency
Shailesh Khandeparkar/
Mumbai
–
ID No. 12216D

MERIT

Public Service:
Outdoor and Posters –
Campaign

Art Directors
Piti Pongrakananon, Sompat
Trisadikun, Paruj Daorai
Writers
Chatchai Butsabakorn,
Fuad Ahmad
Photographer
Chub Nokkaew
Creative Directors
Sompat Trisadikun,
Paruj Daorai,
Keeratie Chaimoungkalo
Client
Safeguard
Agency
Leo Burnett/Bangkok
—
ID No. 12217D

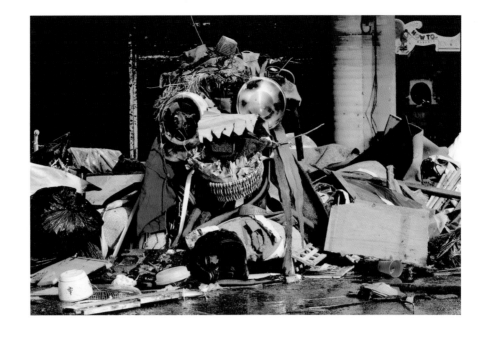

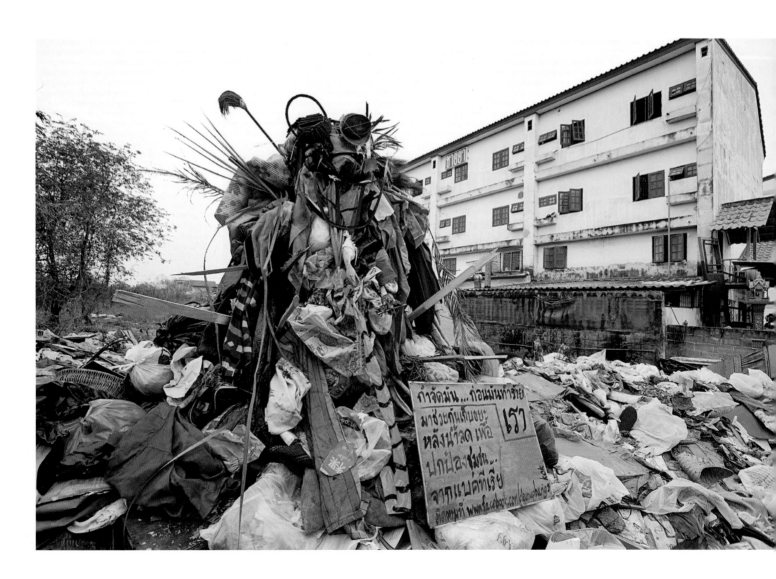

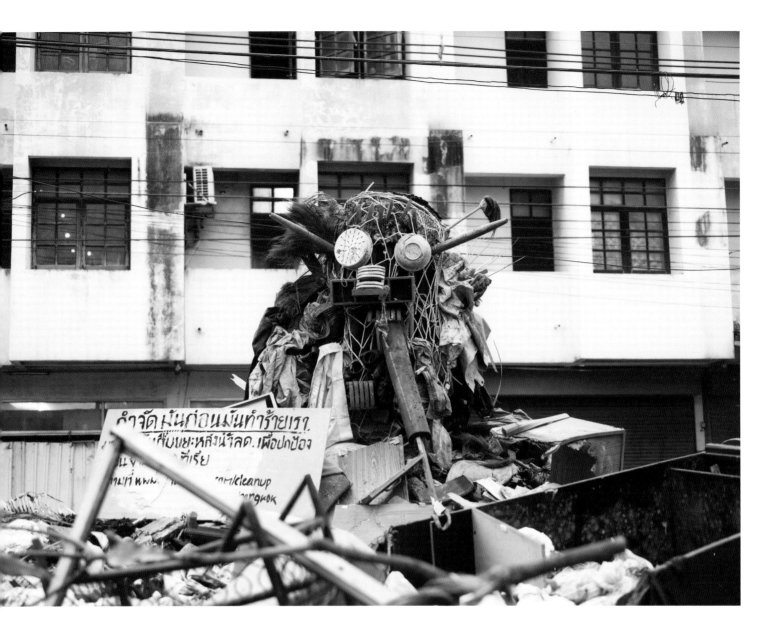

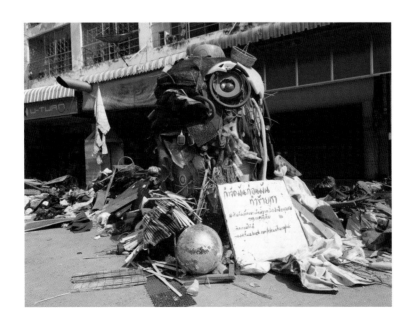

MERIT

Craft:
Typography In Design –
Single

Art Director
Ren Takaya
Designer
Ren Takaya
Typographer
Ren Takaya
Client
IWAI K.K. and Bihaku
Watanabe Company
Agency
AD&D/Tokyo
-
ID No. 12218D

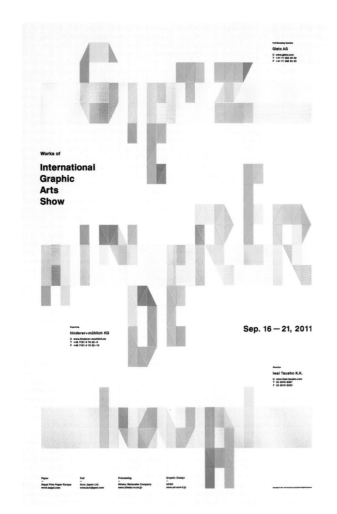

MERIT

Craft:
Typography In Design –
Single

Art Directors
Joel Chin, Elmy Thong
Writers
Neil Johnson, Pradeep
D'Souza
Agency Producers
Jackie They, Francis Tan,
Suhaimi Saadan, Sabrina Tan,
Yumei Ho
Creative Directors
Neil Johnson, Joji Jacob,
Joel Chin
Client
Penguin Books Singapore
Agency
DDB/Singapore
-
ID No. 12219D

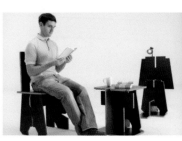

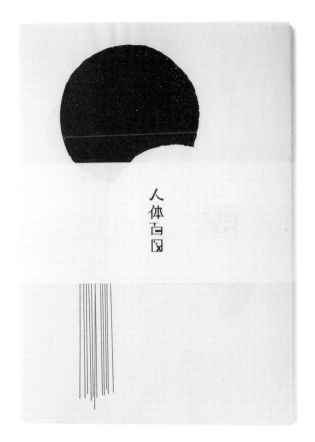

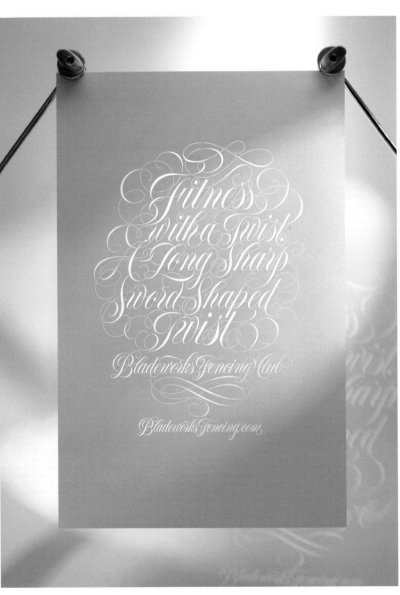

MERIT

Craft:
Typography In Design –
Single

Art Director
Daigo Daikoku
Designer
Daigo Daikoku
Illustrator
Daigo Daikoku
Typographer
Daigo Daikoku
Client
Gallery LETA
Agency
Nippon Design Center/Tokyo
–
ID No. 12221D

MERIT

Craft:
Typography In Design –
Single

Writer
Keri Zierler
Designer
Jeff Harrison
Typographer
Tony Di Spigna
Agency Producers
Kerry Bhangu,
Sheila Santa Barbara
Creative Directors
Ian Grais, Chris Staples
Client
Bladeworks Fencing Society
Agency
Rethink/Vancouver
–
ID No. 12222D

MERIT

Craft:
Typography In Design –
Campaign

Designer
Madelyn Lee
Creative Directors
Geoff Edwards, Mauro Alencar
Client
DOJO
Agency
DOJO/San Francisco
–
ID No. 12223D

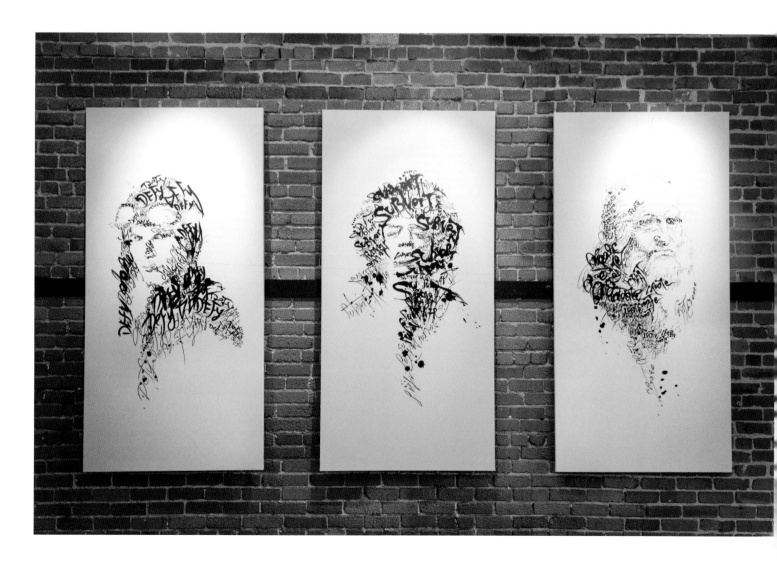

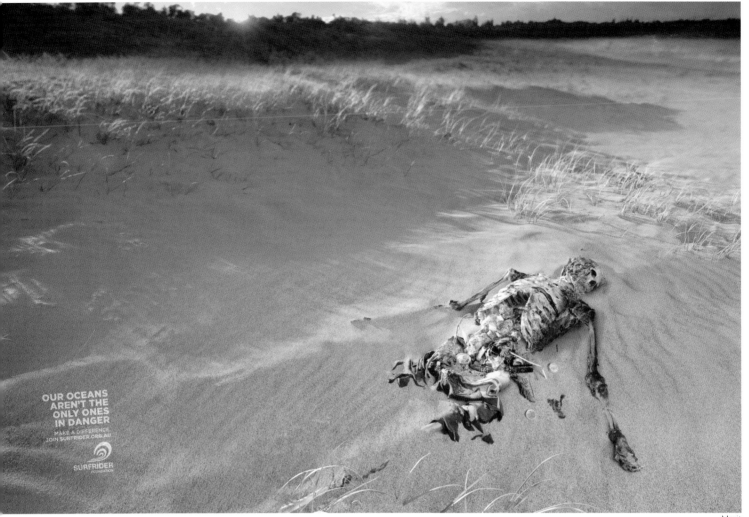

Merit

Merit

Merit

MERIT

Craft:
Photography In Design –
Campaign

Art Director
Brendan Donnelly
Writer
Guy Futcher
Photographer
Adam Taylor
Creative Directors
Andy DiLallo, Mark Harricks
Client
Surfrider Foundation
Agency
Leo Burnett/Millers Point
—
ID No. 12227D

Also Awarded:
Merit: Photography in Design:
Single; Merit: Photography in
Design: Single; Merit: Photog-
raphy in Design: Single

Craft:
Photography In Design –
Campaign

Art Directors
Will Marsden, Jordan Down
Writers
Will Marsden, Jordan Down
Designer
Andy Breese
Photographer
Tal Silverman
Illustrator
David Crofts
Creative Director
Gerry Human
Client
War Child
Agency
Ogilvy & Mather/London
—
ID No. 12228D

Also Awarded: Merit: Posters,
Single

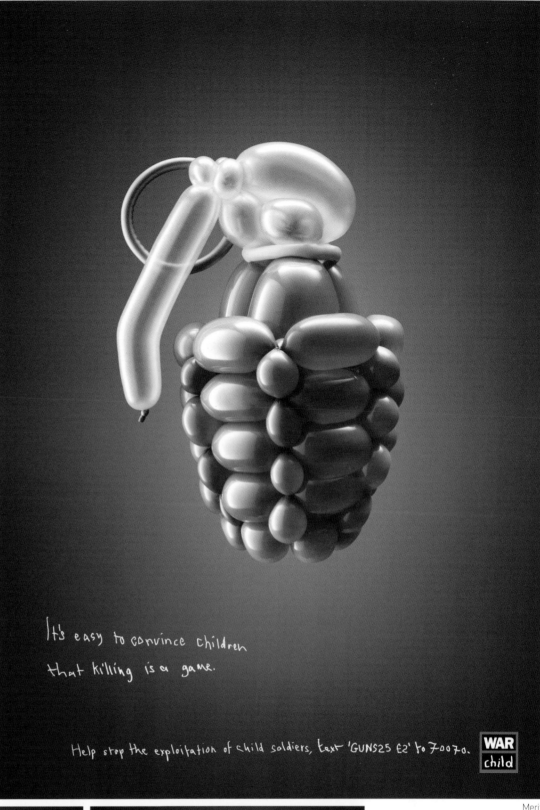

Merit

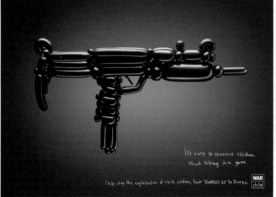

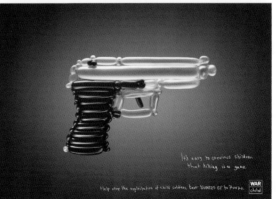

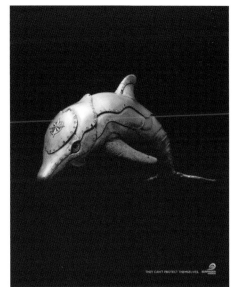

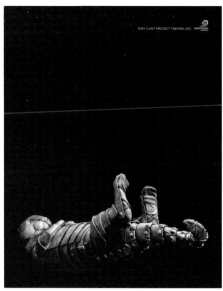

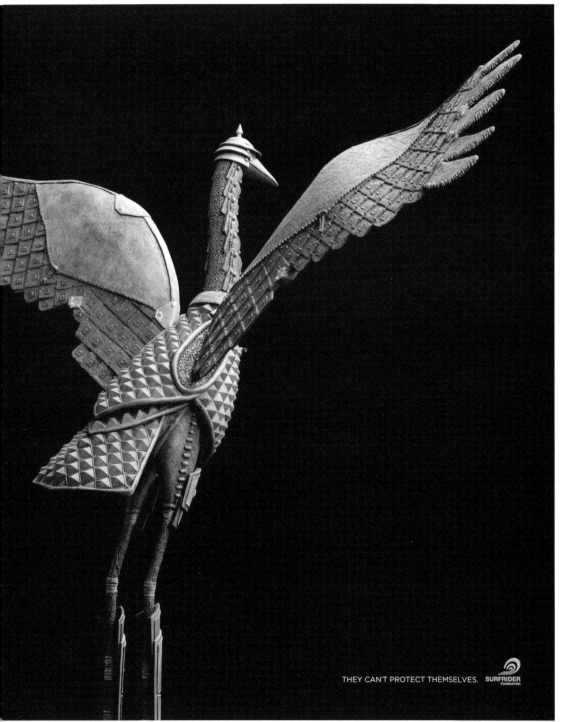

THEY CAN'T PROTECT THEMSELVES. **SURFRIDER** FOUNDATION

MERIT

Craft:
Photography In Design –
Campaign

Art Directors
Juan Bobillo, Erek Vinluan,
Joshua Gilman
Writers
Raymond Hwang
Designer
Joel Francke
Photographers
Mark Laita, Matt Cobleigh
Agency Producers
Tanya LeSieur, Melissa Eccles,
Matthew Kinney,
Gil DeCuir, Jayme Graham,
Jen Vogtmann, Callan Koenig
Production Company
Stopp LA
Creative Directors
Mike McKay, Margaret Keene,
Chris Adams
Client
Surfrider Foundation
Agency
Saatchi & Saatchi LA/
Torrance
–
ID No. 12229D

Craft:
**Photography In Design –
Campaign**

Art Director
Guilherme Racz
Writer
Lucas Casao
Photographer
Brandon Vogues
Creative Directors
Rui Branquinho,
Flavio Casarotti,
Sergio Fonseca
Client
Santa Casa de Misericordia
de Sao Paulo
Agency
Y&R/São Paulo
—

ID No. 12230D

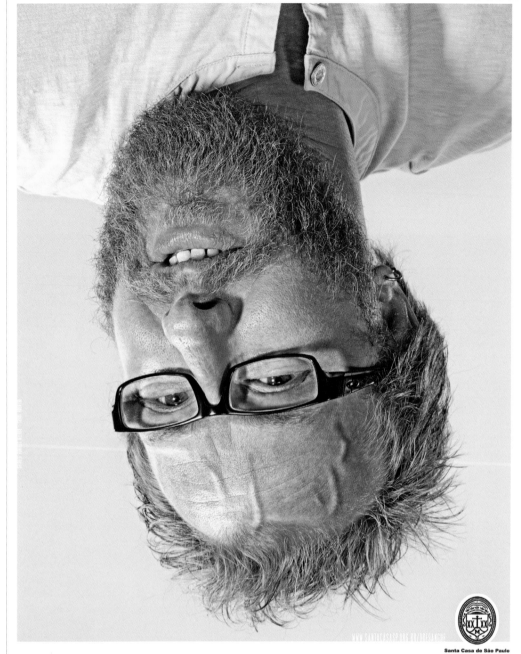

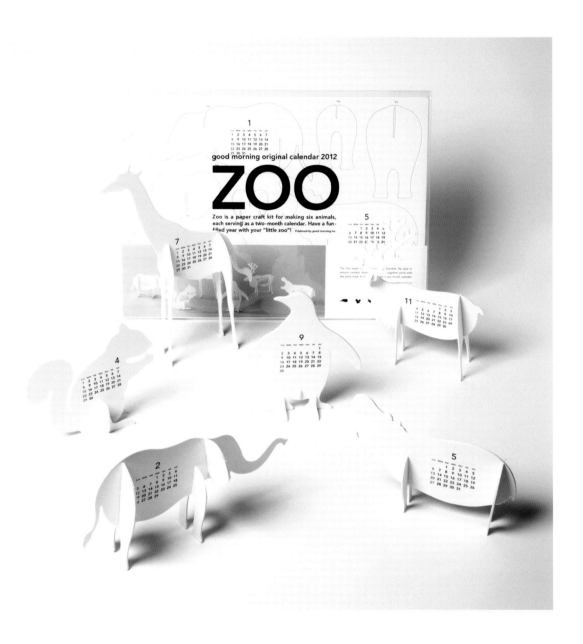

MERIT

Craft:
Printing and Paper Craft
– Single

Art Director
Katsumi Tamura
Writer
Toshiyuki Nagamatsu
Designers
Hiroyuki Fukazu,
Kohei Miyasaka,
Takahiro Sugawara
Client
good morning
Agency
good morning/Tokyo
—
ID No. 12231D

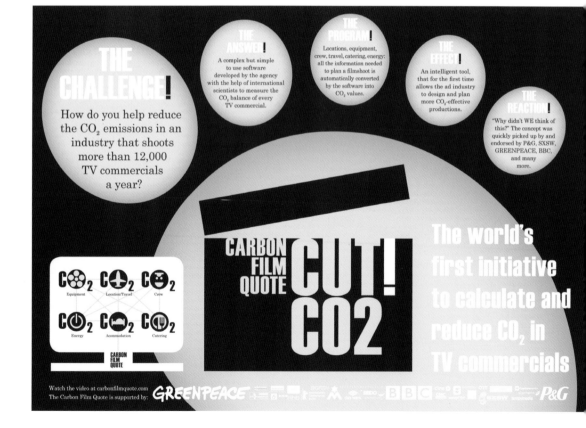

MERIT

Sustainability In Design

Art Directors
Christian Doering,
Christine Knies
Writers
Thomas Voelker, Till Felber
Photographers
Robin Kranz, Ulrike Kirmse
Creative Director
Katrin Oeding
Client
T.D.G. Vertriebs
Agency
Kolle Rebbe/KOREFE/
Hamburg
—
ID No. I2234D

Agencies

Art Directors

A/B

Abraham, George: 49
Acharekar, Mandar: 122
Acret, Luke: 129
Allard, Isabelle: 103
Ang, Pauline: 125
Annandono, Anthony: 106
Arai, Yasuhide: 132
Arikawa, Yasushi: 168
Bakalkar, Purva: 128
Becker, Soen: 164
Belanger, Richard: 103
Berg, Ken: 27
Beyhan, Kaan: 166
Blom, Lizali: 77
Bobillo, Juan: 203
Boer, Danilo: 155
Bofill, Mooren: 166
Bond, Mike: 87
Brown, Dave: 82
Budden, Johnny: 62

C

Cai, Ian: 165
Caldeira, Dulcidio: 68, 95
Caputo, Nicole: 173
Castellari, Rodrigo: 69
Chan, Wendy: 46
Chanana, Rishi: 21, 154
Chapdelaine, Louis: 103
Chee Wee, Choo: 125
Chelvanathan, Anthony: 78, 131
Chen, Linus: 111
Chin, Joel: 198
Cordova, Rolando: 74
Cueto, Ron: 24

D

D'Souza, Glen: 162
Daikoku, Daigo: 199
Daorai, Paruj: 196
Darji, Manish: 38
Das, Rajdeepak: 167
Deb, Manoj: 105
Deer, Adam: 135
Deland, Sebastien: 39
Demary, Gisela: 155
De Queiroz Tatu, Fabiano: 180
de Torres, Carl: 62
Do, Dang Thuong: 144
Doering, Christian: 207
Donnelly, Brendan: 201
Down, Jordan: 202

F/G

Faria, Andre: 68, 95
Farrenschon, Catrin: 175
Federico, David: 24
Flango, Kristi: 109
Fotheringham, Sarah: 33
Franca, Waldemar: 170, 194
Frey, Annika: 15
Frodlund, Mattias: 102
Frost, Matthaeus: 10, 14, 86, 92
Furby, Jay: 144
Galinato, BJ: 144
Gebhardt, Rene: 31, 55, 92, 94
Gillespie, Addie: 161
Gilman, Joshua: 203

Goh, Jerry: 67
Gola, Andre: 79
Goldman, Dominic: 71
Good, Brendan: 24
Groffy, Regina: 206

H/I

Haefele, Mark: 72
Harris, Joe: 144
Hashimoto, Takahisa: 37
Haxton, Kim: 182
Hedde, Antje: 63
Heidt, Julian: 163
Hejduk, Ken: 81
Hill, Joe: 45, 94
Hillier, Liam: 129
Huang, Micky: 62
Hughes, Gordon: 189
Iwamoto, Takeshi: 40, 149, 165
Iyama, Koji: 56, 57, 160, 190, 191
Izique, Pedro: 150

J/K

Ji, Kevin: 171
Johannsen, Leif: 104, 180
Kamp, Sebastian: 55, 94
Karlsson, Niklas: 53
Kaul, Sheehij: 193
Kenney, Matthew: 24
Kernspeckt, Bjoern: 31, 55, 92, 94
Ketzer, Guga: 68, 95
Khandeparkar, Shailesh: 195
Kieneke, Veronika: 127
Kim, Derek: 27
Kim, Jinhi: 31, 92
Kirchner, Katja: 15
Kittel, Andreas: 184
Klinkert, Nick: 172
Knies, Christine: 207
Koh, Aaron: 187
Kothlar, Marcos: 84
Ku, Attlee: 171
Kunduracioglu, Burak: 48
Kureshi, Hanif: 33

L

Labun, Paul: 60
Lakshman, Latheesh: 33
La Mosca: 62
Leder, Scott: 24, 36
Lee, Ken: 189
Lee, Mike: 147
Lefebure, Pum: 157
Le Van, Souen: 183
Lim, Claire: 124
Lim, Gary: 187
Lim, Jeremy: 144
Lim, Pann: 124
Lin, Michael: 105, 113
Linneu, Joao: 47
Loncar, Mario: 85
Lopez, Andres: 161
Luglio, Bruno: 104, 180
Lukowski, Roman-Geoffrey: 158

M

Machado, Diego: 150
Macias, Leo: 41
Mahajan, Shailender: 193
Manzi, Daniel: 75
Marsden, Will: 202
Matsumoto, Kenichi: 149
McCracken, Todd: 144
Medeiros, Marcos: 84
Melo, Murilo: 192
Meyer, Helmut: 175
Mitani, Ken: 153

Moeller, Veit: 85
Mokutani, Yoshinari: 143
Moncayo, Andres: 130
Mora, Daniel: 161
Morelli, Mike: 24
Mowbray, Andrew: 171
Murphy, Dom: 27

N/O/P

Nakamura, Lisa: 115
Nakazato, Hiroyuki: 176
Nelson, Ant: 87
Ng, Fan: 46
Nieuwenhuizen, Ross: 122
Nishiyama, Masaki: 137
Nojiri, Daisaku: 101
Northam, Chris: 140
Norvilas, Alexander: 173
Offenberg, Eva: 54
Onufszak, Sebastian: 62
Oppido, Bruno: 47, 65, 70
P.R, Noothan: 176
Pandya, Viral: 22, 105
Park, Kum-jun: 44, 66
Patankar, Kalpesh: 179
Patil, Makarand: 20, 28, 92, 186
Pau, Irene: 115
Phunwut, Gaioo: 174
Pongrakananon, Piti: 196

R

Racz, Guilherme: 204
Raubenheimer, Freda: 183
Reissner, Lisa: 145
Ribeiro, Marcos: 62
Riffelmacher, Johannes: 32
Rioux, Marc-Andre: 103
Robitaille, Daniel: 18, 58, 146
Rocky: 33
Root, Jim: 186
Rouleau, Rene: 171
Rozenberg, Renato: 62
Ruano, Camilo: 161
Rubeiro, Bruno: 150
Rukhavibul, Tienchutha: 50, 95
Rutledge, Zak: 104

S

Sagmeister, Stefan: 64
Sakai, Takahiro: 176
Salqgueiro, Bruno: 41
Sankhe, Manasi: 167
Sano, Kenjiro: 100, 130
Santos Silvestrin, Fernando: 43
Sattler, Loic: 31, 92
Sawant, Sandeep: 167
Schlaefle, Marcel: 177
Schlosser, Katja: 60
Schroeder, Merle: 159
Sethumadhavan, Satish: 156
Shigetomi, Kenichiro: 34
Shintaku, Mussashi: 62
Sievers, Petra: 206
Smith, James: 72
Soh, Leng: 111
Sousa, Vinicius: 75
Spahr, Nick: 188
Stevanov, David: 61, 169
Suzuki, Katsuhiko: 123
Szymanski, Jakub: 129

T

Takahashi, Todd: 76
Takaya, Ren: 198
Tamura, Katsumi: 205
Tanapatanakul, Thirasak: 50, 95
Thiele, Thomas: 163

Thomsett, Mia: 161
Thong, Elmy: 198
Tito Majumdar, Basab: 151
Todoca, Ramona: 62
Tomkins, Sid: 62
Trefzger, Petra: 54
Trisadikun, Sompat: 196
Tsuboi, Hironao: 37
Tyler, Steven: 148

U/V/W

Uchida, Yoshiki: 152
Ueda, Ryo: 35
Valencius, Chris: 188
Van Oosterhout, Chris: 62
van Rooijen, Frank: 72
Verma, Preeti: 156
Vinluan, Erek: 203
von Ende, Chris: 141
Wagner, Andreas: 145
Wagner, Reginald: 63
Walsh, Jessica: 116
Wenjun, Zhou: 26
West, Martin: 59
Wigle, Carlos: 136
Wolff, Manuel: 43
Wolfgang Nagel: 178
Wong, Handsome: 189
Wright, Tom: 157

X/Y/Z

Xiong, Jody: 187
Xuan, Jack: 187
Yadav, Siddhi: 128
Yagi, Yoshihiro: 30, 42, 93, 110, 138, 139
Yang, Amanda: 189
Yang, David: 171
Ye, Ocean: 46
Yeo, Eric: 61, 169
Young, Forest: 189
Yu, Kobe: 46
Zhang, William: 187
Zhu, Marx: 171

Clients

–

524 Architecture: 26

–

A

ACRES: Animal Concerns Research
& Education Society: 187
Advanced Ice Cream Technologies:
23, 112
Aides: 188
Alive: 173
American Red Cross: 182
Antalis: 175
AOK – Bundesverband: 178
Apotek Hjärtat: 108
Apple: 133
Art Director's Club: 136
ASOS: 71
Atelia Corporation/Hong Kong: 119
Australian Football League: 140
Austria Solar: 10, 14, 86, 92

–

B

B: 126
Basic Books: 173
BBDO/Germany: 206
BEKO: 48
Belkin: 121
Billboard Brasil: 84
BirdLife: 148
Bladeworks Fencing Society: 199
BMW: 64, 83
Boh Plantation: 125
British American Tobacco/Japan: 37
Browsing Copy Project, The: 17
BSH Deutschland: 85
Bumba, Aldor: 130

–

C

Caran d'Ache: 60
Casa do Zezinho: 75
Closed: 127
Clover: 183
CO–1 School of Visual Arts: 188
Coca–Cola: 141
Coca–Cola South Pacific / Coca–Cola
Amatil Team: 129
Colston Julian: 122
Committee of Organ Donation
in Lebanon: 20, 28, 92, 186
Converse EMEA: 53

–

D/E

D&AD: 80
Daimler/smart: 155
DC Comics: 105
DC Entertainment: 113
Deutsche Bank: 54
Diageo/Guinness: 155
Dogwood Initiative: 76
DOJO: 200
Domison: 146
East Japan Railway Company: 139
ECOtality: 25
EDP: 116
Elections Ontario: 24
Endangered Wildlife Trust (EWT): 77
Escola Panamericana de Arte e Design:
79
Expedia: 135

–

F/G

Family Care For Grassroots
Community: 187
FedEx: 182
Fiat: 192
Fisher & Paykel: 107
France 24: 183
Fresh N Friends: 31, 92
Gallery Leta: 199
GE: 87
General Insurance Association
of Singapore (GIA): 16
Gerstenberg Verlag: 63
Gold's Gym: 39
good morning: 205
Grid, The: 115
Grill Burger Club Sasa Grill Burger
Club SASA: 149
Gruner + Jahr/Flora Garten: 51
Gruner + Jahr/National Geographic:
159

–

H/I/K

Hakuhodo+Design Project: 123
Heiwa Paper: 137
Hinz & Kunzt: 206
Holycrap.sg: 124
Hopi Hari: 41
IBM: 62
Imagine: 154
IndiGo Airlines: 33
IWAI K.K. and Bihaku Watanabe
Company: 198
Kamoi Kakoshi: 56, 57, 160
KDDI Corporation: 101
Khalid Javed: 29
Kobrick Coffee Co: 117
Koyama Kanamono: 152
KSC Corporation: 176
KT&G Sangsangmadang: 44, 66

–

L

Lego Singapore: 61, 169
Leica: 47
LemonAid Beverages: 15
Leo Burnett: 174
Leo Burnett, Toronto: 36
Levi Strauss: 96, 120
Li Ning: 165
Lifestyle: 49
Liljevalchs: 102
Loving Hand Ministries: 195

–

M

Magazine Luiza: 150
Maison Gerard: 123
Marmite: 134
Mattel : 161
Mattel Germany: 145
McCord Museum: 103
McDonald's Restaurants of Canada: 161
Menicon: 110, 30
Mercedes–Benz Vans: 164
MINI: 74, 166, 172
Mission Design: 18
MK: 72
MKV Household Products: 21
Mr Cook: 118
MR DESIGN: 130
MTV: 106
MTV Brasil: 68, 95

–

N/O/P

National Arts Council: 19
Neenah Paper: 157
Neon Sound: 111
Nike: 69
Ninseikan Karate School: 40, 149
Oekopool: 177
OFFF Festival: 73
Ogilvy Germany: 175
Open Doors Academy: 81
Oude Meester Brandy: 122
P&G: 46
Panasonic Corporation: 100
Penfield Children's Center: 186
Penguin Books Singapore: 198
Perfeti Van Melle India: 128
Philharmoniker Hamburg: 104, 180
Pinacoteca: 65, 70
Prefeitura de Belo Horizonte (Belo
Horizonte City Hall): 194
Procter & Gamble – Bounty: 131

–

R

Raising The Roof: 78
Red Cross Lebanon: 179
Rembrandt Law Company : 105
Resolute – Forest Products: 103
Rhythm for a Reason: 104
Ribbonesia: 35
Ricola: 32
Röhsska Museum: 174

–

S

Safeguard: 196
Saks Fifth Avenue: 59
Santa Casa de Misericordia
de São Paulo: 204
Scott Holding: 45, 94
SDC du village / Aires libres : 58
Sephora & Firmenich: 52, 94
Sequoia: 181
Serviceplan Hamburg: 43
SESC Videobrasil: 180
Shanghai QingCongQuan
Autism Foundation: 189
Sherry: 109
Showtime: 142
Siam Tamiya: 50, 95
Siemens Electrogeräte: 55, 94
Simply Orange: 166
SLOW (Sustainable Lifestyle
& Organic Work): 89
smart Canada: 171
Soliance Pharma Products: 151
Surfrider Foundation: 201, 203
Swedish Institute: 114

–

T

T.D.G. Vertriebs: 207
Tamiya: 144
TedX: 27
Tenth Caller: 106
Tokachi Poster Award Executive
Committee: 190, 191

–

U/V/W/Y

Umino Seaweed Store: 34
Underscore: 67
UNICEF : 82
Unilever Pty: 88
Union Bank of India: 156
UPDN Broking: 22
Volkswagen: 38
Volkswagen: 158
War Child: 202
Warner Brothers Pictures Canada: 162
Washin Optical: 153, 165, 168
White Collar Hippies: 167
WMF: 163
World kitchen : 171
WVRST: 147
WWF India: 193
Xitam: 170
Yamahei Shoten: 143
Yoshida Hideo Memorial Foundation:
42, 93, 138
Young President Organisation: 176
Yueni: 132

Creative Directors

Designers

A/B

Adachi, Asuka: 101
Akado, Yoshiko: 56, 160
Allard, Isabelle: 103
Ang, Cara: 19
Annandono, Anthony: 106
Arai, Yasuhide: 132
Badger, Lucas: 157
Baron, Andy: 25
Bergstrom, Martin: 174
Boer, Danilo: 155
Breese, Andy: 202
Buerger, Manuel: 64
Bunyalumlerk, Sermpan: 50, 95

C

Chan, Eric: 188
Chan, Mandy: 119
Chanana, Rishi: 21, 154
Chantha, Simson: 109
Chapdelaine, Louis: 103
Charlebois-Zariffa, Karim: 64
Chau, Janson: 107
Chen, Linus: 111
Chen, Naomi: 182
Cheung, Ray: 89
Chia, Eric: 71
Chiang, May: 19
Chittiporn, Chittapootti: 50, 95
Cho, Wendy: 118
Codhadu, Sandesh: 144

D/E/F

Daikoku, Daigo: 199
Darji, Manish: 38
De Leon, Henry: 182
Denekas, Steve: 27
Duchaine, Chris: 24
Duffney, Craig: 155
Ebner, Patricia: 126
Edwards, Aaron: 107
Elbaz, Stephane: 116
Favacho, Raimundo: 126
Ferat, Serhat: 114
Foo, Nicholas: 61, 169
Forbes, Dan: 174
Franca, Waldemar: 170, 194
Francke, Joel: 203
Frediani, Michael: 27
Freimuth, Michael: 116
Fukazu, Hiroyuki: 205

G/H

Gadkar, Alok: 29
Garcia, Xavi: 116
Gordon, Lia: 23, 112
Greet, Christian: 144
Grolman, Aletta: 43
Grover, Prachi: 22
Hall, Tosh: 23, 112
Hammarberg, Martin: 53
Harrison, Jeff: 115, 199
Hatakeyama, Daisuke: 139
Heidt, Julian: 163
Hendricks, Andy: 81
Hergert, Peiter: 27
Hickey, Dr. Patrick: 162
Higa, Ayano: 30, 110
Hinch, Paul: 175
Hirano, Kotaro: 123
Hollowood, Sarah: 27
Huen, Jeremy: 119
Hull, Britt: 96, 120

I/J/K

Iimura, Takuya: 138
Imafuji, Kiyoshi: 37
Imjai, Manasit: 50, 95
Indovina, Lauren: 182
Iwamoto, Naohiro: 35
Iyama, Koji: 56, 190, 191
Jakschik, Lars: 32
Jayamaha, Priyan: 144
Kadam, Darshan: 61, 169
Kaul, Sheehij: 193
Khandeparkar, Shailesh: 195
Kieneke, Veronika: 127
Kimura, Takanori: 37
Klijn, Marko: 144
Kobayashi, Rumiko: 139
Koo, Bon-hae: 66
Kovacovsky, Martin: 105, 113
Kreuser, Carla: 88

L/M

Leder, Scott: 24, 36
Lee, Andries: 188
Lee, Ken: 189
Lee, Madelyn: 200
Lee, Mike: 147
Lee, Weicong: 16
Loh, Inessa: 61, 169
Lui, Justin: 52, 94
Ma, Tracy: 24
Manferdini, Elena: 52, 94
Marshall, Miles: 80
Matsumoto, Kenichi: 149
Matsumoto, Ryo: 137
Mattson, Ty: 142
McGoram, Chevy: 144
McKean, Jason: 174
Meyer, Helmut: 175
Michel, Arne: 54
Minn, Jessica: 105, 113
Miyasaka, Kohei: 205
Moe, Hanna: 102
Mokutani, Yoshinari: 143
Moran, Lis: 27
Mu, Chengtao: 189
Munkongcharoen, Kingkanok: 50, 95
Murakami, Masashi: 100, 130

N/P/R

Noesel, Mathias: 10, 14, 86, 92
Nord, Karl: 53
Omathikul, Eing: 141
Otsuka, Minami: 42, 93, 138
P.R., Noothan: 176
Pagan, Juan Carlos: 136
Pandya, Viral: 22, 105
Park, Kum-jun: 44, 66
Patankar, Kalpesh: 179
Peh, Stephanie: 67
Pelletier, Ken: 52, 94
Perdikis, Talyn: 88
Pereira, Kimberley: 24
Poff, Kyle: 174
Poh, Roy: 17
Poole, Dean: 107
Punjamapirom, Chalermpun: 50, 95
Rangan, Gautam: 52, 94
Reinhardt, Lisa: 27
Riehle, Karina: 32
Riekoff, Christian: 54
Rodpetch, Manamai: 50, 95
Rossow, Simon: 31, 92
Rukhavibul, Tienchutha: 50, 95

S/T

Sandstrom, Steve: 106
Saunders, Jon: 182
Schoenherr, Peter: 31, 92
Schroeder, Merle: 159
Scott, Si: 73
See, Ellie: 125
Seeley, Adam: 59
Sheng, Bonny: 189
Shibata, Saori: 56, 57, 160
Shigetomi, Kenichiro: 34
Shiwan, Shabnam: 107
Shouldice, Joe: 64
Siumak: 89
Soh, Leng: 111
Soukup, David: 164
Sribyatta, Irada: 50, 95
Steele, Brian: 96, 120
Stewart, Andrew: 144
Sugawara, Takahiro: 205
Sugimura, Takenori: 56, 57, 160
Sugiyama, Atushi: 152
Sugiyama, Yuki: 123

T/U/V

Takai, Kazuaki: 42, 93
Takaya, Ren: 198
Talford, Paula: 80
Tan, Matt: 144
Tanaka, Toshimitsu: 30, 110
Tanapatanakul, Thirasak: 50, 95
Tancharoen, Nitipong 50, 95
Tatebayashi, Hiroki: 123
The, Richard: 64
Too, Jun Jie: 61, 169
Townsend, Kirsten: 122
Tsuboi, Hironao: 37
Uchida, Yoshiki: 152
van Heerden, Kelda: 175
Vasquez, Ramon: 135

W/X/Y

Wakabayashi, Eriko: 37
Wasielewski, Collette: 175
Watanabe, Mayuko: 56, 57 160
Watkins, Jeff: 24
Wenjun, Zhou: 26
Witwasin, Kantaphat: 50, 95
Woltman, Christian: 81
Wynn, Ryan: 175
Xiong, Jody: 187
Yadav, Siddhi: 128
Young, Forest: 189

Writers

A/B

C

D

E/F

G/H

I/J/K

L/M

N/O/P

Q/R

S

T/V

W/X/Y/Z

One Club Members

Australia

Dave Bowman
Mark Braddock
Briony Marsden
Damian Royce
Vanessa Ryan
Karen White

Belgium

Joeri Van Den Broeck

Brazil

Carolina Saraiva

Canada

Erik Christensen
Jordan Doucette
Kai Exos
Karen Feiertag
Ian Grais
Lance Martin
Zak Mroueh
Steve Mykolyn
Matt Orlando
Carey Sessoms
Mo Solomon
Thomas Stringham
Nancy Vonk
Sabrina Wong

China

Yiyang Hei
Lin Jingyang
Zhou Wenjun
KianFong Wong
Lin Yuanju

Colombia

Armando Rico

Finland

Niko Sipila

France

Chris Garbutt

Germany

Sascha Hanke
Ralf Heuel
Stefan Meske
Goetz Ulmer
Joern Welle

Hong Kong

Keith Ho
Raymond Tam

India

Anuja Chauhan
Naveen Tripathi

Ireland

Brendan O'Flaherty

Italy

Fabrizio Ballabeni

Japan

Kenichiro Shigetomi

Kazakhstan

Juan Pablo Valencia

South Korea

Younghwa Moon
John Park

Malaysia

Ted Lim

Netherlands

Jeff Kling
Liza Sie
Trey Tyler
Valentine Vale

New Zealand

Sam Ramlu

Norway

Tore Woll

Puerto Rico

Raul Cosculluela

Qatar

Mohamad Alaa Jazmati

Romania

Andreea Strachina

South Africa

Grazyna Koscielska
Lebo Mokone
Liam Wielopolski
Waldo Zevenster

Spain

Javi Inglés

Sweden

Magnus Andersson

Switzerland

Roger Ruegger

Thailand

Jureeporn Thaidumrong

Turkey

Levent Kaya

Uganda

Sonny Opiyo

United Kingdom

David Abbott
Daryl Corps
Tim Delaney
Jaime Diskin Diskin
Rick Dodds
Benjamin Lynch
Teh Tarty

Vietnam

Todd McCracken

United States

Jonas Ahlen
Hyung Jein Ahn
Mauricio Alarcon
Christopher Alborano
Manuel Aleman
Mauro Alencar
Joe Alexander
Craig Allen
John Allen
Sezay Altinok
Janet Alvarez
Patricia Alvey
Ralph Ammirati
Da In An
Alexandra Anderson
Astrid Andujar
Jonathan Angot
Frank Anselmo
Suzana Apelbaum
Laura Arnold
Yoshie Asei
Jimmy Ashworth
Amanda Askea
Brian Avenius
Ron Bacsa
Chris Baier
Hannah Bailey
David Baldwin
Bob Barnwell
Nicholas Barrios
Nick Barrios
Marcio Barros
Ben Bartholomew
Victoria Bellavia
Emily Benfield
Aksana Berdnikova
Chris Beresford-Hill
Joe Berkeley
Lamon Bethel
Tess Bethune
Anthony Bianchi
Arthur Bijur

Bruce Bildsten
Britt Blake
Gerardo Blumenkrantz
Helen Boak
Juan Cruz Bobillo
Bill Borders
Kevin Boswell
Michael Boulia
Douglas Bourne
Lindsey Brand
Tim Braybrooks
Patricia Brinkmann
Allan Broce
Mark Brown
Victoria Bukoski
Allison Bulow
Melissa Burnett
John Butler
Iryna Butsko
Jonathan Butts
Patrick Byers
Molly Callaghan
Bridget Camden
Brittany Campbell
Austin Campbell-Cohen
Serafin Canchola
Josephine Carey
Andy Carrigan
Timothy Cawley
Damien Chambers
Won Jin Choi
Romy Chowdhury
Marcia Christ
Antoine Christian
Jailee Chung
Su Hyun Chung
Noelle Clark
Bart Cleveland
James Clunie
Bryan Coello
Ian Cohen
Simeon Coker
Christopher Cole
Glenn Cole
Marty Cooke

Kathryn Corning
Brian Cosgrove
Fabio Costa
John Cox
Jay Cranford
Susan Credle
Kathleen Creighton
Brian Cundari
Hal Curtis
Joseph D'Allegro
Joni Davis
Astrid De Fries
Enmibeth de la Cruz
Ramon A. De Los Santos
Lori DeBortoli (Nolan)
Jeff DeGeorgia
Rich Degni
Kaitlin Del Campo
Jerry Della Femina
Christine Dempsey
Richard R. Dendy
Castro Desroches
Curt Detweiler
Brian DiLorenzo
Rose Dionicio
Tony DiPietro
Rob Donnell
Elise Dransfield
Willem Droog
Alice Drueding
Gary du Toit
Joe Duffy
Jim Durfee
Warren Eakins
Lee Earle
Dana Edwards
Geoffrey Edwards
Tiffany Edwards
Alison Eng
Glenda English
Nomin Enkhbold
Elizabeth Erastova
Erik Fahrenkopf
Corinna Falusi
Jin Fan

Stephen Fechtor
Laura Fegley
Aileen Ferris
Joshua Fiebig
Dan Fietsam
Jasmin Figueroa
Anna Fine
Kevin Flatt
Brooke Foley
Dillon Font
Mark Forsman
Roger Frank
Jordan Franklin
Cliff Freeman
Jenny Friedman
Jennifer Frommer
Mei Xin Fu
Sarah Fuentes
Phil Gable
Vincent Garbellano
Crystal Gee
Mike Geiger
John Gellos
William Gelner
Eleni Georgeou
Jannie Gerds (Matteson)
Paul Gigante
Kent Gilbert
Ken Gleason
Ryan Goldberg
Dan Goldgeier
Juan Pablo Gomez
Kayla Gomez
Jeff Goodby
Kara Goodrich
David Graddick
Hayley Grassetti
Amanda Green
Jimmy Greenway
Norm Grey
Nigel Gross
Kevin Growick
Eric Grunbaum
Juan Carlos Gutierrez

Christopher Gyorgy
Lori Habas
Michael Haffely
Calum Handley
Chris Hansen
Stuart Harricks
Jim Haven
Stefan Haverkamp
John Hegarty
Brent Heindl
Megan Helwig
Ryan Henry
Bo Yun Heo
Sarah Herron
Yu Wei Ho
Rob Hoffman
Dave Holloway
Erik Holmdahl
Jim Hord
Stephen Howell
Mike Hughes
Joost Hulsbosch
Amanda E. Huntzinger
Tara Iannotti
Brenda Innocenti
Paula Ip
Todd Irwin
Sabrina Italiano
Jiffy luen
Dmitry Ivanov
Consuelo Izquierdo
Charles Jackson
Rob Jackson
Chris Jacobs
Harry Jacobs
Ashley Jahn
Robert James
Hong Joon Jang
John Jay
Lance Jensen
Bona Jeong
Bo Mi Jo
Erin Johnson
Janet Johnson

Jeffrey Johnson
Jennifer Johnson
Malissa Johnson
Ryan Johnson
Lars Mars Jorgensen
Jae Sung Jung
Jamie Kakleas
Linus Karlsson
Andrew Keller
Kevin Kelly
David Kennedy
Tyler Kevorkian
Elizabeth Kiehner
Jessica Killian
Larissa Killough
Anna Kim
Joanne Kim
Moonee Kim
Paul Kim
YouJin Kim
Brian Klam
Joe Knezic
Mary Knight
Brent Koepke
Rich Kohnke
denis koltsov
Julian Konig
Dennis Koye
Mike Kriefski
James Kuczynski
Anais La Rocca
Nicole Lague
Summer Lambert
Christopher Lane
Lachrisha Lark
David Laskarzewski
Jennifer Lau
Charles Lawson
Chung woo lee
Gue Rim Lee
Hae Jeon Lee
Hanso Lee
Jung A Lee
Jungheun Lee

Katie Lee
Na Rae Lee
Ralph Lee
Soo Yen Lee
Yong Jun Lee
Pum Lefebure
Ann Lemon
Jim Lesser
Shuo Li
Guilet Libby
Duri Lim
Julio Lima
Teresa Lin
Hisn Yu Liu
Ian Liu
Ke Jun Liu
George Lois
Ekaterina Lopantseva
Lucila Lopez
Edward Loyola
David Lubars
Dan Lucey
Tiffany Maisonave
David Mannion
Steve Mapp
Olivia Maramara
Xavier Marcial
Elena Margulis
Alfred Marks
John Matejczyk
Kim Mathers
Marie Matuszewski
Ed McCabe
Mennelle McCahill
Sara McCarthy
Jacob McFadden
Whitney Mendelsohn
Tommy Mendes
Ari Merkin
Graham Mills
Duncan Milner
Laurence Minsky
Delainna Minter
Can Misirlioglu

Joaquin Molla
Jose Molla
Sakol Mongkolkasetarin
Jy Montague
Darren Moran
Benjamin Morejon
Doug Morgan
Pam Morrell
Erin Murphy
Stella Hye Jung Na
Michel Napolis
Teresa Naranjo
Arun K. Nemali
Michelle Neunert
Diana Nichols
Amy Nicholson
Ray Noce
Shenika Nolan
Wanqin Nong
Jason Norcross
John Norman
Michael Norton
Bukola Ogunmola
Sol Oh
Frankmy Olivo
Manuel Olmo-Rodriguez
Joe Olsen
Takashi Omura
Jonathan Ong
Dylan Ostrow
Peter Pagan
Andrei Pagsisihan
Michael Palma
Candice Park
HaeHyun Park
Jeong Yoon Park
Joon Yong Park
Min Yeong Park
Sanggun Park
Seyoung Park
So Hyeon Park
Sujung Park
Yuna Park
Kimberly Pasqualetto

Ruben Perez
Bryan Perido
Jason Peterson
Laddie Peterson
Aaron Phua
Susan Pominville
Emlyn Portillo
Ryan Potter
Andrei Prakurat
Alan Rado
Bjorn Ramberg
Robert Rasmussen
Robert Raspanti
Anthony Reda
Rob Reilly
NiRey Reynolds
Sean Reynolds
Jason Ring
Brittany Rivera
Blake Roberts
Alana Robinson
Danny Robinson
Daniel Rodriguez
Fabiola Veronica Rodriguez
Peter Rodriguez
Jason Rogers
Meg Rogers
Shada Rogers
Noah Ross
Ted Royer
Elizabeth Sadkowski
Liz Sadkowski
Michael Sai
Steve Sandstrom
Robert Sawyer
Ben Schneider
Jonathan Schoenberg
Michael Schrom
Jaime Schwarz
Doug Scott
Amee Shah
Andrew Shedd

Carly Sheehan
Glen Sheehan
Jeff Sheppard
Jarwon Shin
Nikolai Shorr
Jason Siciliano
Rich Silverstein
Steve Simpson
Rich Singer
Bart Smith
Jimmy Smith
Dahee Song
Hannah Song
James Spence
Morgan Spurlock
Kash Sree
Joe Staluppi
Scott Steidl
Ellen Steinberg
Hillary Steinberg
David Steinke
Aaron Straka
Rob Strasberg
Amy Strickland
Steven Su
Rich Sullivan
Steve Swartz
Claire Swibinski
Nancy R. Tag
Mahdad Taheri
James Talerico
Jerry Tamburro
Mark Taylor
Andrew Teoh
Phil Thompson
Dana Tiel
Renny Tirador
Luba Tolkachyov
Vinh Tran
Scott Trattner
Julia Trieschmann
Tommy Troncoso
Siembra Trujillo

Mark Tutssel
Lauren Ullmann
Deanna Ulrich
Alejandro Valdivieso
Davis Van Luven
Meredith Vaughan
Elizabeth Vautour
Ashley Veltre
Paul Venables
Jamie Venorsky
Carol Vick-Bynum
Amanda Vinci
Joseph Vinci
Larry Vine
Anthony Vitagliano
Domenico Vitale
Jessica Voight
Thomas Vullo
Saritha Vuppala
Wayne Waaramaa
Marvin Waldman
Bob Warren
Latice Washington
Stephen Weisbrot
Mary Wells
Craig Welsh
Robert Wesson
Robert Shaw West
Matt Whitfield
Dan Wieden
Bryan Wolff Schoemaker
Jieun Won
Charles Wood
William Wood
Amber Worrell
Bill Wright
Stephen Wyatt
Daniel Xavier
Betsy Yamazaki
Czarine Yee
Patrick Yonally
Mark Zapico
Richard Zeid
Mat Zucker